THE BEST OF PHOTOJOURNALISM 2001

"A person's work is nothing but a long journey to recover,

through the detours of art, the two or three simple and great images

which first gained access to their hearts."

ALBERT CAMUS

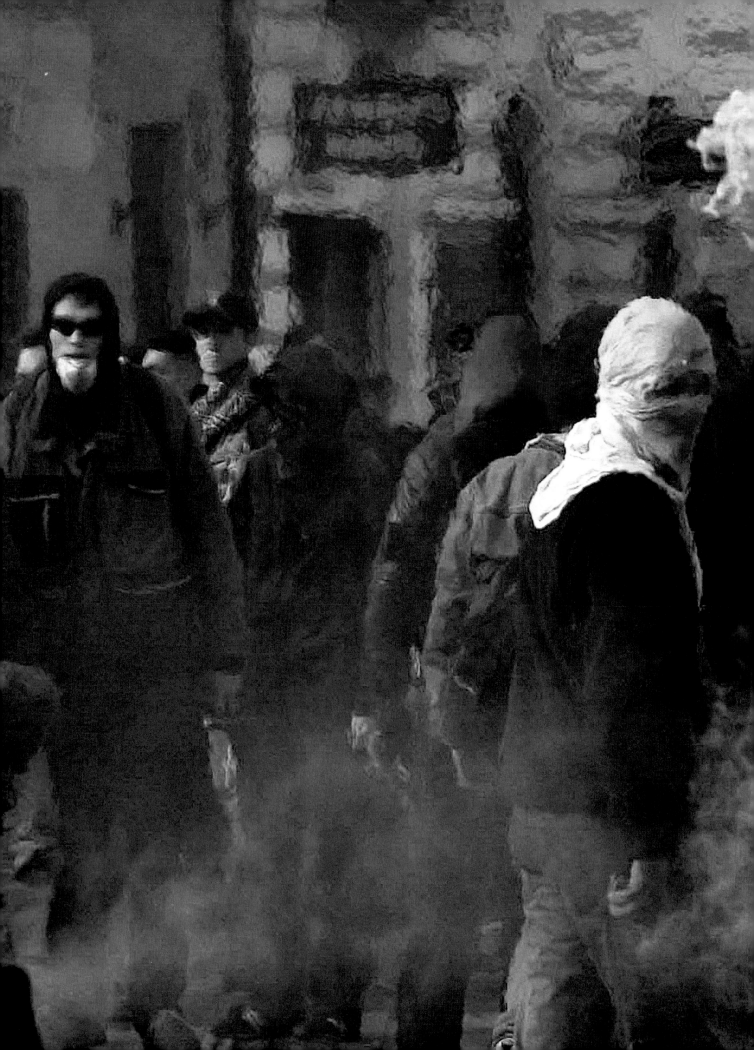

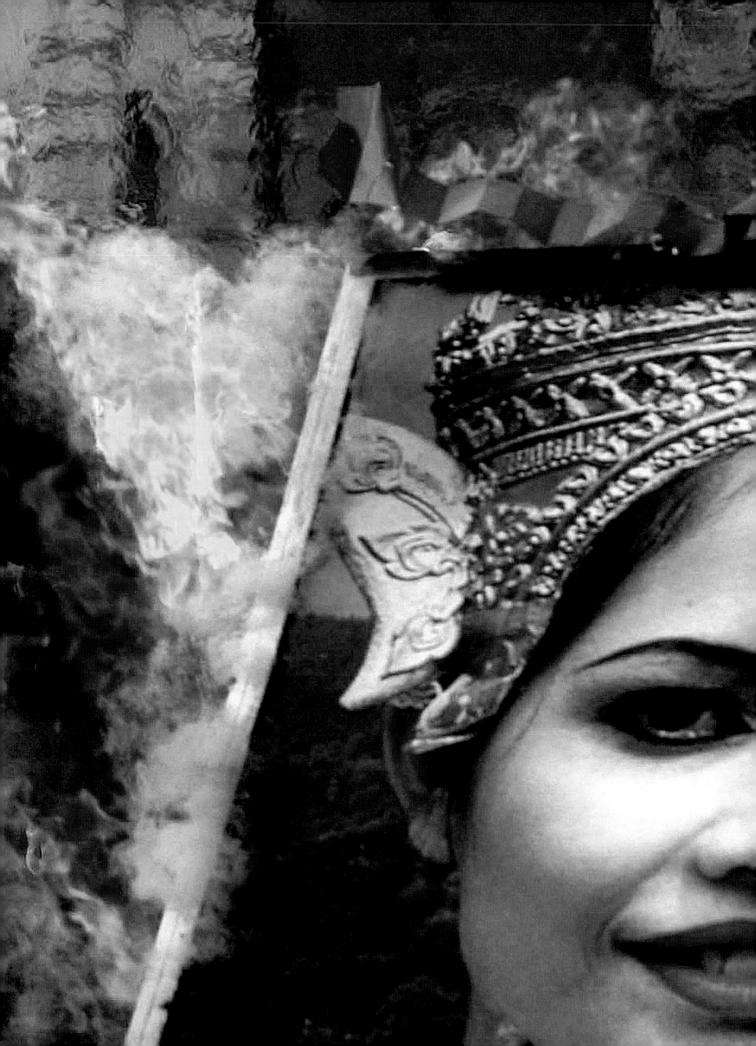

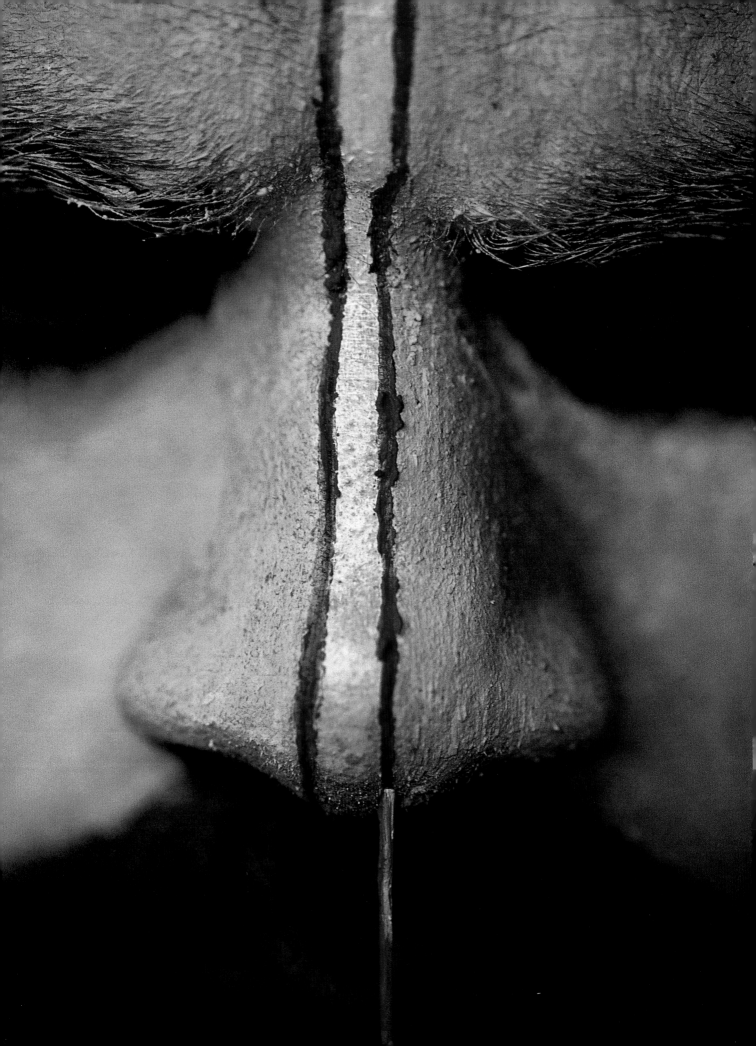

THE BEST OF
PHOTOJOURNALISM
2 0 0 1

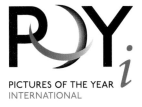

PICTURES OF THE YEAR
INTERNATIONAL

The University of Missouri School of Journalism

Canon FUJIFILM

NATIONAL PRESS PHOTOGRAPHERS ASSOCIATION

DURHAM, NORTH CAROLINA

Dudley M. Brooks
The Washington Post

Cover: Two days after an explosion at a
church in Kanungu, Uganda, killed 330
people, a girl holds rosemary taken from
a nearby garden to mask the stench of
decaying bodies. The dead were mem-
bers of The Movement for the Restora-
tion of the Ten Commandments of God.

Peter Dejong
Associated Press

Pages 2-3: A left-wing protester turns
to watch police and a burning
billboard during riots at the IMF and
World Bank meeting in Prague. Some
5,000 activists marched at the summit,
throwing firebombs and rocks at riot
police, who responded with tear gas
and water cannons.

Jodi Cobb
National Geographic

Previous page: A Huli man of Papua
New Guinea has decorated his face
for the annual "sing sing" at Garoka where
tribes from all over PNG gather
to sing and dance. The sing sings were
started as a means of pacifying the
warlike tribes. The Huli are also known
as the "wigmen" because of the
elaborate headresses they make of
human hair decorated with bird
of paradise feathers.

**Published by the National Press
Photographers Association**

Founded in 1946, the National Press
Photographers Association is dedicated
to the advancement of photojournalism,
its creation, editing and distribution, in
all news media. With more than 10,000
members worldwide, NPPA encourages
photojournalists to reflect high stan-
dards of quality in their professional per-
formance and in their personal code of
ethics. NPPA vigorously promotes
freedom of the press in all its forms.
To this end, NPPA provides continuing
educational programs and fraternalism
without bias as members support and
acknowledge the best the profession
has to offer.

President
 David Handschuh
Vice President
 Clyde Mueller
Secretary
 Tom Costello
Board Member Representative
 Michel duCille
Immediate Past President
 Manny Sotelo Jr.
POY Liaison
 Joseph Elbert II
 Frank Folwell
 Bill Luster
Interim Executive Director
 Charles H. Cooper
Editor, News Photographer
 James Gordon

BEST OF PHOTOJOURNALISM 2001
Editors
 Bill Marr
 Sarah Leen
Assistant Editor
 J'nie Woosley
Copy Editor
 Tom Kavanagh

Copyright © 2001
National Press Photographers Association
3200 Croasdaile Drive, Suite 306, Durham, NC 27705
http://www.nppa.org

Printed and bound in the U.S.A.
ISBN 0-9701104-1-3

Missouri School of Journalism

Pictures of the Year International has
resided at the Missouri School of Journal-
ism since its inception in 1944. Created
by Clifton and Vi Edom as the "Annual
Fifty-Print Exhibition," POYi continues its
original mission of creating a visual
archive of our shared history by recogniz-
ing excellence in photojournalism and
honoring press photographers, editors
and the publications where they work.
Joining together in support of POYi in
1957, the NPPA and the Missouri School of
Journalism are proud to continue the tra-
dition of providing a venue for thoughtful
and educational discourse committed to
the advancement of the profession.

MISSOURI SCHOOL OF JOURNALISM
Dean
 R. Dean Mills
PICTURES OF THE YEAR INTERNATIONAL
Director
 David Rees
Coordinator
 Catherine Mohesky
Administrative Assistant
 Kimberly Morrison
POYi Special Consultant
 Loup Langton
Student Coordinators
 Dan Williamson
 Bill Carwin
Web Producer
 Stephanie Kuykendal
Digital Imaging
 Brian Kratzer
 Andrew Rush

For information on entering the Pictures
of the Year International Competition,
contact info@poyi.org. For more infor-
mation on the contest and a complete
display of winning images, go to
http://www.poyi.org.

CONTENTS

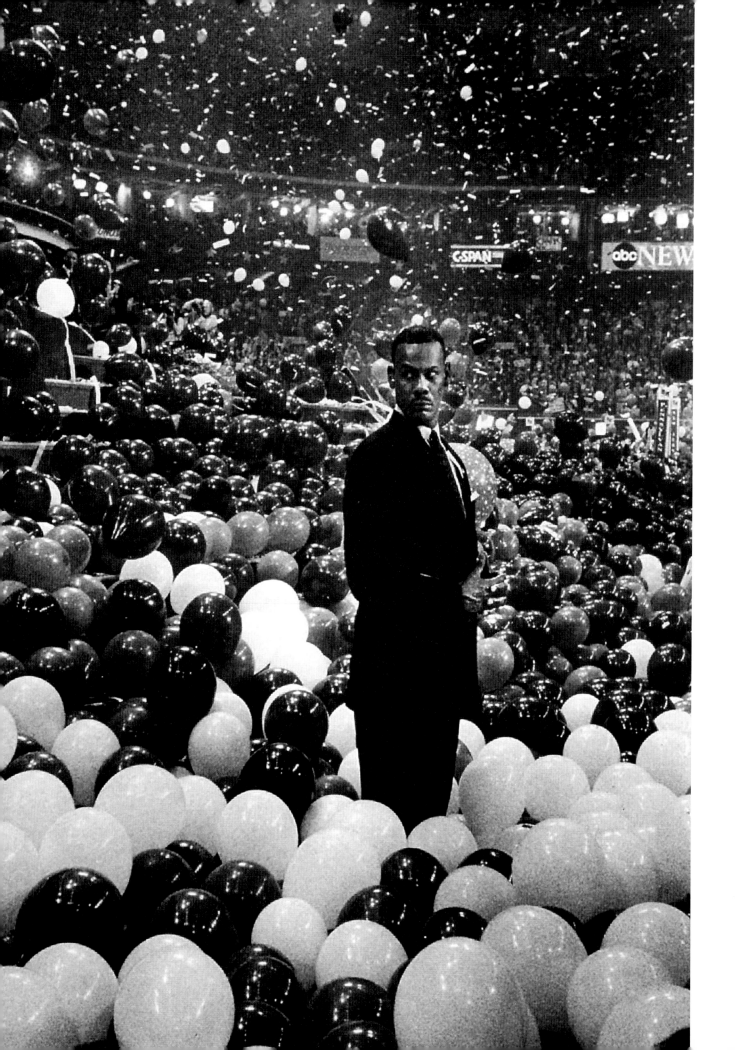

BY SCOTT SIMON

■ A picture is not worth a thousand words—not as long as the 286 words of Lincoln's Gettysburg Address are inscribed on our minds, along with the 179 of the Ten Commandments. What the pictures that are great photographs accomplish is to pierce a heart muscle inside us that is not always touched by words.

The Pictures of the Year contest dates back to the spring of 1944, when the University of Missouri School of Journalism sponsored its first national forum for what it called "photographers of the nation to meet in open competition; and to compile and preserve…a collection of the best in current, home-front press pictures."

That first competition received 223 prints. By 2001, that number now exceeds 33,000. Twelve distinguished judges view slides and sift through tear sheets, all featuring the most outstanding photographic work of the year. It has been my great fortune to be a small part of handing out these awards, and to see many of the photographs honored—and quite a few of those that fall just short—flicker by.

There is no single theme to a sequence of great photographs. But there is, if you look closely, a kind of thread: the isolated moment of human experience. There are famous faces in some of the photographs—monarchs, presidents, and celebrities—but usually in some unexpected moment. The preponderance are photographs of unrecognized people all over the world—lovers, soldiers, refugees, athletes, artists, criminals, and parents—living through utterly recognizable human moments: exultation, fear, anxiety, accomplishment, happiness or pain. The photographs that have most signified our times—Charles Moore's portraits of civil rights marchers, Jacques Lowe's portrait of Jack Kennedy bending beneath his burdens, and Nick Ut's searing photo of a young Vietnamese girl running in agony from American napalm—are POY winners. The parameters of Pictures of the Year have expanded, now that the world can be seen in its entirety from the surface of the moon, and we can share the same image in the flick of a switch. Pictures of the Year's "home-front" now extends around the world.

Each year's winners help form a memory book of our human family. Welcome to a few new leaves in a book that grows larger and more resonant each year.

Scott Simon is a writer and reporter for National Public Radio's "Weekend Edition/Saturday" and PBS's "This Week Considered."
He joined NPR more than 20 years ago and has filed reports from around the world.

Eric Mencher
The Philadelphia Inquirer

Opposite: After presidential nominee George W. Bush's acceptance speech, a Secret Service agent keeps an eye on the crowd amid a sea of balloons at the Republican National Convention in Philadelphia.

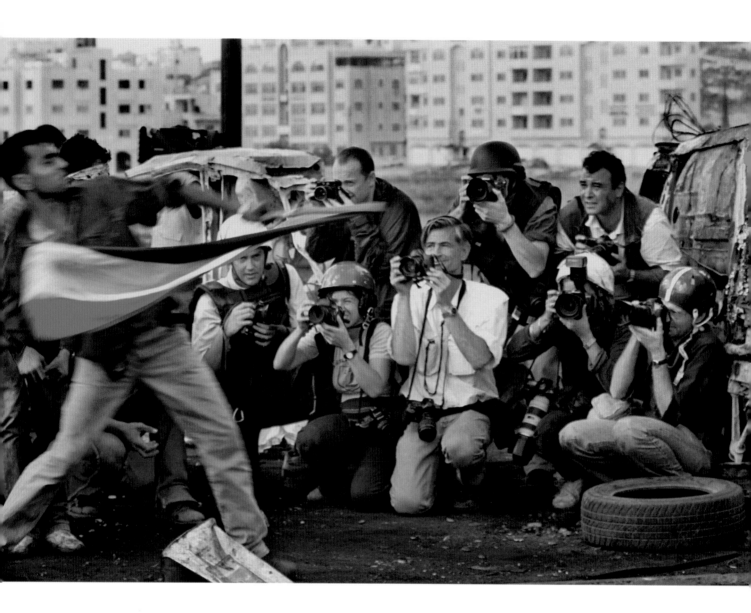

David Silverman
Newsweek

Press photographers take pictures of Palestinians hurling stones at Israeli troops during clashes on the outskirts of the West Bank town of Ramallah. "First, even though I do think that photographers' presence does have an effect on events, this does not mean that they actually play an active role in their enactment," explains Silverman. "No two photographers shoot the same event in the same way, and even the technological differences—which lens we choose, what angle we use—have an effect on the image's impact."

The Art of the Moment

BY HENRY ALLEN

■ These are pictures of hell, maybe two-thirds of them.

Sometimes you're not sure.

Does a picture show hell or heaven when it presents a joy-crazed Brazilian slum kid waving his arms in the rain? The picture could come right out of "The Family of Man," back in the 1950s, happiness the whole world over. Except the kid is high on glue, is the point.

Or Todd and Marci in a honeymoon bathtub lit by candles. They look happy and loving. They're both mentally retarded. He uses a wheelchair, she has cancer. And they've taken a photographer with them on their honeymoon.

Or 17 pictures by a photographer who shows herself dying of cancer. She gets the bad news about the biopsy. She wakes up from a double mastectomy. Toward the end she gets so weak she asks somebody to finish the story for her. Is she exploiting her own death? Does she make us all voyeurs? Is she sacrificing her privacy for the public good?

Then there's plain old hell, a cavalcade of starved rib cages, blood and flames; a panorama of AIDS, exile, starvation, loneliness, bulimia, deracination, riots, rage, grief, futility, Armageddon, the smoking hoofprints of the Archfiend himself.

Should you really be staring at these things?

Can you help staring at them? Many of them are even beautiful—the torchy pageant-moment of a man throwing a Molotov cocktail in the manner of the statued Greek throwing a discus, for instance.

Very complicated, this press photography of the hell variety.

Circus freak shows have become politically incorrect in America, but we can always turn to our newspapers and magazines for the bizarre and the mutated. Step right this way, ladies and gentlemen, and witness the unequalled and educational spectacle of the fabric of humanity itself coming unraveled.

You look, and you feel bad. You also feel good that you've got such a big heart you feel bad looking at this suffering, though not bad enough to avert your eyes from

Henry Allen is a writer and editor at The Washington Post. *He was awarded a Pulitzer Prize in 2000 for his critical writing on photography. He has also written on photography for the New Yorker and the New York Review of Books.*

the freezing refugees, filthy children or the exploding Concorde airplane. Strange: A lot of editors will print pictures of charred human beings when they wouldn't think of printing a close shot of a burning cow in Britain's foot-and-mouth epidemic. Readers would protest.

There's no end to these paradoxes. Looking at these things puts you on moral tumble-dry. Then you forgive yourself because you know you're staring out of hard-wired Homo-sapiens pleasure to be found in a savoring of squalor, a delight in disorder, as the poet said; a world-wisdom that includes a death-hip sense of existential whimsy. And, of course, these pictures show victims, who are the heros of our time, and the stars of the ongoing morality play presented by the media. Also, hell is more interesting than heaven. This is one reason a lot of people have read Milton's "Paradise Lost" and not so many have read "Paradise Regained."

The other third of the pictures in this book show beauty, disappointment, triumph, humor, eccentricity (why are those football players sitting inside an ice locker?), grace, hope, striving, impossibility (all those soccer players leaping at once) and sentiment. The freakish is now the extraordinary, the appalling is merely the sad. This is life as most of us know it, full of people with whole psyches, doing their best.

Here's a melancholy, determined Tiger Woods evoked with bold and strange half-lighting. George W. Bush waves from a campaign train in Michigan, his arms spread, his tie dangling, the tracks angling toward a vanishing point, a picture with as many angles as a Gothic cathedral, all of them leading to his smiling face. A little Congolese girl walks to church, her head radiating pigtails, her profile sharp against the background of a yellow wall.

And community: There's nothing but good news at an integrated block party in Verona, NJ—black and white together in a fulfillment of an American dream of equality. And nature: the greens and oranges of an acacia tree; a ghostly seal rising through water; jungles and oceans.

And sports: The air is full of gymnasts, the water alive with swimmers, the magnificence of the human body at extremes of effort both physical and spiritual. A fabulous grass green and storm-cloud gray surrounds jumping horses and their jockeys in red and yellow silks.

There's a sort of heaven in parts of this third of the book. Instead of a hellish smog of alienation, there's the clarity of realities that can only be understood with the ideas of beauty and order.

The odd thing is that both sorts of photographs spring from the same sensibility. They both attract the eye and they are both news, telling us something we don't know, or exalting something that we do. More important, though, is the fact that most of these pictures are narratives. They tell a story, they show us people and the world at the point of change.

Someone has said that the old New Yorker's short stories were the closet scene from "Hamlet" without the rest of the play—turning points, distillations, essences,

epiphanies. So are these pictures. They have the quality of the sidelong glance that turns out to be what you remember of a scene for the rest of your life. They're narratives, rather than monuments. They exist in time, unlike, say, a portrait of George Washington that seeks to take him out of time and make him immortal.

Part of the basic appeal of photographs is their tangy melancholy of time passing, of caught moments that vibrate with the past that led up to them and the future that disappears into the distance like the railroad tracks in the picture of George W. Bush waving from the train. Part of the appeal of the pictures in this book is that they may be some of the last of the photographs from an era when people believed the camera didn't lie. With movie special effects and computers bending the world around like Silly Putty, people don't believe the camera is incapable of lying anymore. Besides, like all arts, photography has always lied, usually in the hope of showing some higher truth.

Now the opportunities for lying are greater than ever with digital photography and its million manipulations.

And color: press photographers can shoot everything in color now, even if it's going to be printed in black and white. If they think it will appear in color, they'll compose for color—balancing hues the way they used to balance the values of black and white—and take pictures where the color lures the eye more than the subjects. All of this is a sort of lie.

All this to think about in a newspaper or magazine picture—what a feat of art good press photography is! How many other modern art forms provoke such complex reactions in people who are not intellectuals?

Modern gallery and museum photography moves further into monumentalism and escape from time, but news photography stays with narrative and the moment. You could argue that journalism's photographers are old-fashioned with their pathos and sentiments, but what's more old-fashioned nowadays than anything with the word "modern" attached to it?

Modern painting, postmodern architecture—nothing looks more passe than yesterday's future. Press photographers don't have this problem—they worry about today's present. Instead of making the concrete into the abstract, they make the abstract concrete. (Point of interest: editors call all graphics "art"—court sketches, stock market charts, photographs.) You drink wine while looking at art photography, you drink coffee while looking at press photography. A good news picture is a picture people look at. A good art picture is one that people should look at.

The great photographers of all kinds go beyond these categories. They reach the point where a good picture is a good picture, and that's all you need to know. It stays mysterious, there's no explaining it, like the picture of the Hindenburg disaster, a zeppelin aflame at its mooring. Only 36 people died. Why do we keep looking? It's art. Ezra Pound once said that literature is news that stays news. Maybe great news photography is art that stays art.

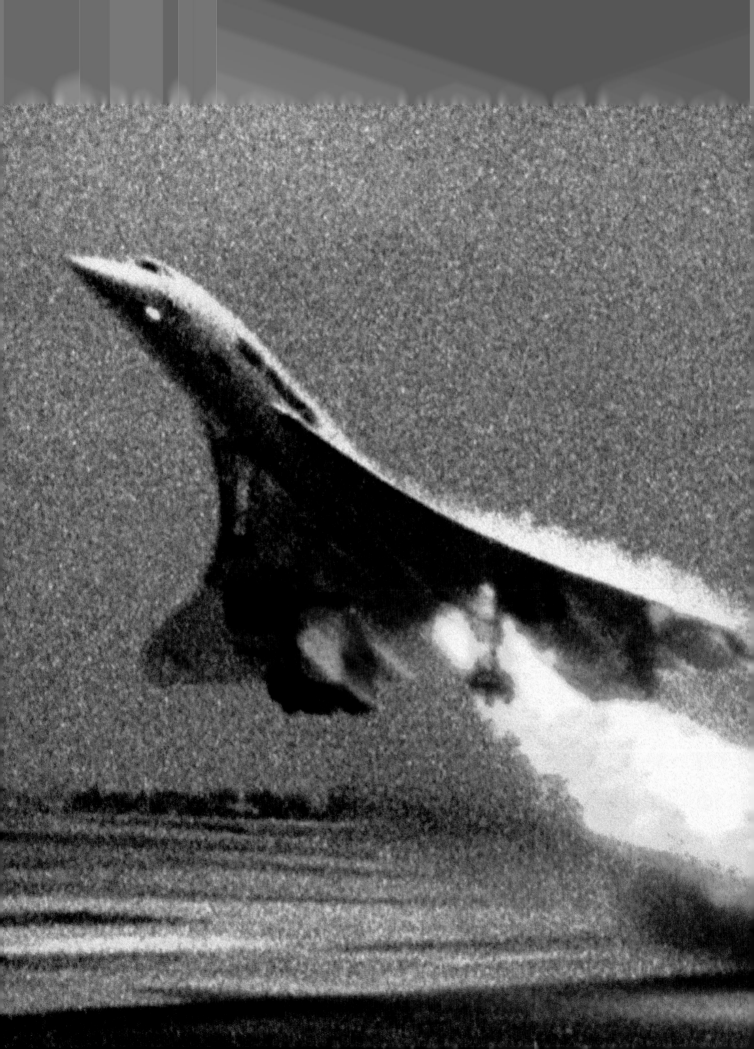

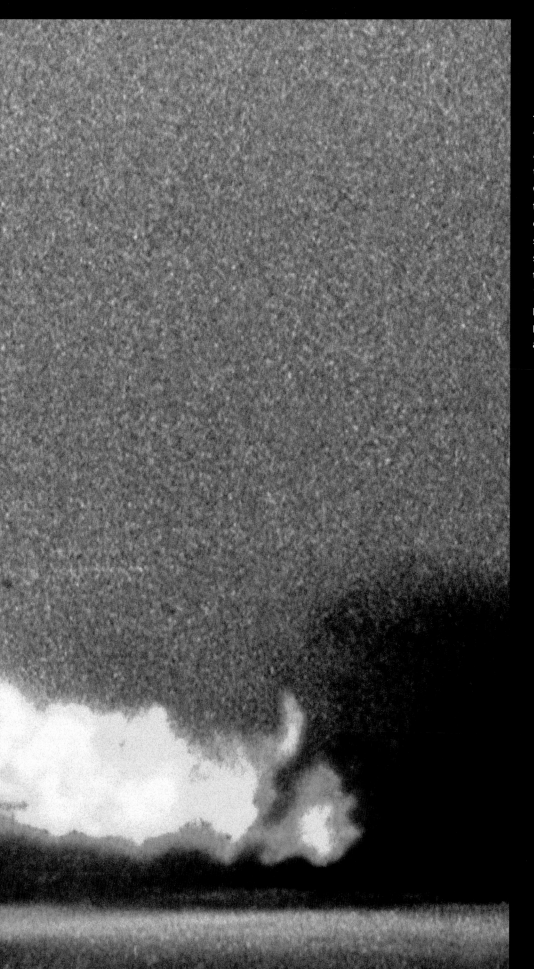

Toshihiko Sato
Associated Press

An Air France Concorde takes off from Charles de Gaulle Airport in Paris with fire trailing from its left engine on July 25, 2000. The supersonic jet crashed shortly afterward in the town of Gonesse, killing all 109 passengers and four people on the ground. This photograph was taken with an instamatic camera.

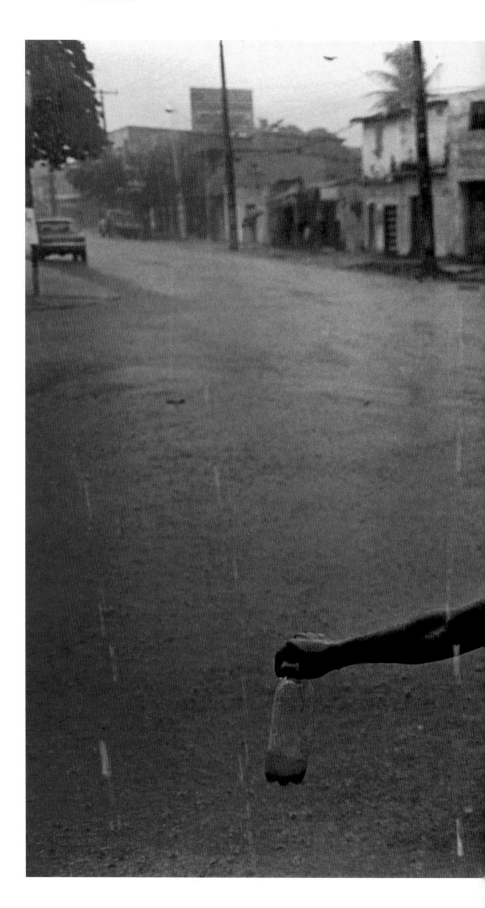

Tyrone Turner
ICWA / Black Star

DISCARDED:
GLUE KIDS OF RECIFE, BRAZIL

The preferred drug of Brazil's estimated 90,000 to 100,000 hard-core street children is shoe glue, a legal substance. Turner documented the struggle of such children in Recife, a town in the poor northeastern region of the country. "The glue kids would warn me when to put my camera away and warned me when things were too dangerous, and I would listen," said Turner. Right: High from glue sniffing, Toni, 15, exults in the rain. When high, the addicts' emotions swing wildly, from ecstasy to rage.

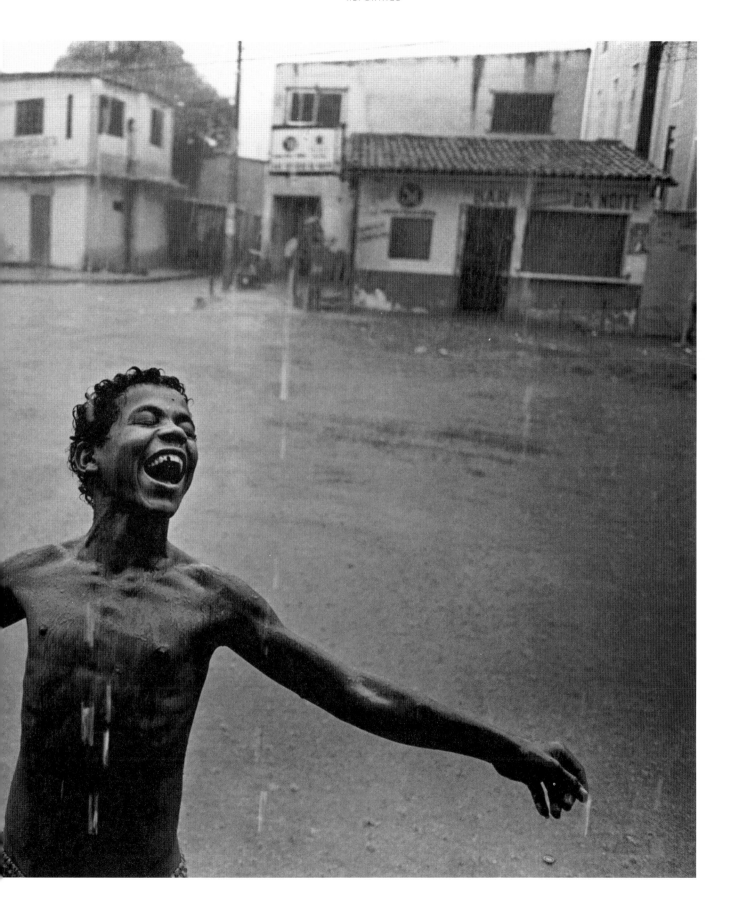

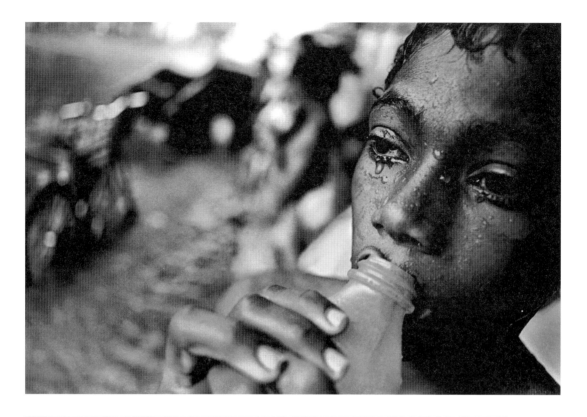

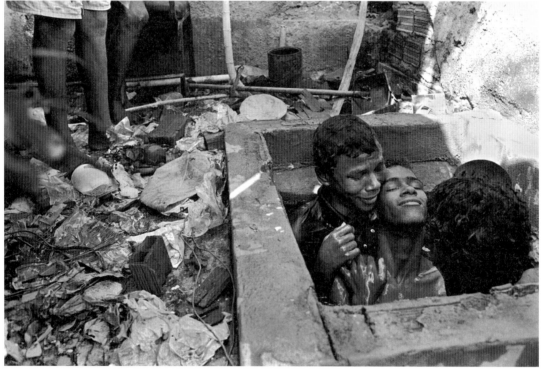

Top: As rain drops bead on his face, Breno inhales glue fumes. One inch of glue, which costs about 50 cents, gives a three-hour high. Above: Glue kids caress and bathe in an abandoned factory. Many street kids have sex with one another, though few, like Josenildo, center, admit their homosexuality.

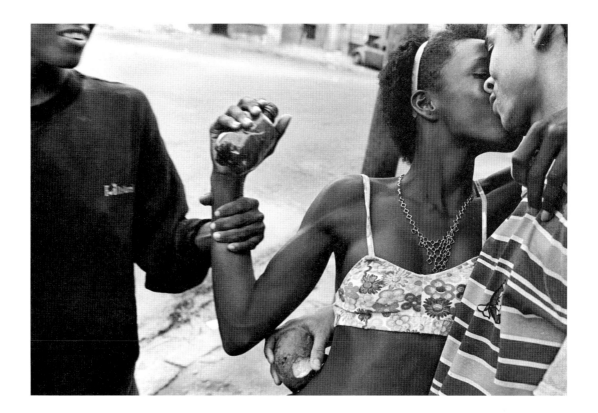

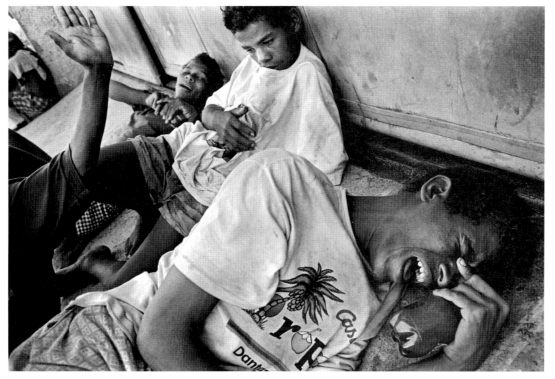

Top: Tatai, 14, pregnant by one glue addict, kisses another. She uses her sexuality to intimidate fellow glue addicts and passing adults. Above: Surrounded by other addicts, Josenildo, 16, is consumed by disappointment after missing his chance to attend a recovery camp for street children.

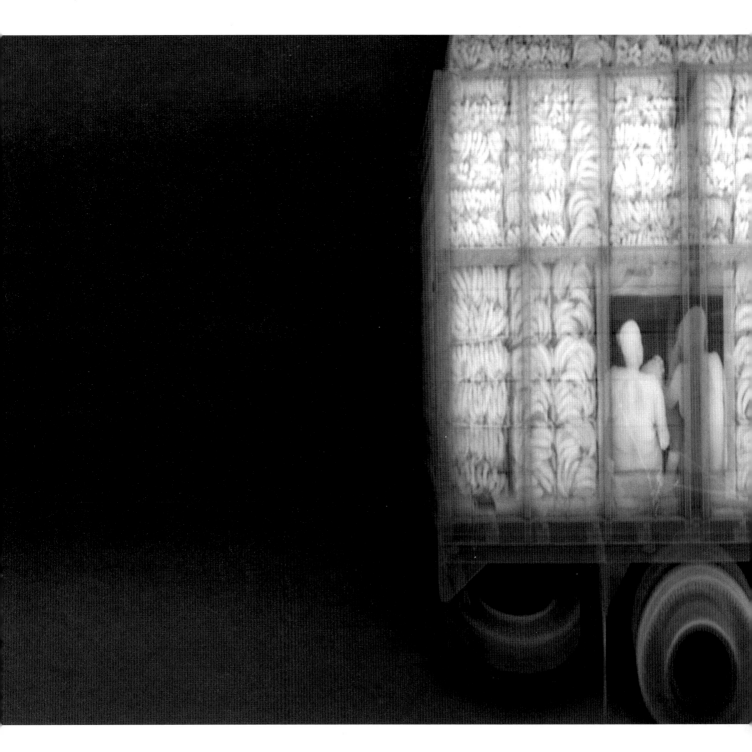

American Science & Engineering
Newsweek

An X-ray image of a truck in southern Mexico shows illegal immigrants hiding inside with a shipment of bananas. The photograph was taken with X-ray technology that detects organic materials.

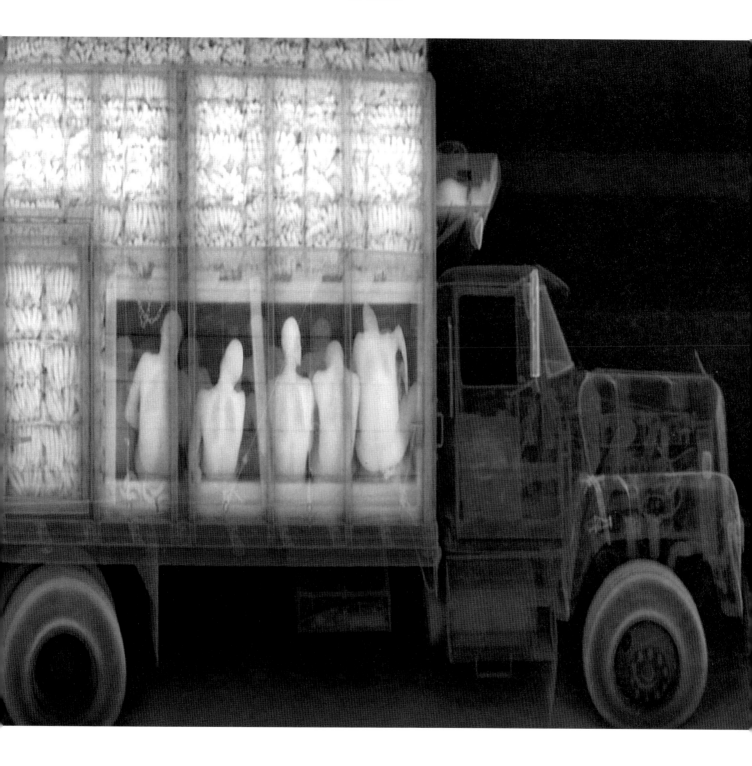

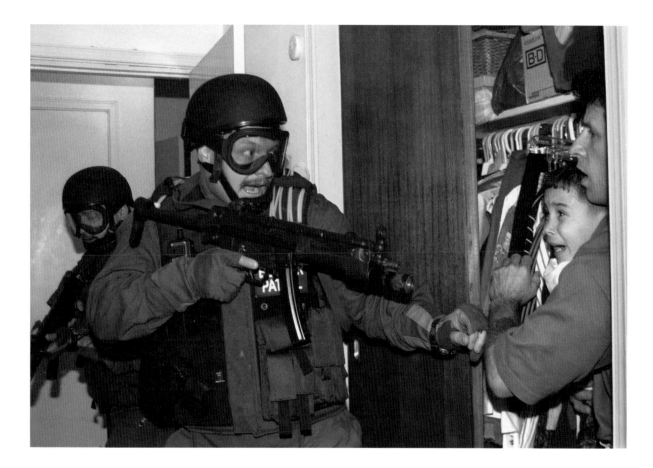

Alan Diaz
Associated Press

Donato Dalrymple holds Elián Gonzalez as federal agents storm the bedroom where the boy and Dalrymple
were hiding. Elián, a 6-year-old Cuban refugee, was rescued from the Atlantic Ocean on Thanksgiving Day,
1999. A five-month custody battle followed between his father in Cuba and his relatives in Miami. Diaz said
that when he heard INS officers in the back yard, he ran through the house to find Elián. "It's a strange
moment; they were going crazy," explained Diaz. "All I remember was this kid crying."

Antonio Scorza
Agence France-Presse

Opposite: Confronted by police while trying to rob a bus in Rio de Janeiro, Sandro do Nascimento
holds one of his 11 hostages during negotiations. Both Nasciemento and the hostage, a 20-year-
old art teacher, were killed when police stormed the bus after a four-hour standoff.

Lannis Waters
The Palm Beach Post

Haitians line up to vote in national parliamentary elections on May 21, 2000, outside a polling place in an abandoned movie theater. Polls opened severals hours late, but voting was not marred by the widespread violence that had plagued previous elections. The U.S. government spent millions of dollars on a new voter registration system to ensure free and fair balloting. Haiti had been operating without a parliament since early 1999 when President Rene Preval dismissed its members and ruled by decree.

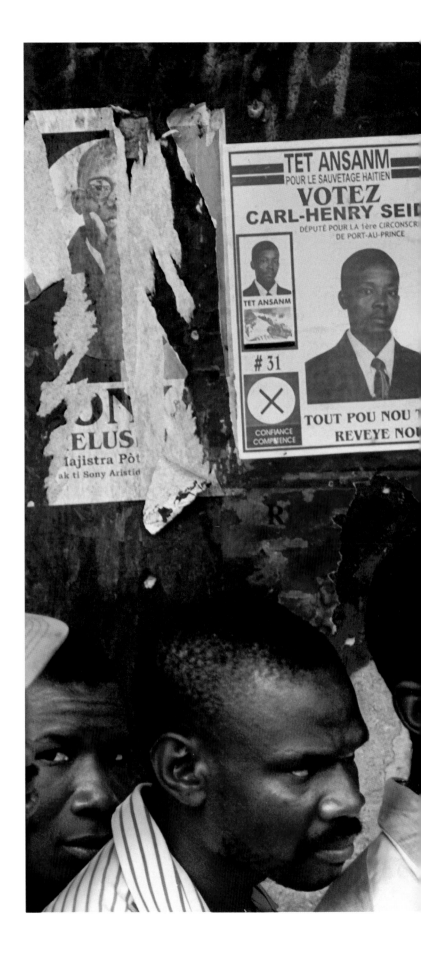

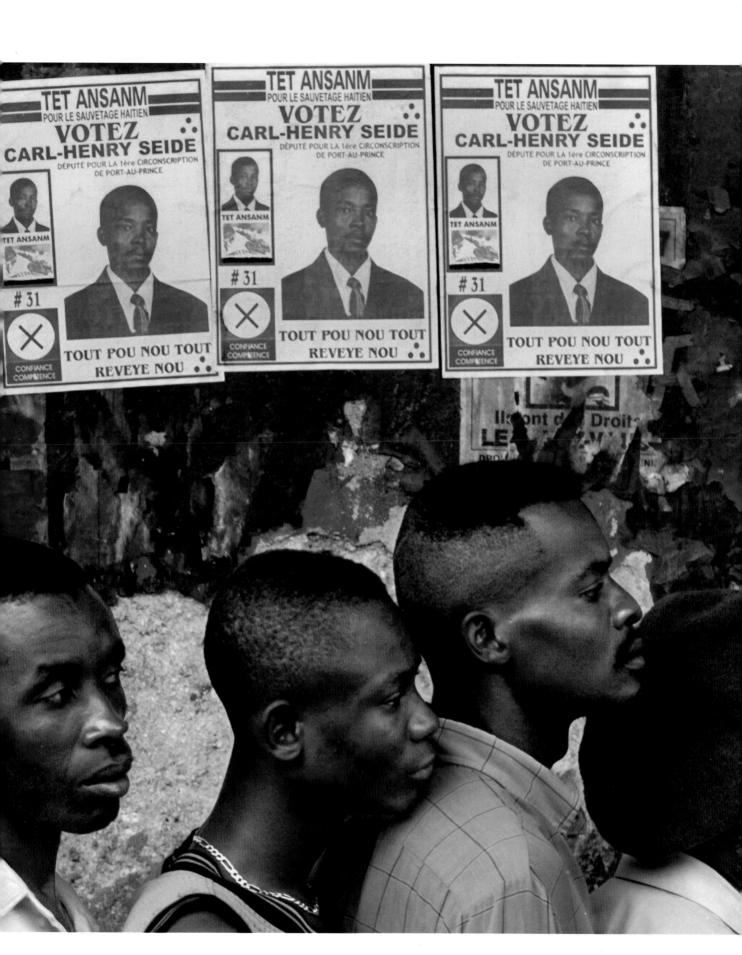

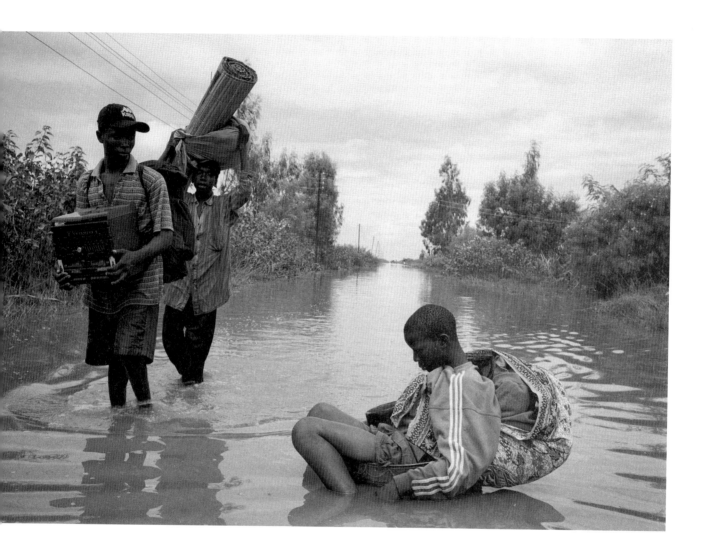

Tom Stoddart
IPG

People fleeing rising floodwaters in Chokwe, Mozambique, pass an exhausted victim. The floods devastated the country—which is still recovering from years of war—claiming a thousand lives and destroying homes, crops, bridges and roads. In a massive rescue operation, thousands of people and animals were lifted by helicopter from trees and rooftops as the waters closed in.

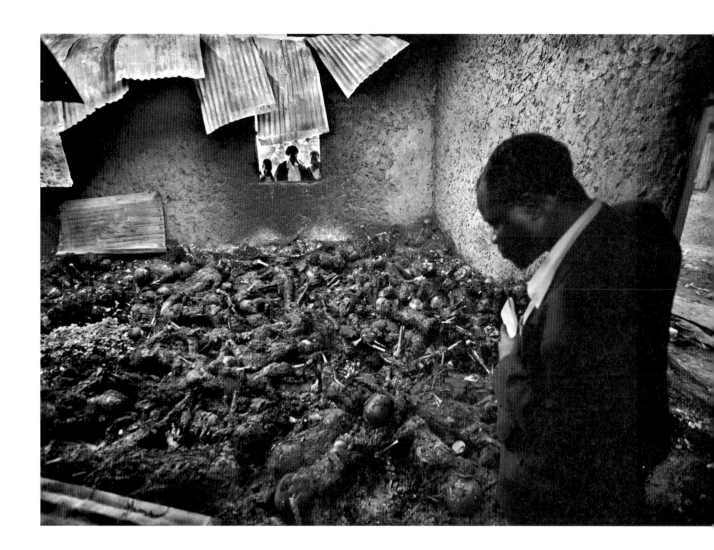

Dudley M. Brooks
The Washington Post

On the morning of March 17, neighbors of The Movement for the Restoration of the Ten
Commandments of God, in Kanungu, Uganda, heard a bell summoning its members to worship.
A half-hour later, they heard something else: an explosion. A physician, above, walks through the
charred remains, tallying the skulls. "Three hundred thirty," he announced afterward, looking up
from the total jotted on the back of a business envelope. "Or more. Because some are ash."

Tom Stoddart
U.S. News & World Report/IPG

AIDS victim Kelvin Kalasa, 30, is helped into a bath at the Mother of Mercy Hospice in Chilanga, Zambia. Hospice founder Sister Leonia Komas and her staff give care and dignity to the poorest sufferers in the area near Zambia's capital, Lusaka. This year, as the disease tears through the continent, some 2.4 million Africans are expected to die, many of them teachers, doctors, civil servants and soldiers. "So overwhelming has been the scale of the scourge that our medical, social and traditional structures are unable to cope with the human cost of the pandemic," admitted Zambia's president, Frederick Chiluba, in a rare statement about AIDS.

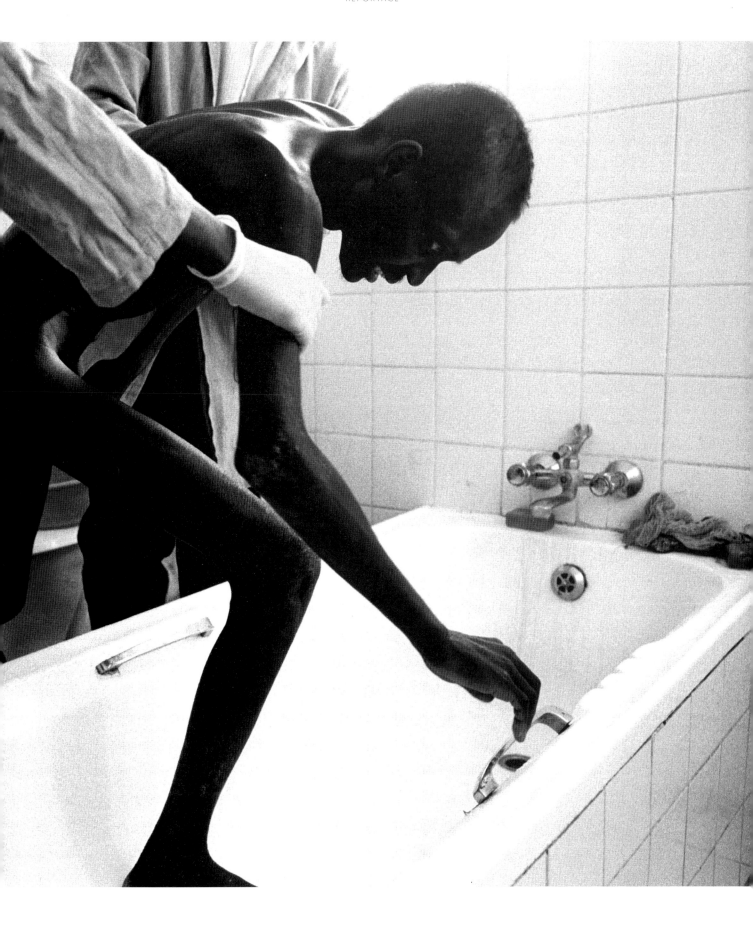

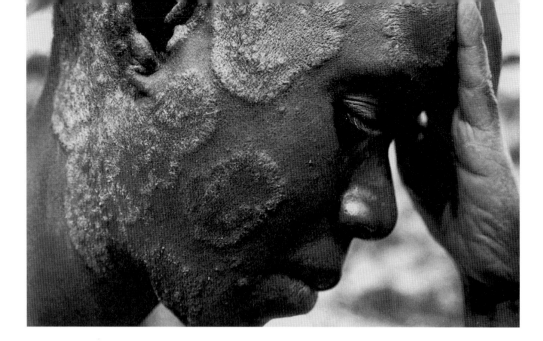

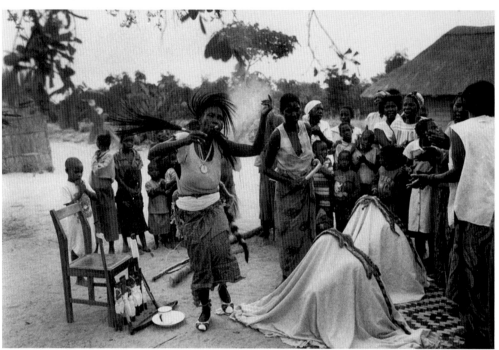

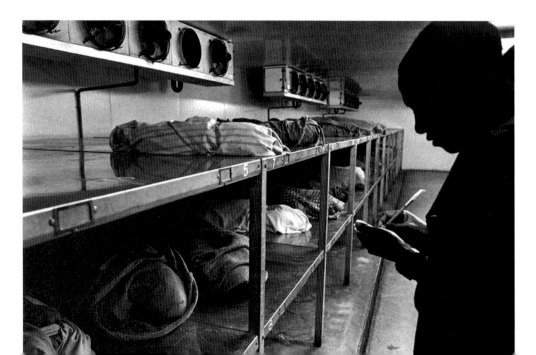

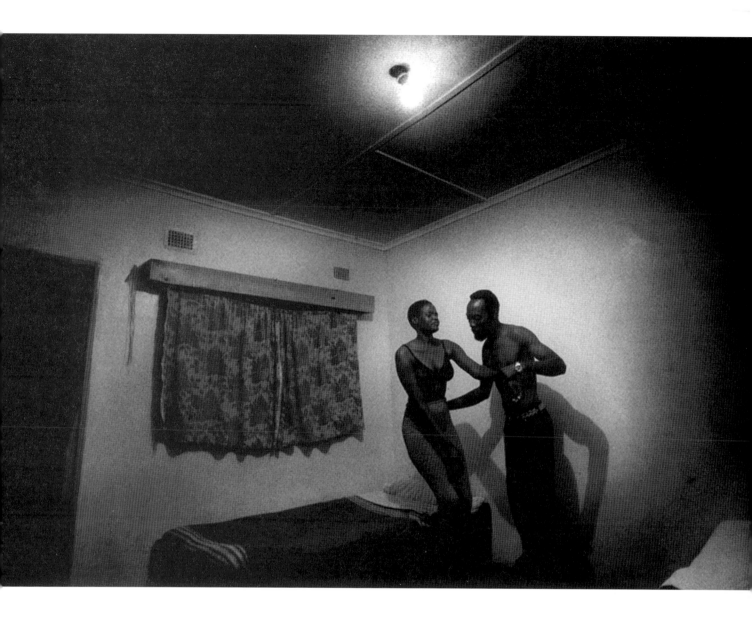

Geert van Kesteren
Newsweek

AIDS IN ZAMBIA Thirty-percent of Zambia's 9 million people have AIDS, and 20 percent of the population will likely die of the illness in the next 10 years. Top left: Lylian, 34, whose face shows an effect of AIDS, is afraid to come out of her hut in Chilanga. Center left: Many Zambians seek traditional healers, like "Dr. Syjungi," who believe that AIDS is not a disease but a demon. Bottom left: The mortuary of the University Teaching Hospital in Lusaka receives at least 80 bodies daily, many of them babies. Above: A prostitute, who does not know her HIV status, engages a customer. Clement Mfusi, an AIDS activist, says, "Almost every Zambian man sleeps with other girls than their wife."

Ettore Malanca
The New York Times Magazine / SIPA

Hutus who did not receive
food tickets fight among
themselves for the little food
that is left after distribution at
the Rushubi Camp in Burundi.
The Hutus used to produce
food in Burundi until the
Tutsis moved them inside
camps to better control rebel
factions. The Tutsi minority
represents the power in
Burundi, running both the
government and army.

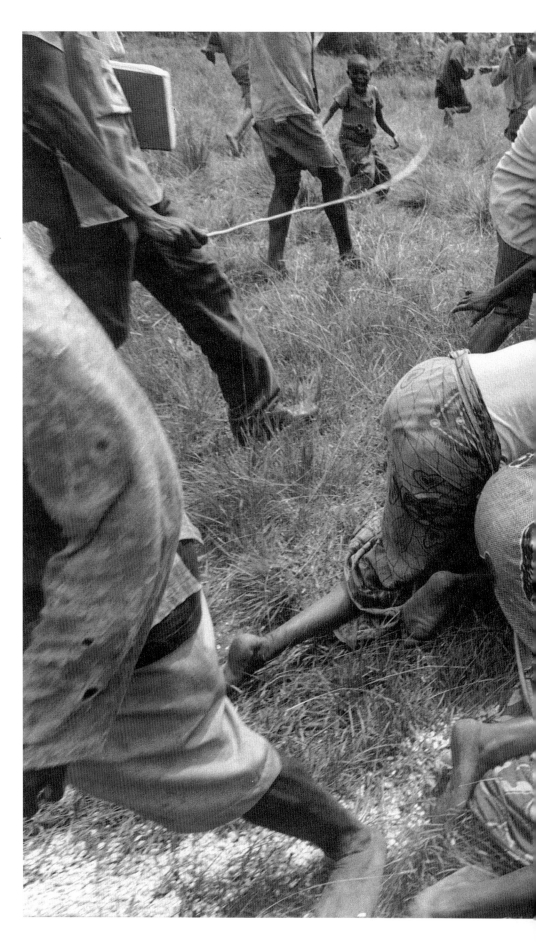

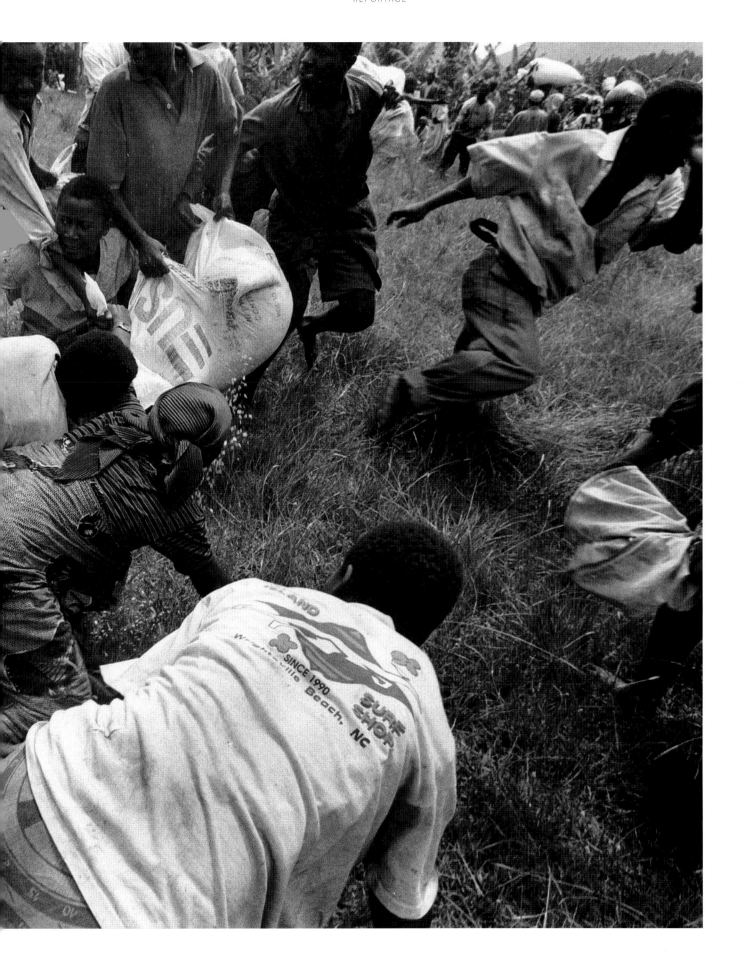

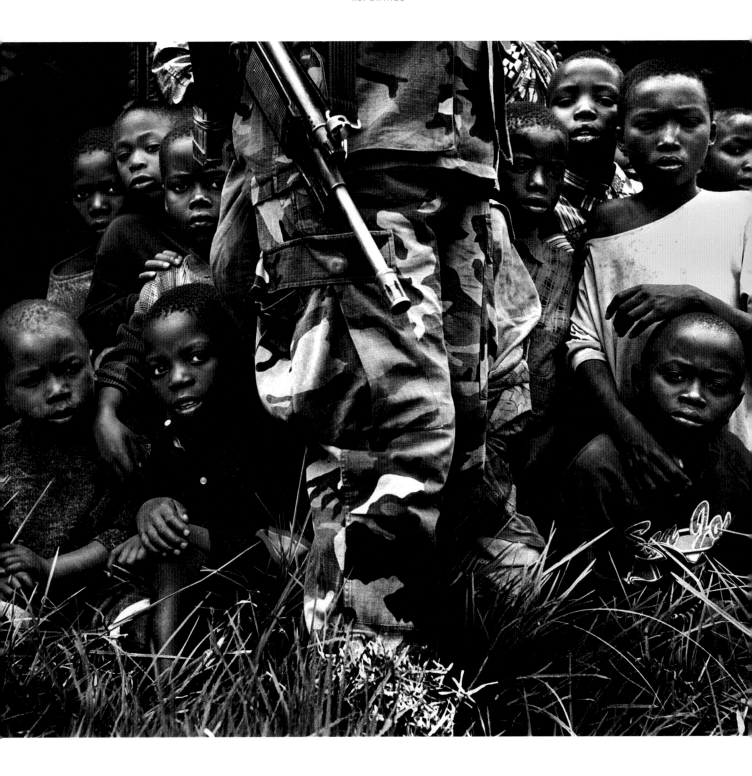

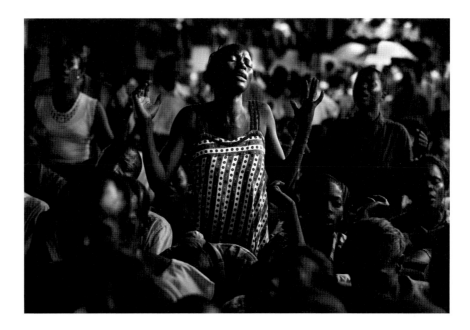

Barbara Davidson
The Dallas Morning News

WAR IN CONGO

The fighting in the Democratic Republic of Congo at once reflects a civil war of government vs. rebels, an ethnic struggle and a regional conflict. The United Nations estimates that the fighting has displaced 1.3 million people and that 14 million are short of food. "There is no sense to this war," refugee Mess Tembe says. Opposite: Children huddle behind a rebel soldier during a rally in the Goma countryside. Top right: Church members worship during Sunday services at the Evangelical Christian Army of Victory Church in Kinshasa. Right: A Congolese woman, upset about the distribution of rations, stares down a guard in the village of Ngungo. Bottom right: At the ill-equipped Kinshasa General Hospital, a malaria-stricken patient waits to die.

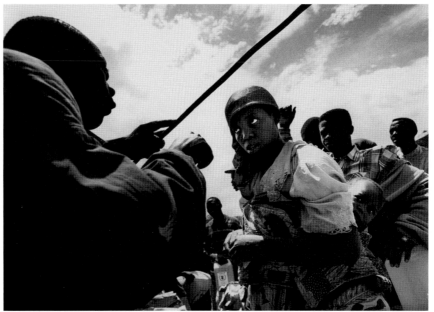

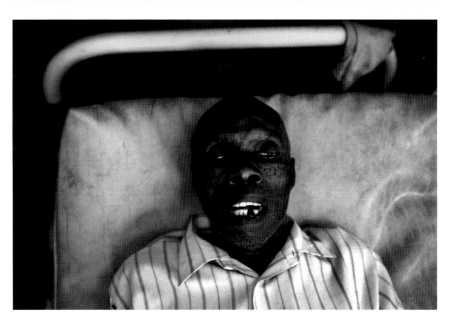

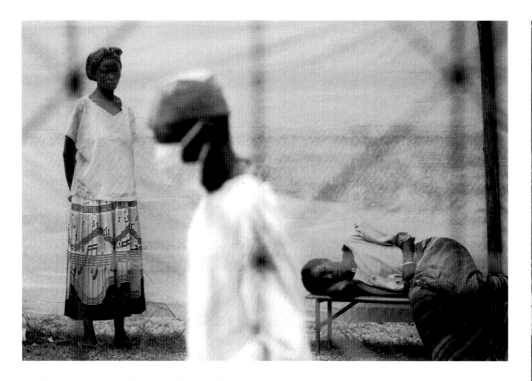

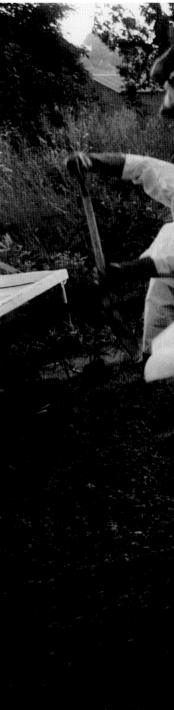

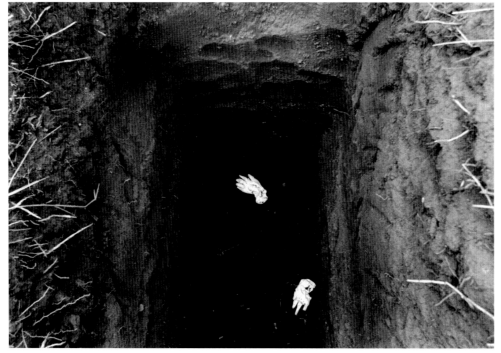

Seamus Murphy
SABA

A DEADLY VIRUS Ebola Sudan, one of three strains of the deadly hemorrhagic fever, broke out in Uganda. The illness also struck the doctors and nurses who attended to the sick. Top left: Patients and relatives wait outside the Ebola isolation ward at the Lacor Hospital in Uganda.

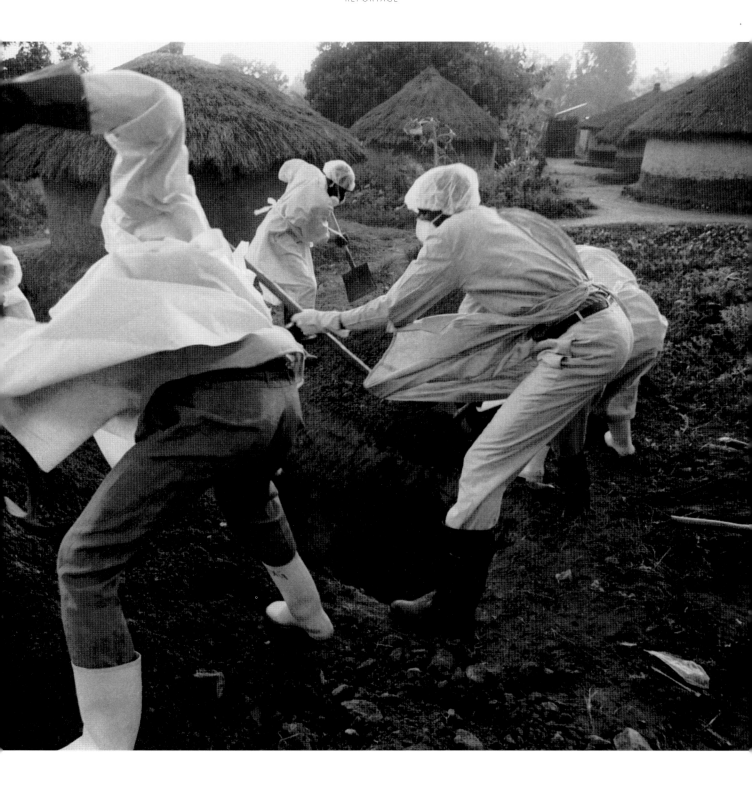

Bottom left: A burial team's contaminated gloves are thrown into a grave, to be covered by the body of the next victim. Above: A burial team contends with wind and rain while digging a grave for Akera Beatrice, 38, who died in the isolation ward at Gulu Hospital.

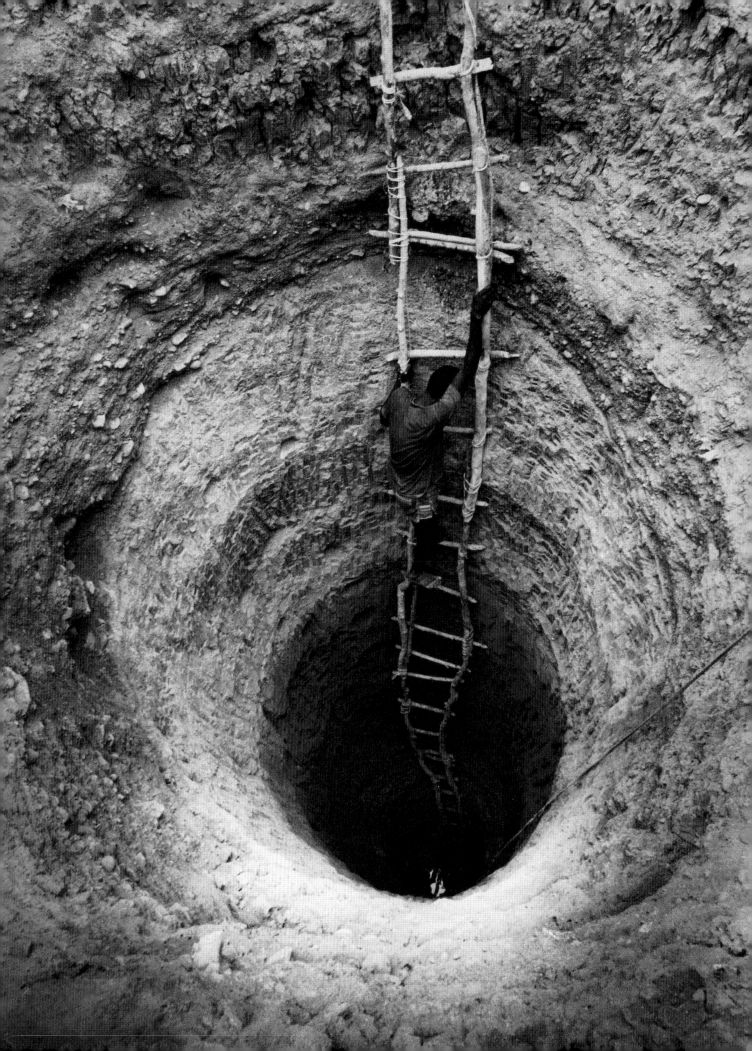

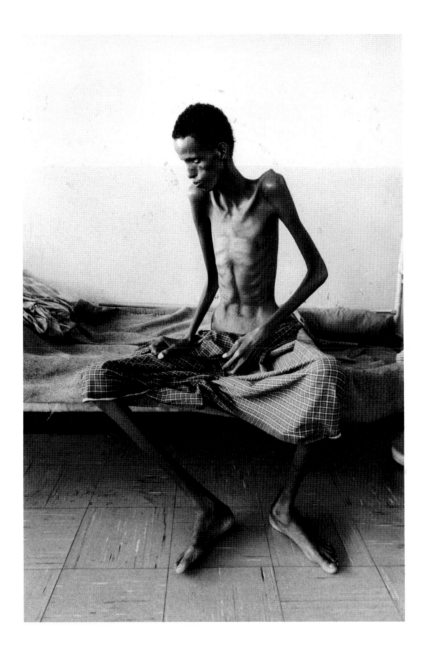

Seamus Murphy
TIME/SABA

PARCHED EARTH Politics and drought plunge the vast Horn of Africa into catastrophe,
threatening mass famine once again. Above: A man suffering from malnutrition and
tuberculosis sits at a hospital in the Ethiopian town of Gode. Opposite: The
desperate search for water forces a man down a 40-foot well that took a month to
dig. At the bottom, his companion collects what little water is available.

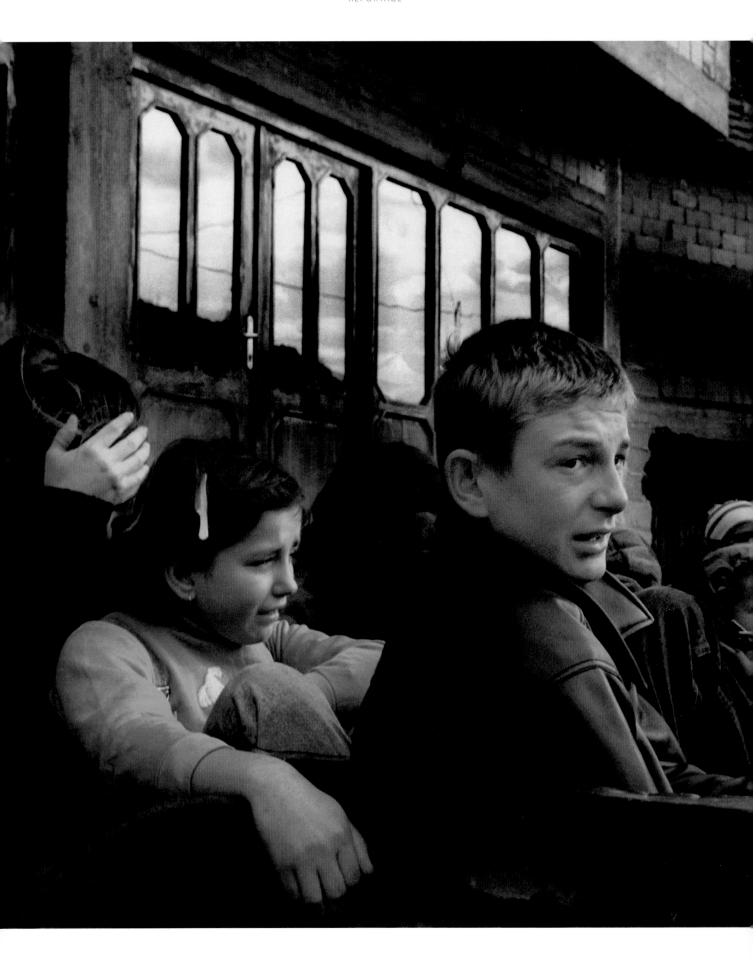

Kael Alford
Newsmakers/Freelance

Fear is etched in the faces of Albanian refugee children, whose fathers, brothers and uncles had stayed behind to protect their homes in the southern Serbian town of Oslarje. Stopping in Koncul on their way to safety in Kosovo, the children reported that the Serbian Army had surrounded their village to combat Albanian guerillas. The refugees feared that their village would be looted and burned and that the men in their families could be involved in the fighting. Approximately 5,000 ethnic Albanians have fled Serbia in fear of war.

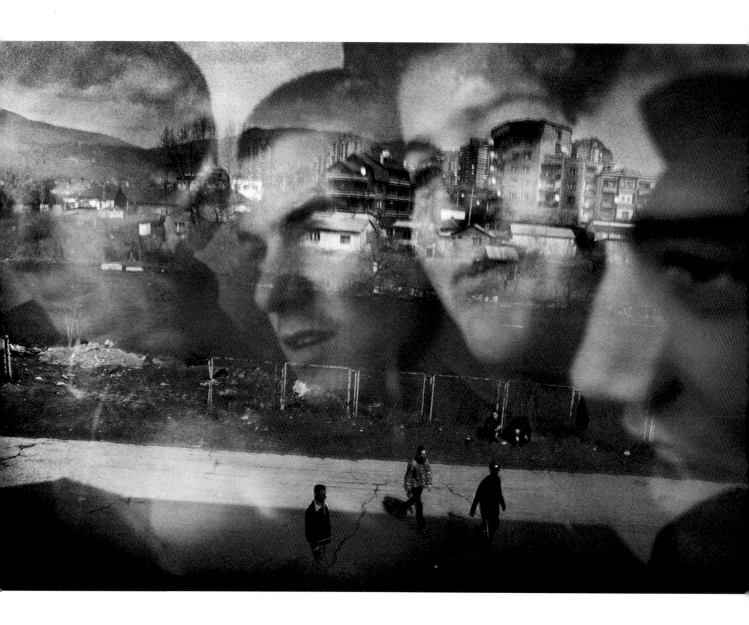

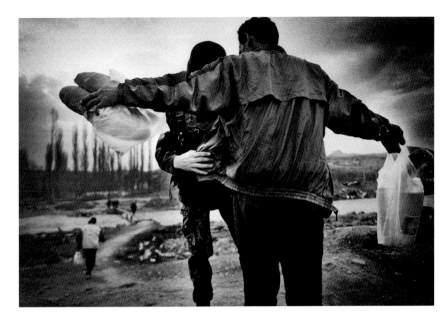

Joachim Ladefoged
Pro Helvetia/Magnum Photos

KOSOVO, ONE YEAR AFTER

Peace has been difficult for the Kosovars a year after the NATO bombings. In the divided city of Mitrovica the situation has been especially tense as both Serbs and Albanians try to survive and rebuild. Opposite: Albanian students, reflected in a window pane, look out on the Serb side of Mitrovica. Top right: A NATO soldier searches an Albanian before letting him cross the river dividing Mitrovica. Right: Albanians watch a soccer match from burned-out Gypsy homes. Below right: Serbs wait at the bridge in Mitrovica which connects the divided city. The northern half is predominantly Serb and the southern half is ethnic Albanian.

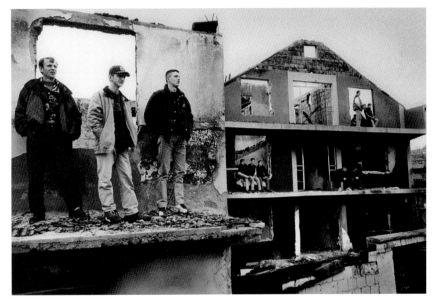

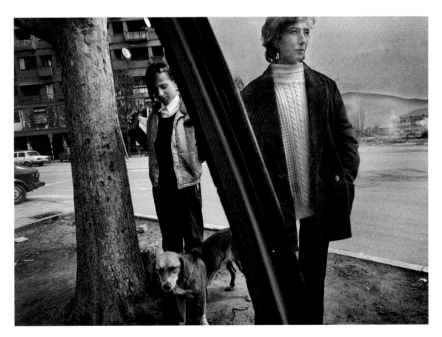

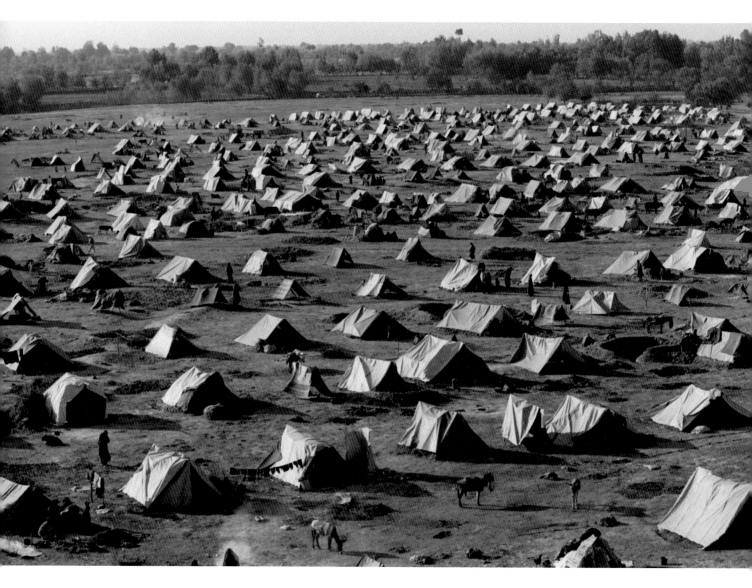

Seamus Murphy
TIME / SABA

WAR IN AFGHANISTAN

Above: Refugees at a camp
in Moghol Qislaq in northern
Afghanistan prefer to endure
hunger, cold and poverty
rather than live under the Talib
authority. Right: A father waits
with his daughter, who is
gravely ill with malaria, at the
Swedish Committee Clinic
near Dasht-I-Qala.

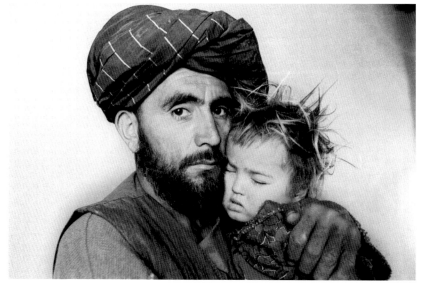

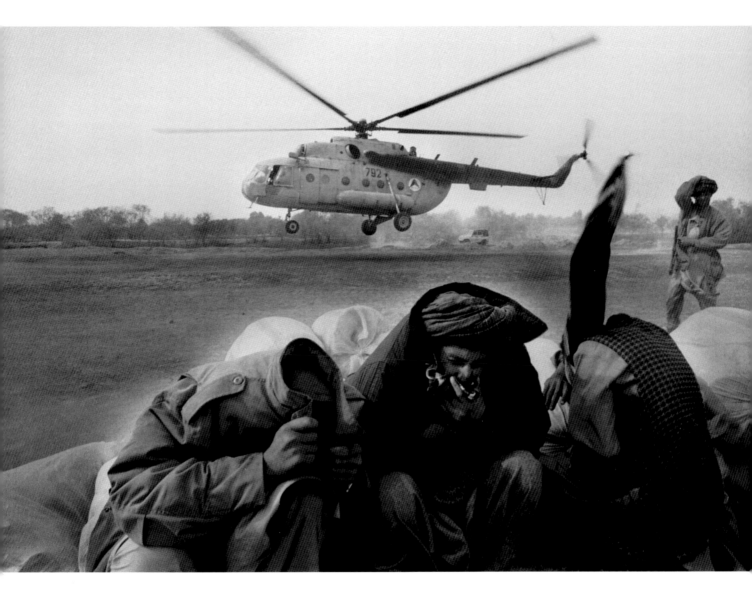

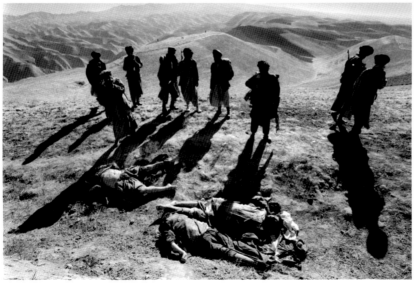

Above: A Russian-made helicopter lands near the headquarters of Ahmed Shah Massoud, commander of the Northern Coalition Forces, to pick up supplies for Mujaheddin units. Left: Mujaheddin soldiers examine Taliban bodies after retaking a mountaintop at Ibar.

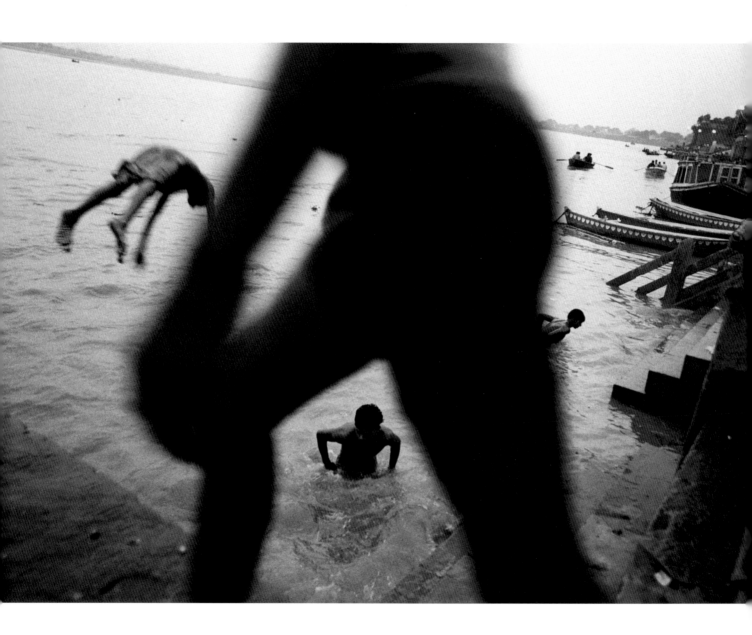

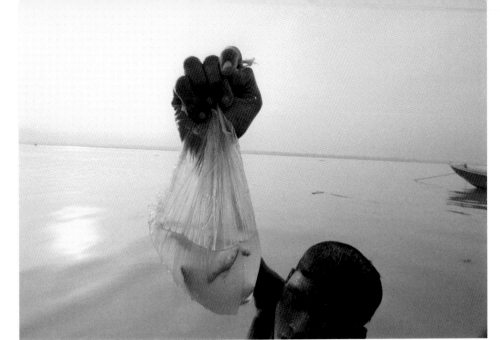

Ilkka Uimonen
Gamma Presse/Corbis Sygma

WATER CRISIS IN INDIA

The fresh water supply in India, where the population has recently topped 1 billion, has become a critical issue. Drought, unfinished dam projects and contamination affect millions of people. Opposite: Swimmers take a dip in the Ganges River at Varanasi. Above right: A fish caught in the increasingly polluted Ganges River. Right: Samun Sekh shows his extremely thick palms, a symptom of hyperkeratosis, caused by exposure to arsenic in the groundwater. Below right: 35-year-old Navi Kaki suffers from skeletal fluorosis, which causes extreme curvature of the spine. The illness stems from fouled drinking water.

Ed Kashi
Freelance

PINE RIDGE

Jimmy Charging Crow and
his wife, Eleanor, visit the
grave of their son, Floyd, who
died in his forties. The life
expectancy for young Lakota
men on South Dakota's Pine
Ridge Indian Reservation is
48 years, almost three
decades shy of the national
average. "I went to Pine
Ridge to study the tribe's
elders and see how they
managed to survive such
insidious odds," said Kashi.
"They are fighting to
preserve the Lakota
language, which is slowly
dying out. They are the last
generation to have
experienced the traditional
way of life."

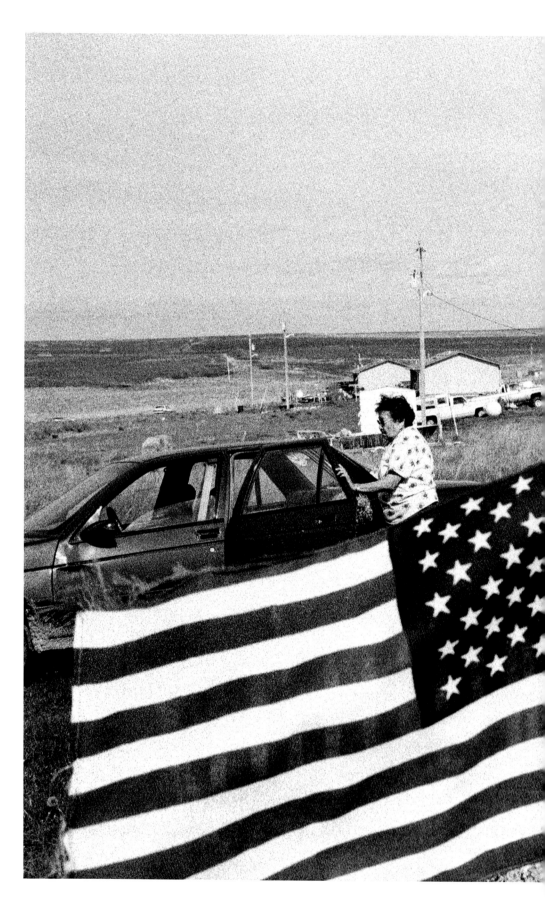

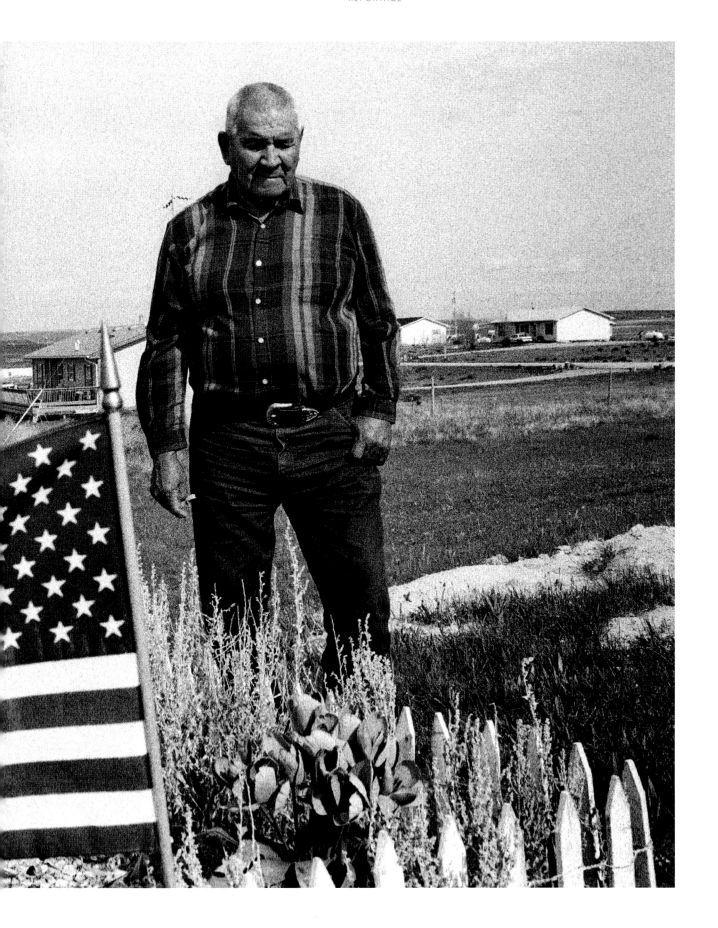

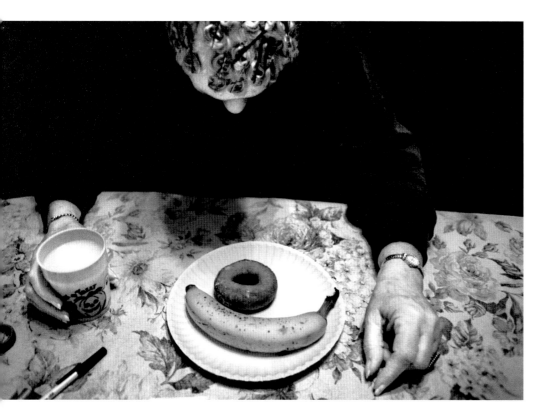

Leigh Daughtridge
Copley Chicago Newspapers

PAINFUL CHOICES: SENIORS AND PRESCRIPTION DRUGS

Left: Pat Gimber, 66, of Joilet, IL, prays over a meager breakfast before starting her day. She cashed in her life insurance in order to qualify for Medicaid. A heart transplant recipient, she pays $2,000 per month for prescriptions drugs.

Below left: Jean Justic of Shorewood, IL, reads cost comparisons before driving to area pharmacies for her arthritis prescriptions. "Middle income people never fall into the programs where you can get the help," she says. "Yet, you can never afford the luxury of paying full price."

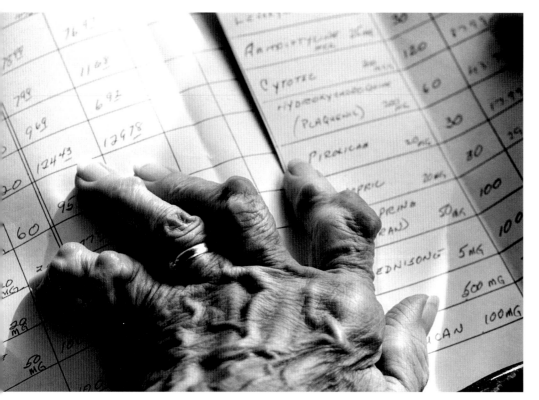

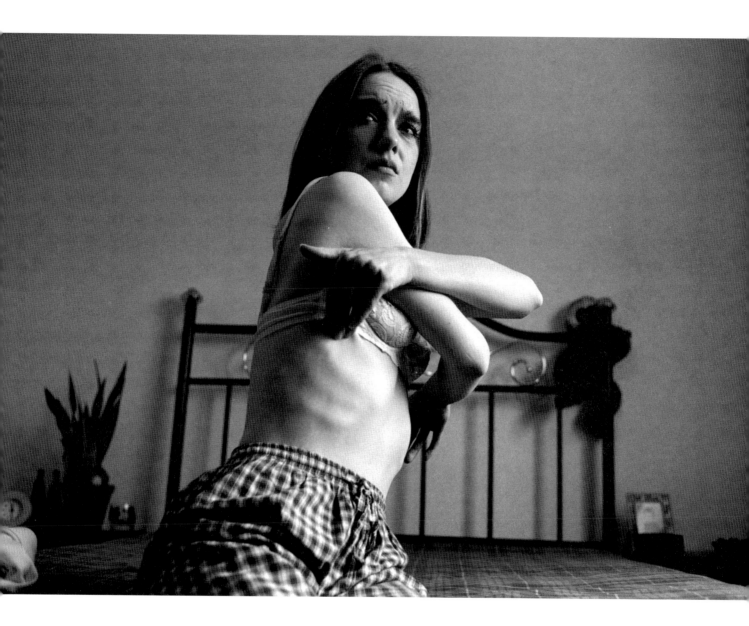

Felicia Webb
Katz Pictures, London

Becky, 25, checks her body in a daily ritual to ensure her ribs are showing. Over a million people in the United Kingdom suffer from eating disorders. Anorexia has the highest mortality rate of all psychiatric illnesses: Some sufferers commit suicide, while others die of heart or kidney failure or pneumonia.

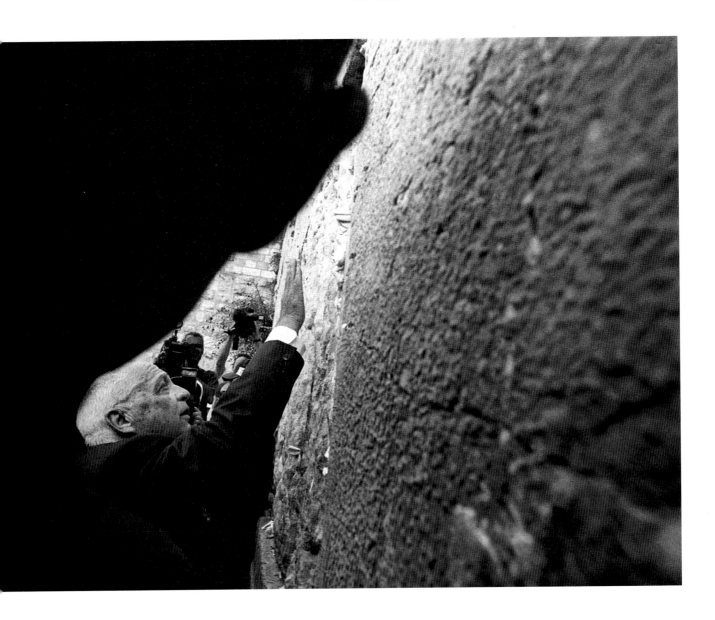

The West Bank

Ilkka Uimonen
Newsweek / Gamma Presse

Ariel Sharon prays at the Western Wall of the Second Temple, the most sacred site in Judaism, just after his visit to the Temple Mount (Al-Haram al Sharif). Sharon's visit to the site outraged Palestinians and led to the Al Aqsa Intifada uprising. Sharon was trying to press Israeli rights of sovereignty over the Muslim holy site.

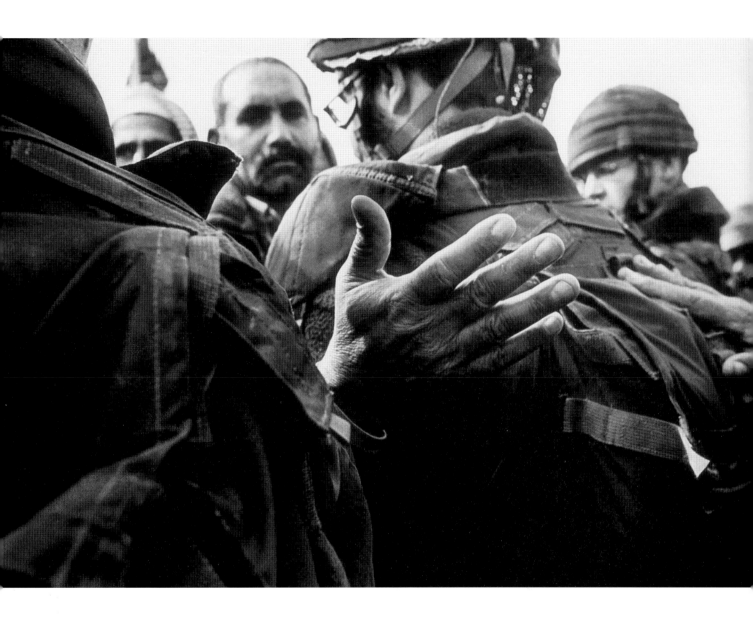

James Nachtwey
TIME /Magnum

Palestinians from Bethlehem, attempting to go to Jerusalem to pray at Dome of the Rock, are stopped by Israeli soldiers.

James Nachtwey
TIME /Magnum

Following pages: Palestinian demonstrators hurl Molotov cocktails at Israeli soldiers in the West Bank town of Ramallah.

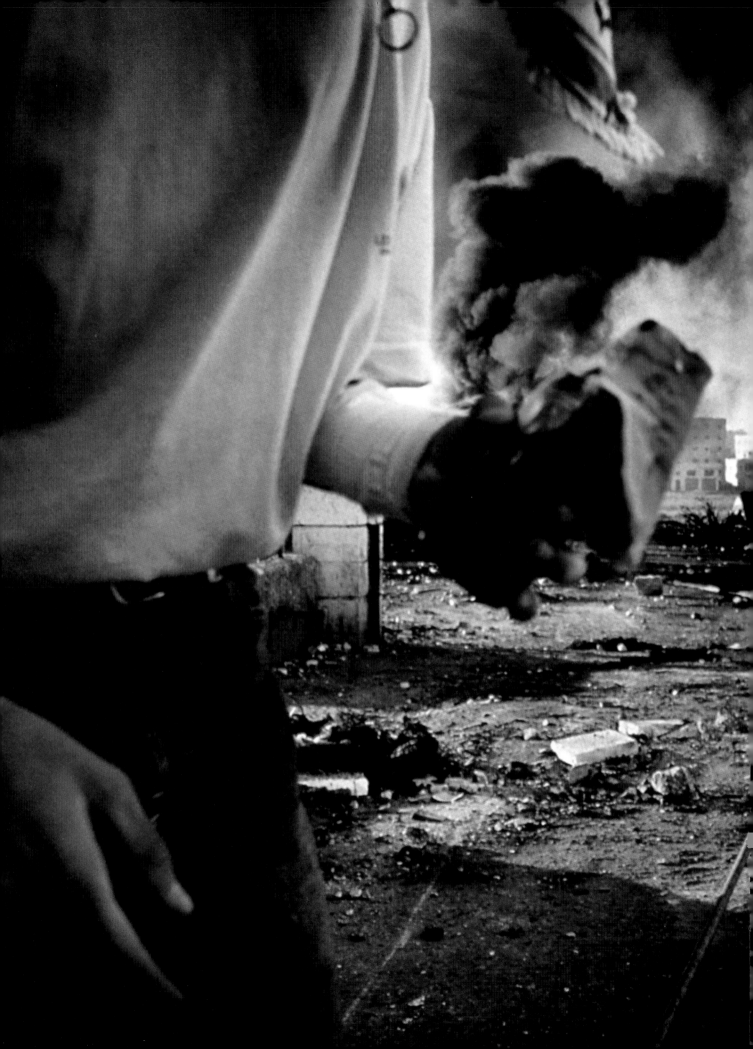

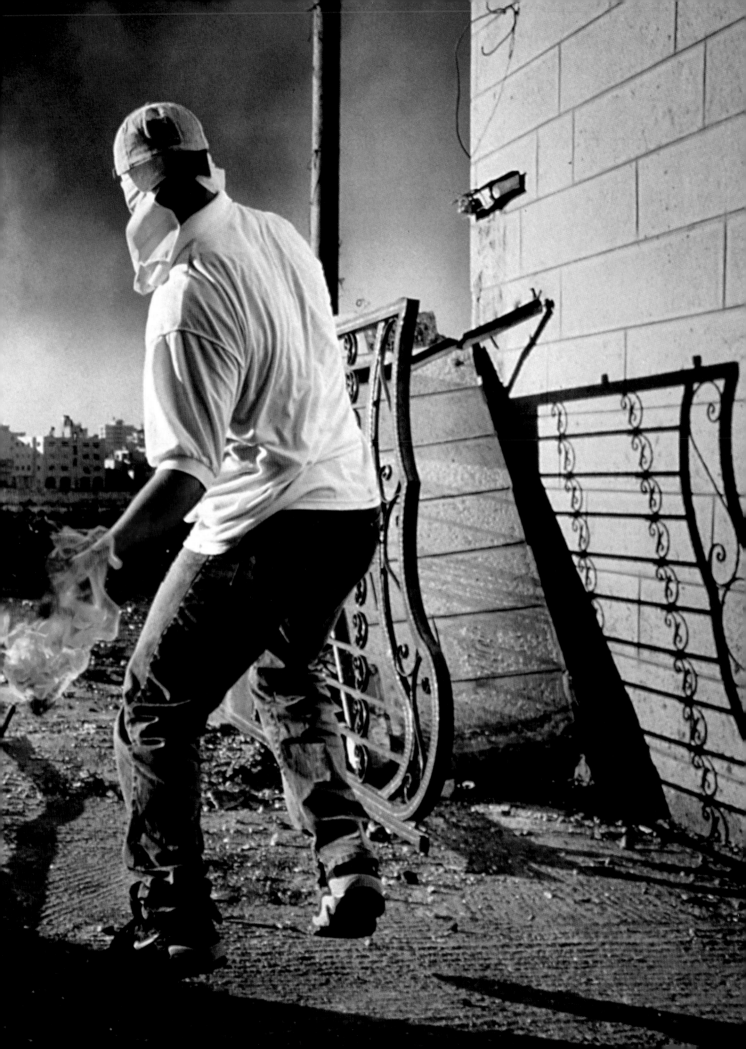

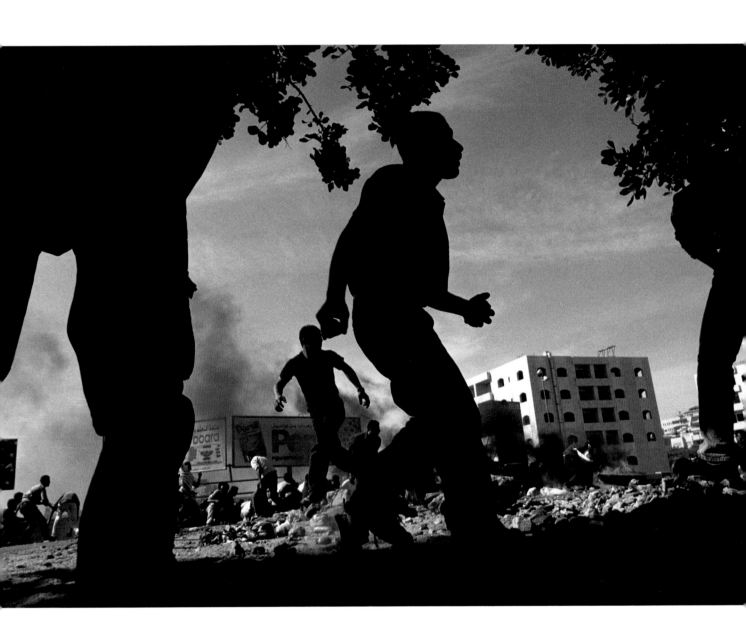

Ilkka Uimonen
Newsweek

DAYS OF RAGE The Al Aqsa Intifada started after Ariel Sharon's visit to the Temple Mount in September. By year's end, the death toll mounted to more that 350, mostly Palestinians. Above: Palestinians attack Israeli soldiers with rocks and Molotov cocktails in the West Bank town of Ramallah. Top right: Students rally against Israel in Gaza City. Right: A Palestinian flag is carried during the funeral procession for 14-year-old Mouayad Osama Jawaris, who was shot to death in Bethlehem by Israeli soldiers.

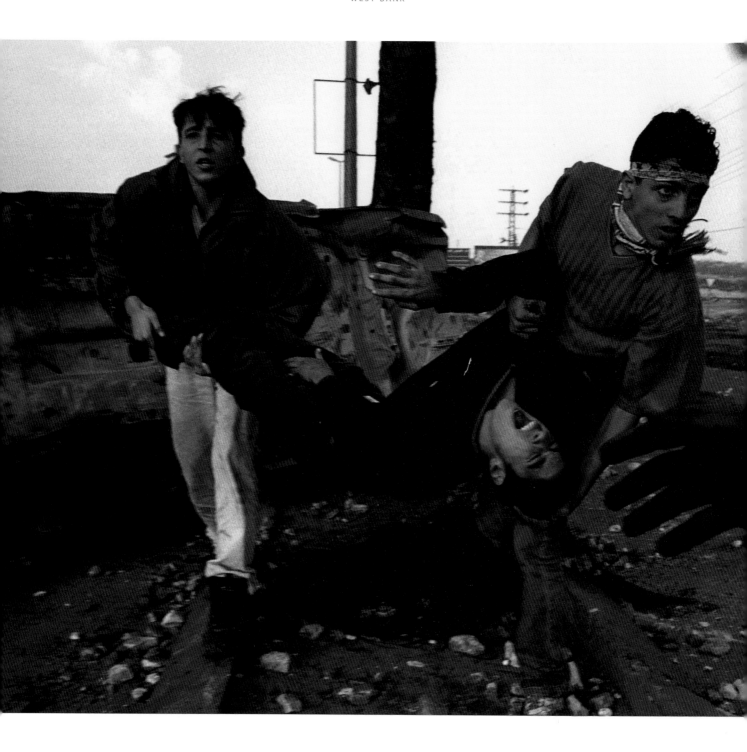

Above: A young Palestinian, who received a severe head injury, is carried to safety by his friends on November 16, 2000, in Ramallah. Top right: A Palestinian shot by an Israeli soldier is buried in Hebron. Bottom right: A Palestinian boy takes cover behind a wall as Israeli helicopters open fire during clashes in the West Bank village of al-Khader.

Luc Delahaye *Magnum*

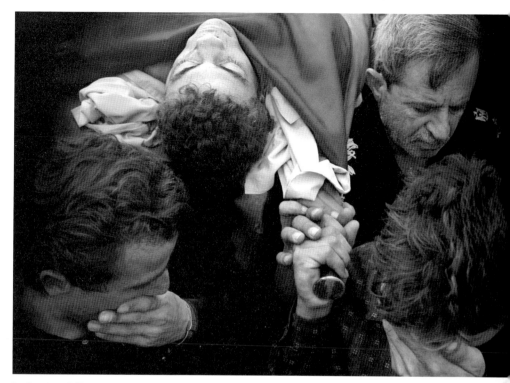

Anders Vendelbo *Ekstra Bladet/Freelance*

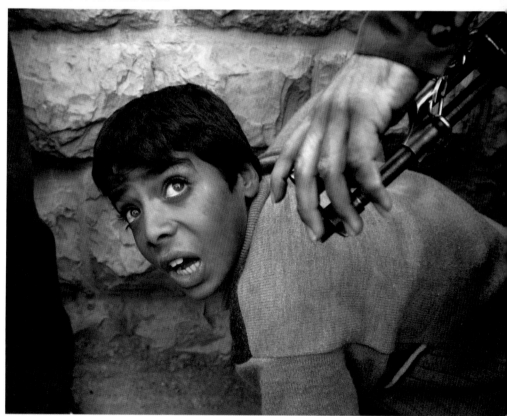

Peter Dejong *Associated Press*

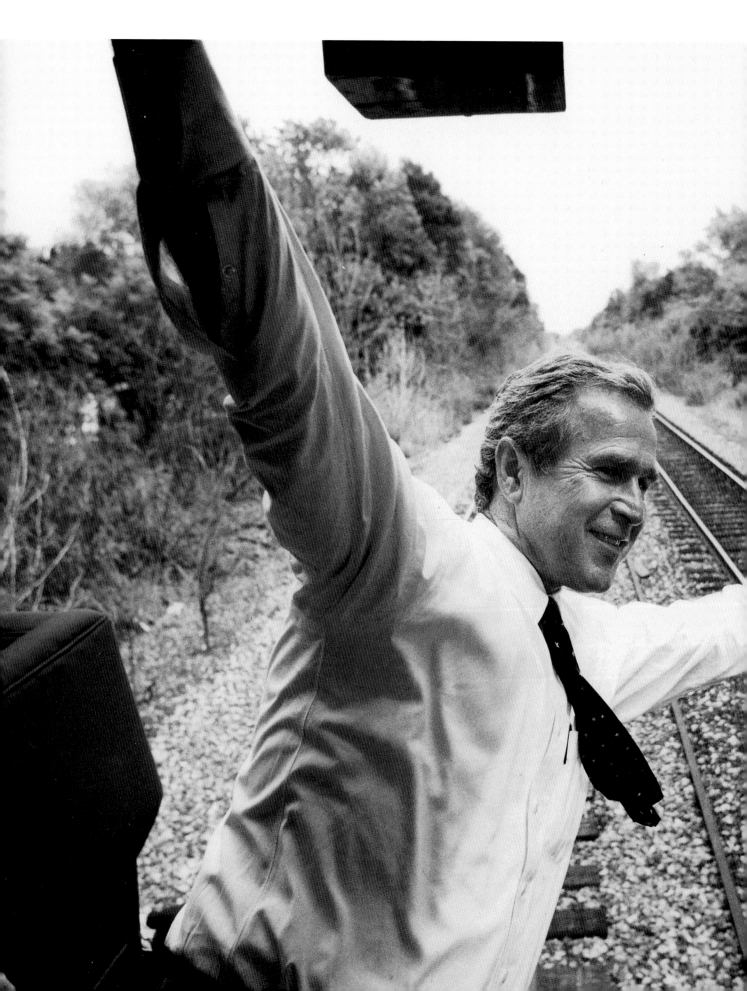

The U.S. Elections

Brooks Kraft
TIME / Corbis Sygma

Leading by as many as 18 points in the polls after the Republican National Convention, presidential nominee George W. Bush waves from a train passing through Michigan. Bush whistle-stopped for three days through the Midwest.

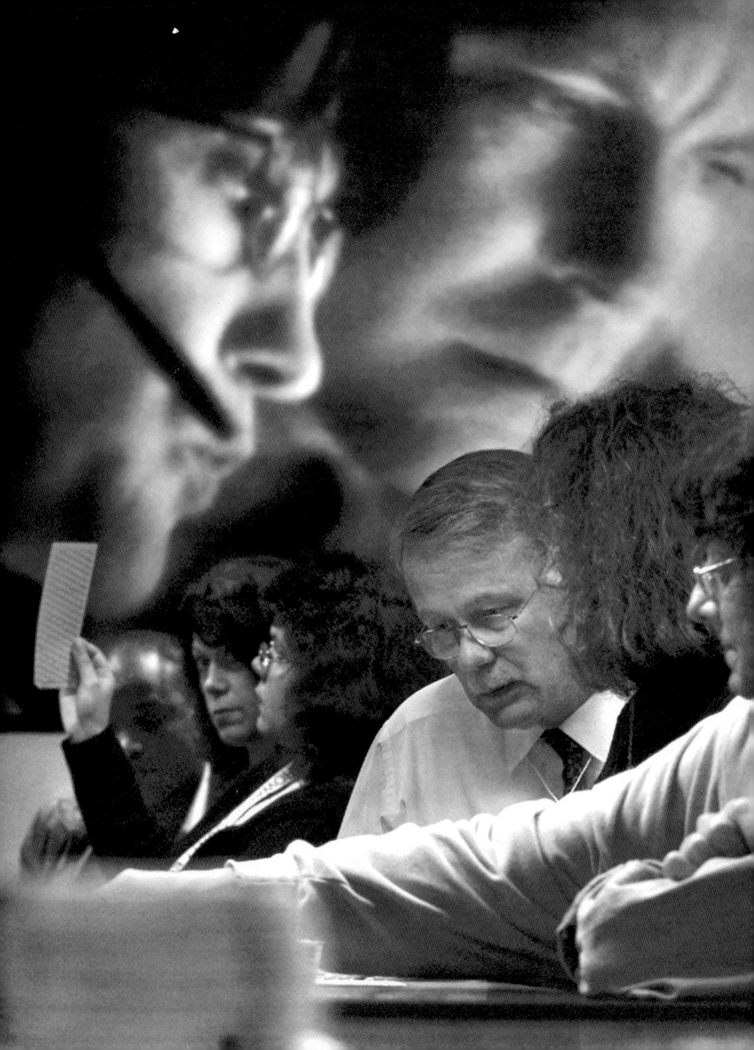

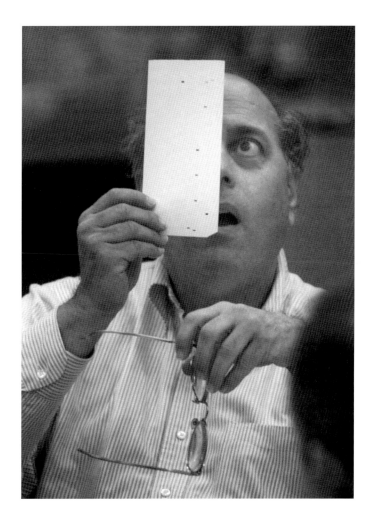

Jon Naso
The Star-Ledger/Newark, NJ

Above: Republican Judge Robert Rosenberg, a member of the Broward
County Canvassing Board, scrutinizes a disputed presidential ballot at a
courthouse in Ft. Lauderdale, FL.

Mike Stocker
Sun-Sentinel/Ft. Lauderdale, FL

Opposite: An image from a large-screen television looms over volunteers as
they recount ballots at the Broward County Emergency Operation Center.

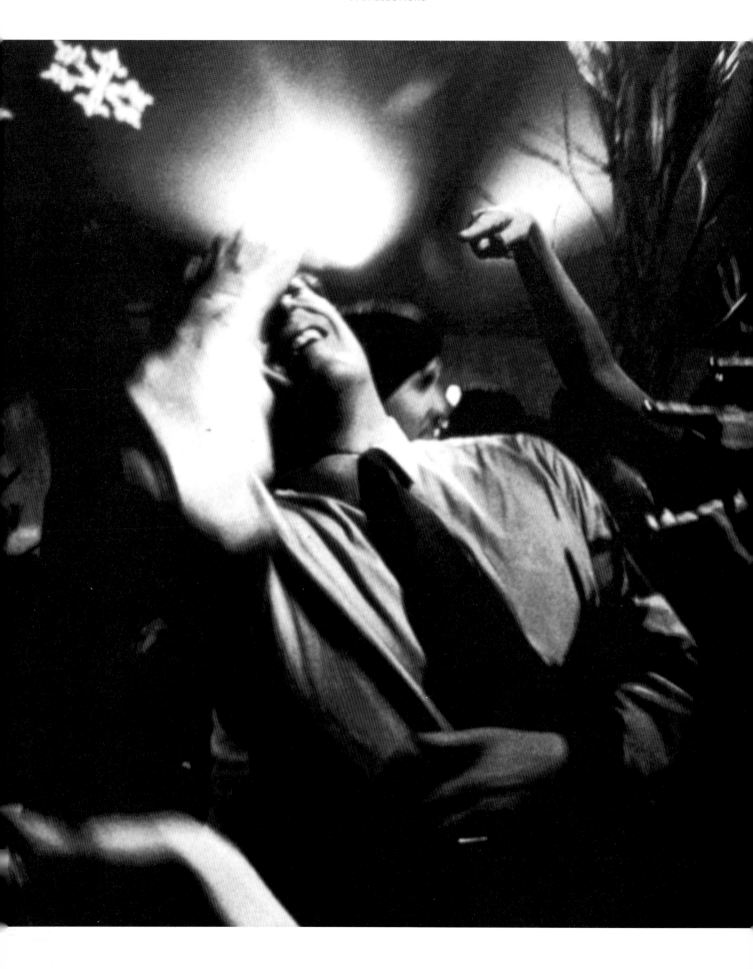

Molly Bingham
The White House

Vice President Al Gore, after conceding the presidential election to George W. Bush, dances to music by Tom Petty, who performed live at the vice president's residence in Washington, D.C.

*John Russell, 5, declares his
supremacy after a short but
spirited wrestling match
with his little brother in their
Chicago backyard.*

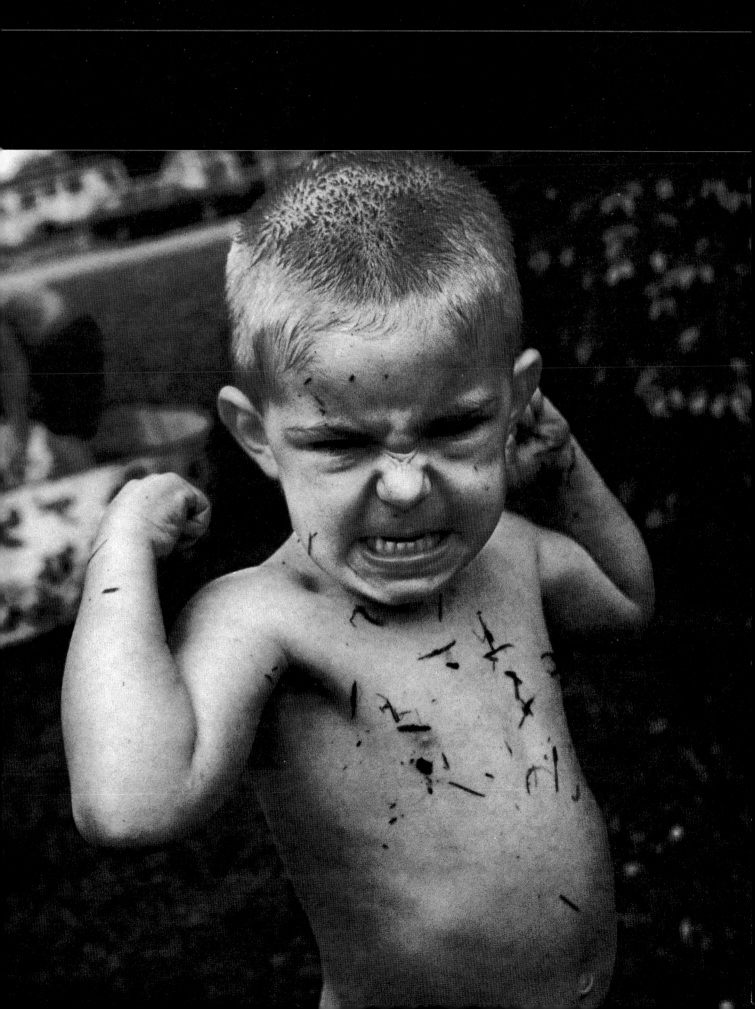

■ Scott Strazzante was named Newspaper Photographer of the Year for his work as a staff photographer for *The Herald News* in Joliet, IL, a suburb of his hometown of Chicago. "I want to show people things that they can't see themselves," Strazzante said. His highest priority, he said, is "making a photo that makes people feel something."

Strazzante's motivations have changed over the years. He explains that at first his goal was to win as many awards and contests as he could, but now he is trying to set a good example for his children. "I'm trying to inspire more than aspire."

Strazzante, 37, grew up in the East Side neighborhood of Chicago. As a child, his love of sports and *Sports Illustrated* motivated him to start taking photographs. "I borrowed my dad's camera and took pictures from my stadium seat."

Today Strazzante makes a habit of becoming involved with his subjects. "As a photographer you are involved with the people in the photos and in their lives. I get to experience things I never would otherwise."

Becoming involved sometimes means following a subject for years, even on his own time. Since 1994 Strazzante has been visiting and photographing Harlow Cagwin, a 78-year-old farmer, and his wife, Jean. What started as an assignment to photograph people raising animals turned into documenting a farming couple determined to survive through age and illnesses. "They enjoyed having someone interested in their life," Strazzante said.

Harlow plans to leave his 118-acre cattle farm this year. "He's not giving up farming, he's just changing locations," said Strazzante.

After years of documenting the Cagwins, Strazzante admits he is going to miss their company. "I love them—they are my dear friends. This is a relationship where I bring my kids and we have lunch. Then there is the photojournalism relationship where I am here to work and take pictures."

Strazzante's three-week coverage of the Woodcreek Mobile Home Park came after he was sent on an assignment to preview the anticipated eviction of the tenants. There he saw what he describes as "Third World conditions in Joliet: The trailer park had a lot of vandalized homes, and sewage was running down the street."

"The residents thought I was a savior—that I was going to help get the word out." But his paper didn't publish the pictures at the time. "I felt powerless," Strazzante said.

But his continued efforts to get *The Herald News* to run a story on the trailer park paid off five weeks after he finished shooting. The paper sent a reporter and ran 10 photographs. However, "No one had the opportunity to help out because we ran the story after the fact."

Strazzante is currently working on a similar eviction story. The difference is that, "this year we are running it before the eviction to give people a chance to help," he said.

"I'm always amazed by how powerful pictures are. You can move people to do things that they never thought they could do. I just can't imagine doing anything else."

■ *Opposite, above: Three umpires try to decide if threatening skies will delay the Coal City Regional High School baseball playoff game. Opposite: "I'm tired of being one game away," moaned St. Francis baseball player Gene Kanak in his Joliet, IL, dorm room after his team, the Saints, lost, finishing one game short of qualifying for the NAIA College World Series.*

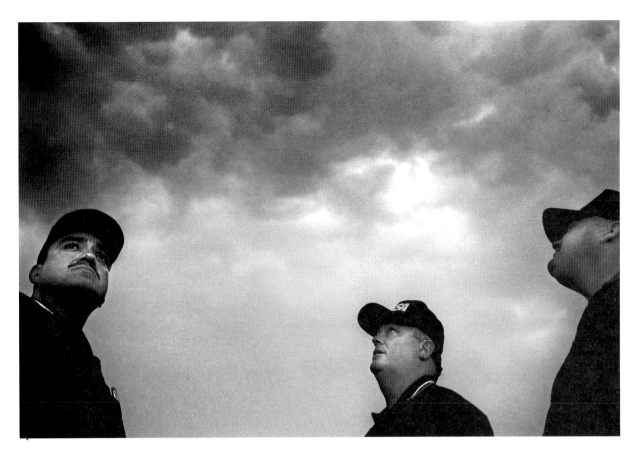

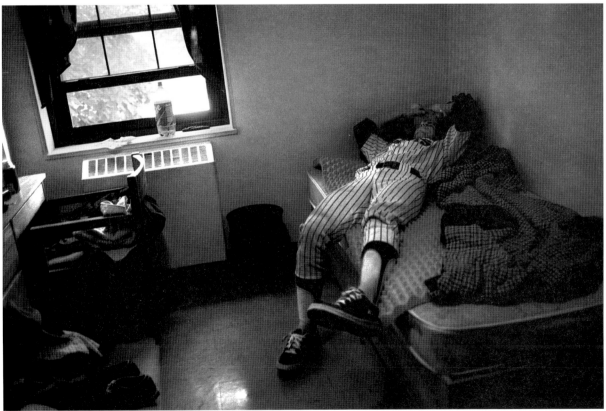

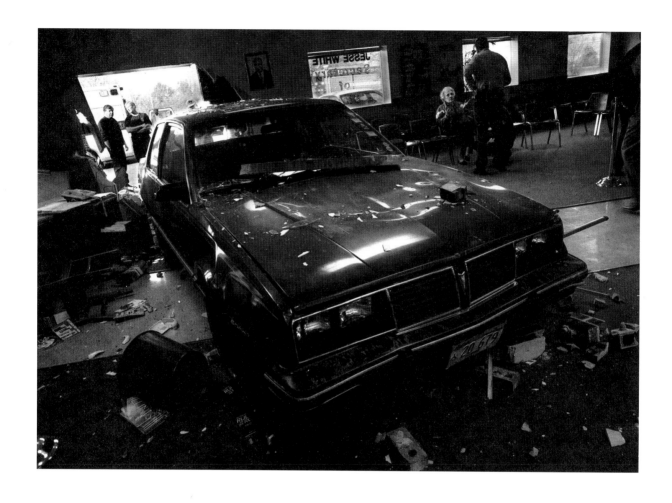

■ *Above: Ann C. Stiley, 87, seated to the right behind her car, explains to a Joliet police officer how she drove into the waiting area of the local driver's license facility. Opposite: Manhattan, IL, residents Maria Lawson, 3, and her sister Lorraine, 5, joined their mother and three of their sisters in the first Illinois Face the Truth Tour, a month-long anti-abortion demonstration held in 29 cities.*

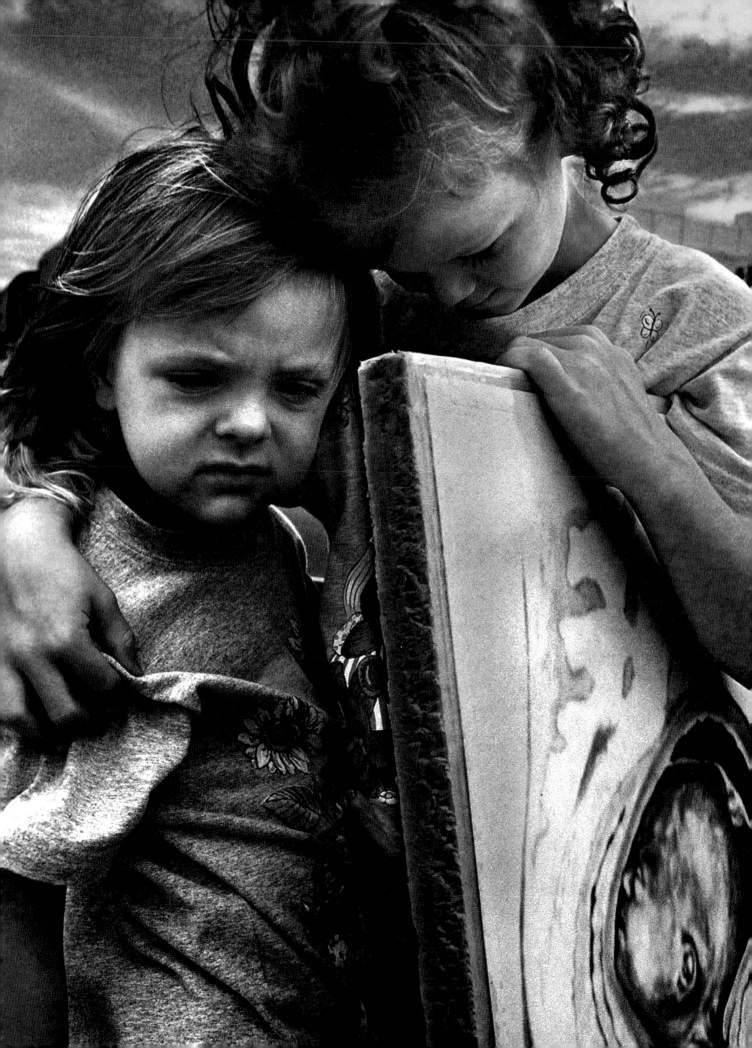

Caught in the Middle

■ *Woodcreek Mobile Home Park was the home to 40 hard-working immigrant families, but that all changed when a dispute between the City of Joliet and the park's owner led to the eviction of the residents. Lourdes Espinosa is the matriarch of one of these families, who, despite having nowhere to go, readied to leave the only home they had known in the United States. Below: Minutes before leaving her trailer for good, Espinosa is comforted by her daughter Juanita Thongphadith. The family moved to a friend of a friend's apartment as their search for a permanent home continued.*

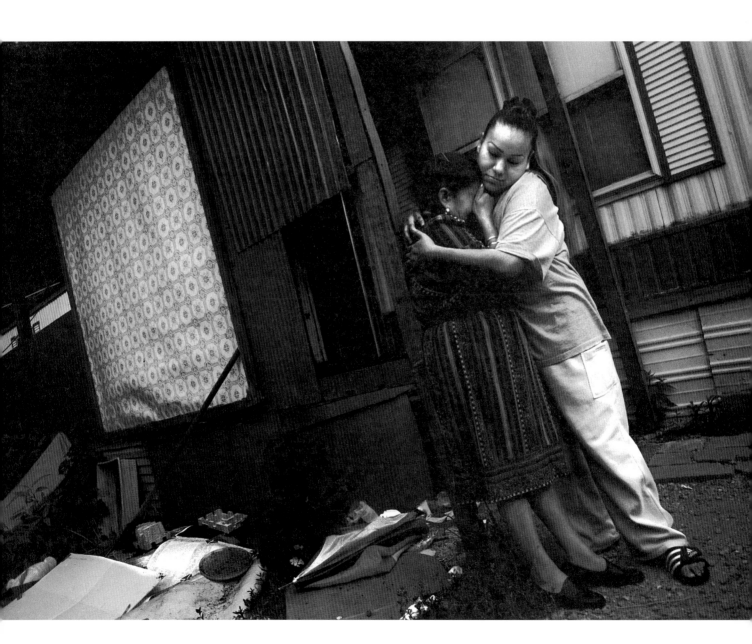

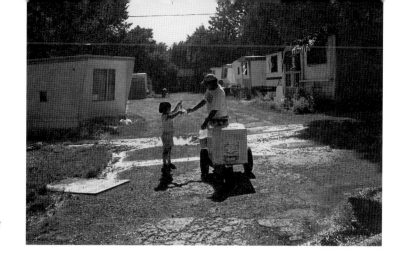

■ *As raw sewage flows past her, Jeanette Alvarado buys a Popsicle from a neighborhood ice cream vendor.*

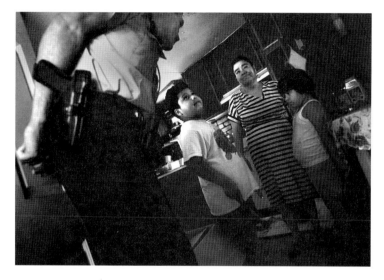

■ *On the day all residents were required to leave their trailers, Joliet Police officer Bob Blackburn tries to determine where Juanita Espinosa and her seven relatives will move. Using her grandson Erik Alvarado as a translator, Espinosa replied, "I don't know."*

■ *Jeanette Alvarado struggles to climb into a vandalized trailer. As residents move out, their empty trailers become playgrounds for the remaining children.*

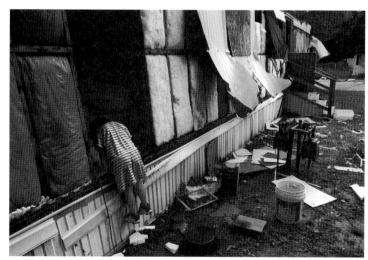

■ *"I'm going to jail because I don't have anywhere to live," laments 8-year-old Erik as he takes a break from helping his family move their belongings out of their trailer. The Espinosa family ultimately resettled in a housing project.*

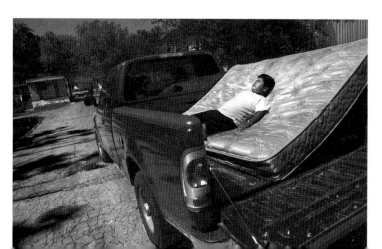

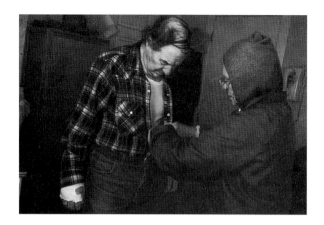

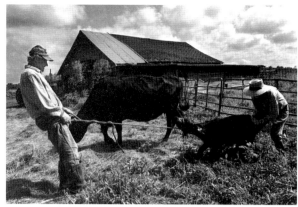

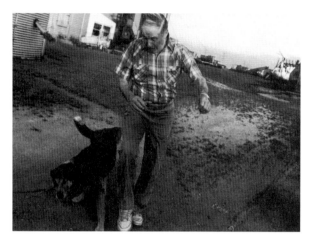

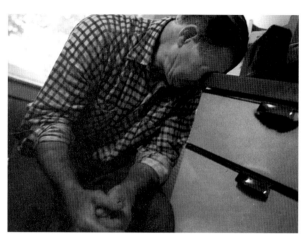

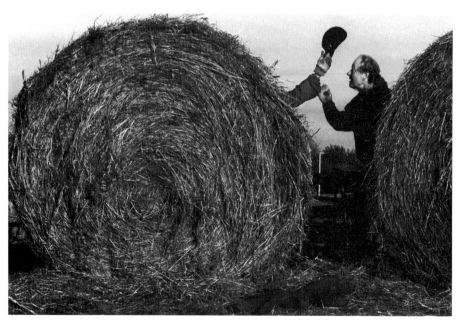

■ Clockwise from bottom left: While finishing baling hay, Cagwin has his hat placed on his head by his wife, Jean. "What else can go wrong?" jokes Cagwin after a neighbor's dog mistakes him for a fire hydrant. Cagwin's wife helps him button his shirt; years of labor and arthritis have limited Cagwin's manual dexterity. Things are done the old-fashioned way at the Cagwin farm: A rope and a little pushing and pulling are used to encourage a calf to return to the barn. Even listening to the radio appears to be a painful undertaking for Cagwin; an hour with Rush Limbaugh is the farmer's only daily entertainment.

Trying to hold on

■ *Harlow Cagwin, 78, has known only one home—a 118-acre cattle farm 45 miles southwest of Chicago that he works with his wife, Jean. Cagwin's eroding health has caused this hard-working man to question whether he can fulfill his dream to "farm 'til the day I die." He and his wife will relocate this year, putting an end to another family farm. Below: "I don't know how much longer I can do this," said Cagwin.*

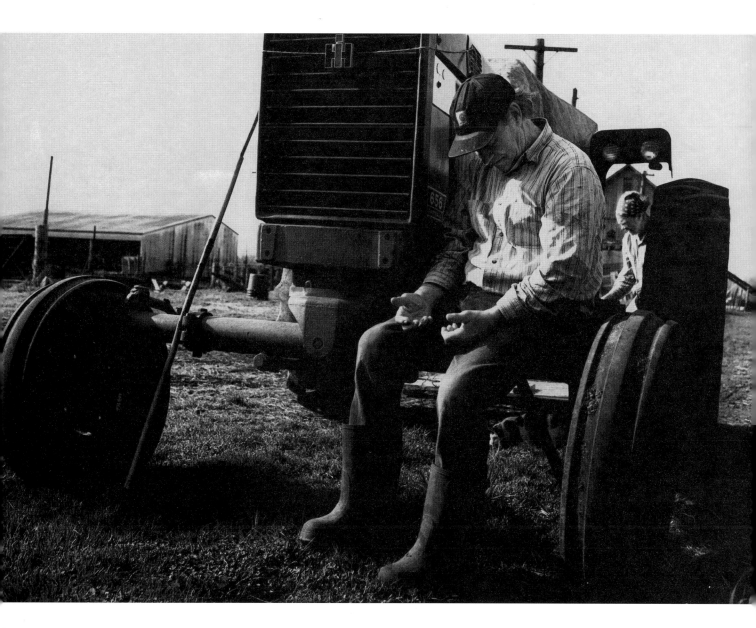

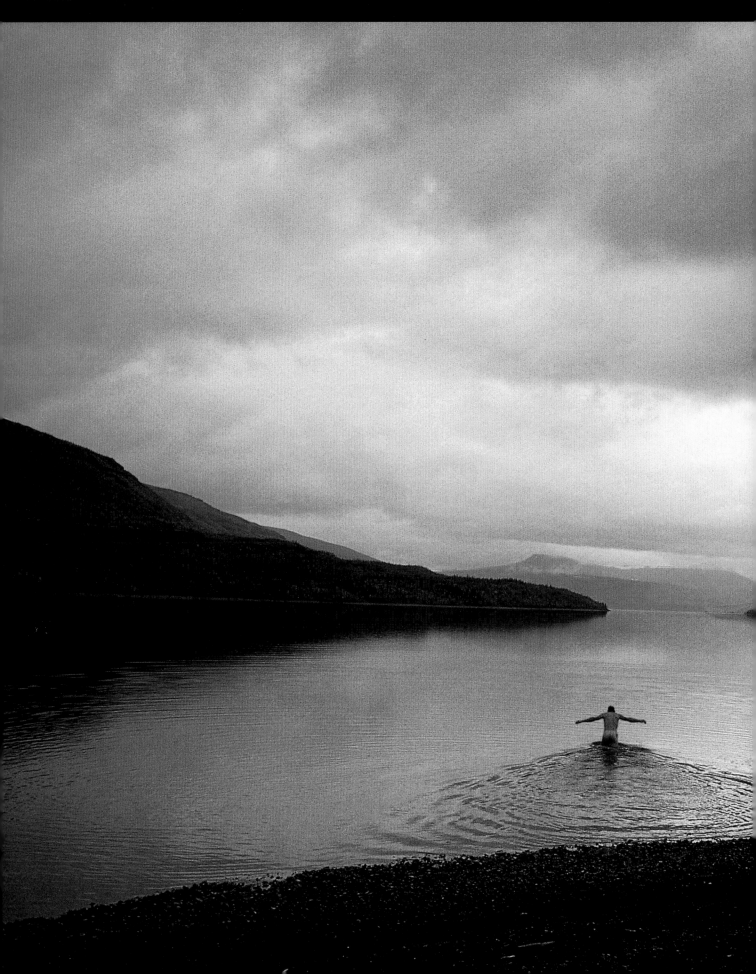

Randy Olson
National Geographic/Freelance

Russian scientist/explorer
Valeri Ivanov embraces an icy,
Arctic bath on Siberia's
Putorana Plateau. This land is
a primeval expanse of volcanic
rock and pristine waters the
size of Nevada, located 200
miles north of the Siberian Arc-
tic Circle. Putorana was closed
to the world during the Cold
War because a Soviet nuclear
missile installation—with war-
heads pointed at the United
States—was located at the
entrance to this wilderness.

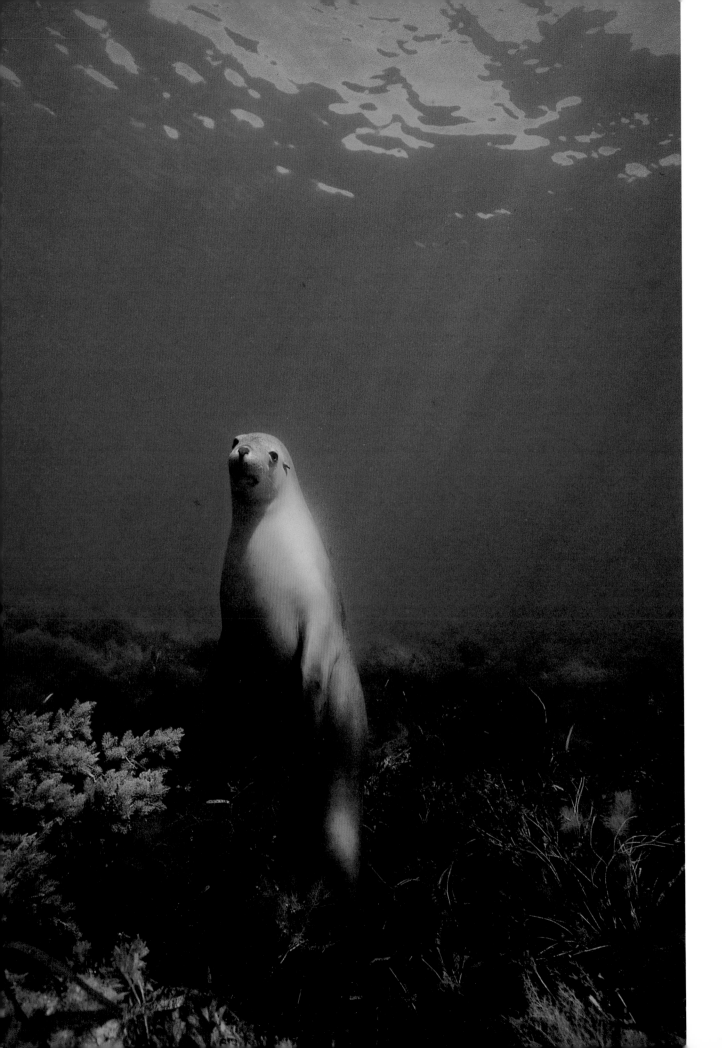

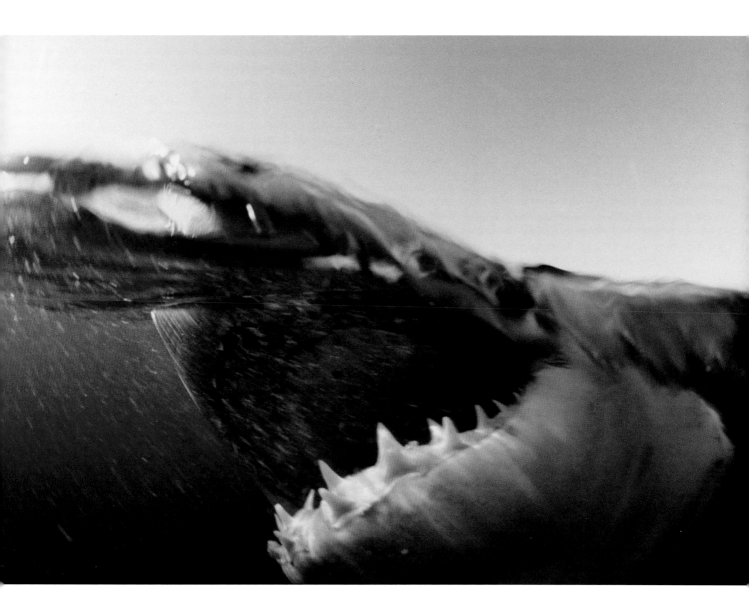

David Doubilet
National Geographic/Freelance

Opposite: The main prey of the great white shark, the rare Australian sea lion is always on alert.

Above: Sharks are the ultimate predator in the ocean, fearsome yet strangely delicate. The great white
is the only shark that displays open jaws on the surface. This one cruises near Gawsbai, South Africa.

Randy Olson
National Geographic/Freelance

Intently watching the sky, a
hunter near Mohenjo Daro,
Pakistan, on the Indus River,
uses an egret headdress to
disguise himself while he
waits for birds to arrive. Hoops
are placed in the middle of
the river to which the hunters
tie their pet birds, using them
to lure in the wild birds. The
men put on their headdresses
and sink to their shoulders
into the water. When an
unsuspecting bird lands
nearby, the hunters wiggle
their heads back and forth,
slowly approaching the prey,
and catch it with their bare
hands. A 5,000-year-old pot
depicting this form of bird
hunting was found in a nearby
archaeological site.

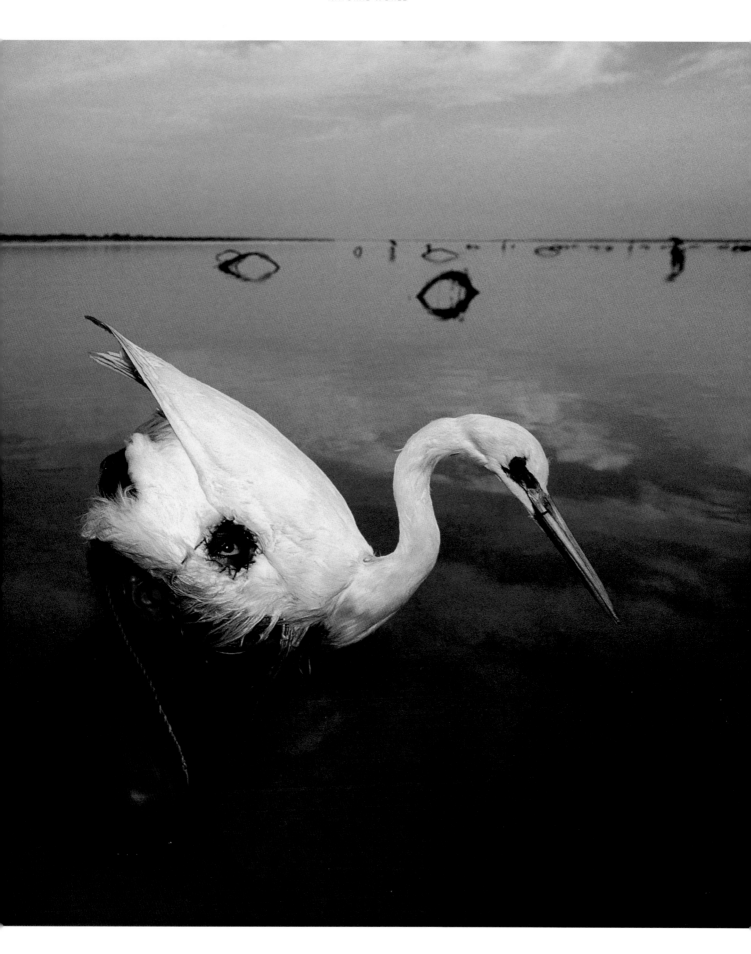

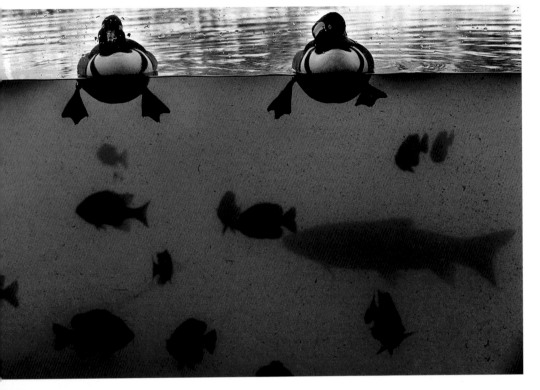

Mona Reeder
The Dallas Morning News

Left: Two bufflehead ducks float patiently on the surface of an outdoor aquarium at the Texas Freshwater Fisheries Center in Athens, TX.

Mark Moffett
National Geographic/Freelance

Opposite: Acacia trees grow nutritious carrot-shaped bodies on the tips of their leaves, which serve as a special food for wasp-ant "babies." The trees provide the ants with food and housing. In return the ants fend off the tree's leaf-eating enemies and keep it clean and healthy.

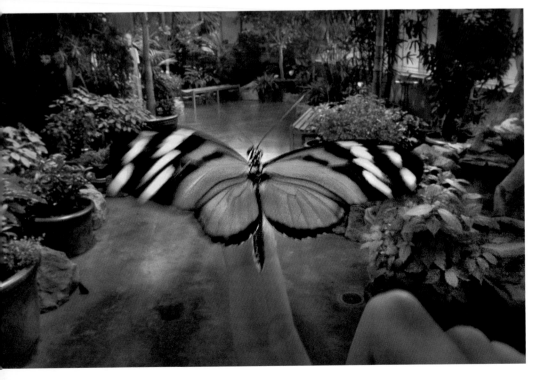

Dale Guldan
Milwaukee Journal-Sentinel

Left: A passion vine butterfly, less than an hour old, flies free in the new 6,000-square-foot butterfly wing at the Milwaukee Public Museum in Wisconsin.

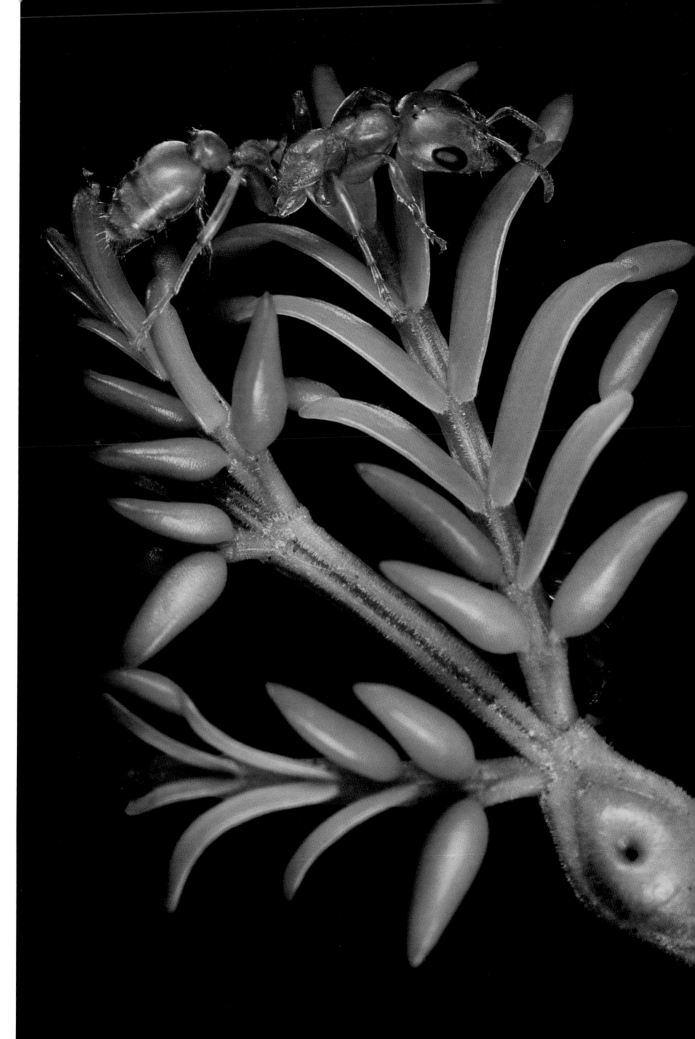

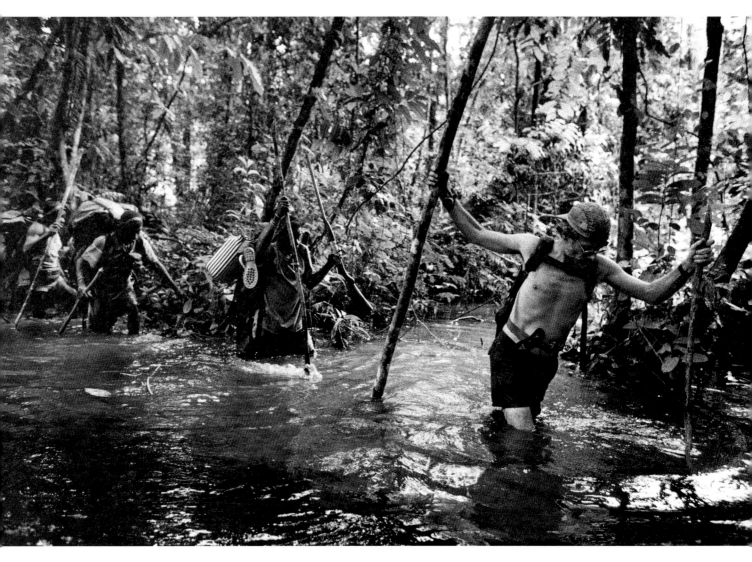

Michael Nichols
National Geographic

MEGATRANSECT

Ecologist J. Michael Fay, of the
Wildlife Conservation Society,
led a year-long trek across 2,000
miles of central Africa to
chronicle the region's pristine
forests. Above: Fay leads his
team of Bambendjelle Pygmies
through the Goualougo swamp
in the Congo Republic. Right: In
Makao, a Motaba River village, he
encountered a hunting deity
who'd been "captured" at a forest
camp and made to dance.

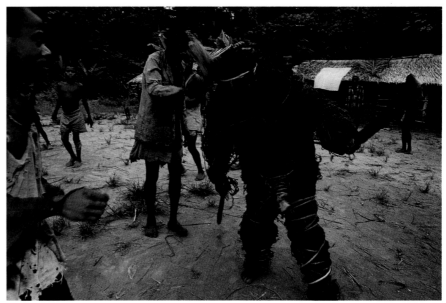

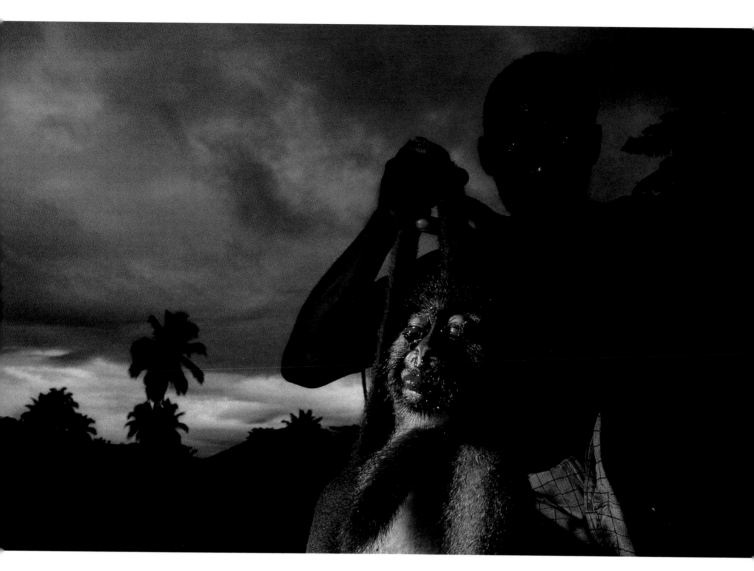

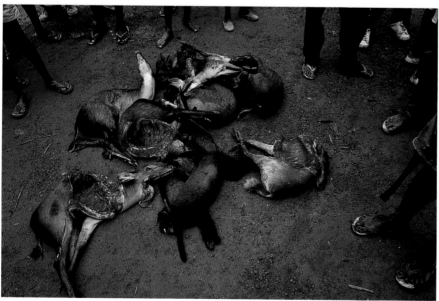

Above: To feed his family, this Motaba River man in the Congo Republic killed a mustached monkey. "You hear a lot these days about the bush-meat problem," says Fay. "Well, it isn't the little guys. It's the professionals—the hunters who kill lots of animals to feed increasing numbers of people." Left: Logging camps depend primarily on bush meat for food where the human appetite for timber and meat threatens the central African forests.

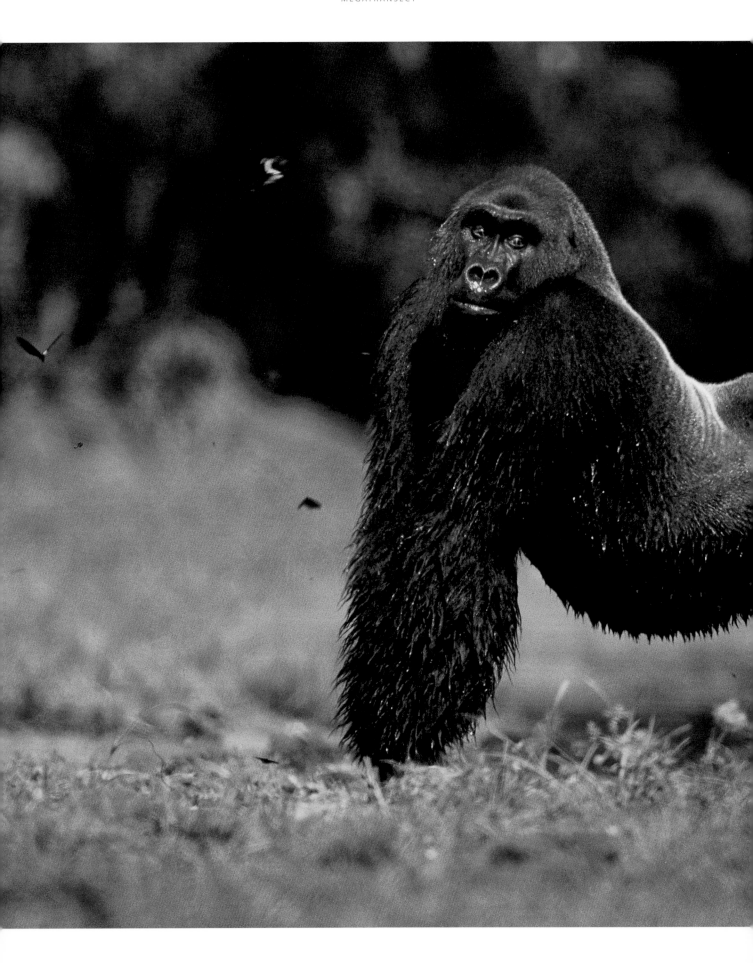

Michael Nichols
National Geographic

A lone silverback gorilla challenges a nearby rival, stirring up butterflies drawn here by salt-rich animal urine in Lokwe III, a clearing along the Lokwe River in Odzala National Park, the Congo Republic. This isolated sanctuary attracts a striking array of animals, including one of the world's largest concentrations of western lowland gorillas.

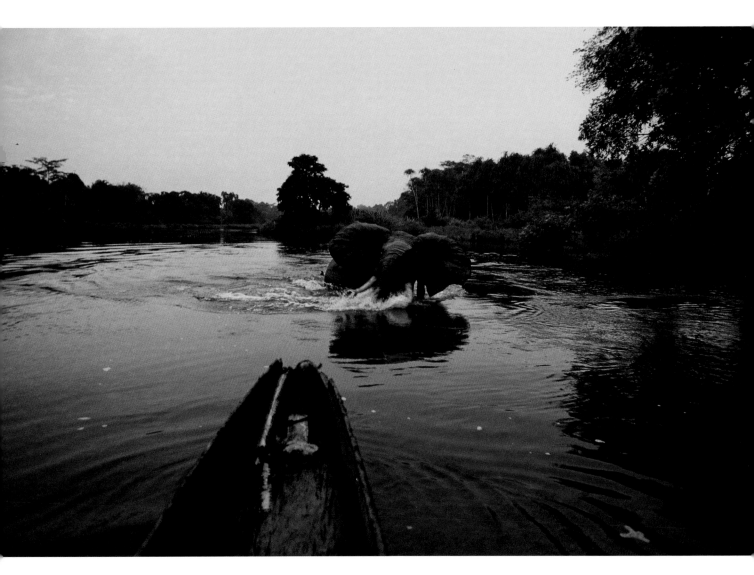

Michael Nichols
National Geographic

Above: An elephant charges
in Odzala National Park.
Poachers once overran the
park, but now a guard posted
downriver has made it safe
for elephants to reclaim their
kingdom. Right: A mandrill,
orphaned by hunters and
tethered in a hunting camp,
grabs for the camera.

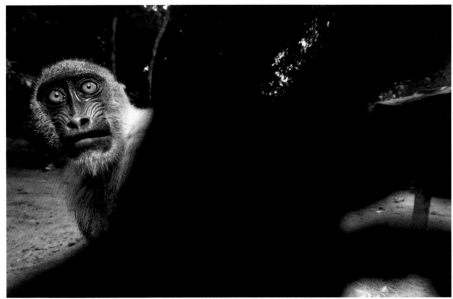

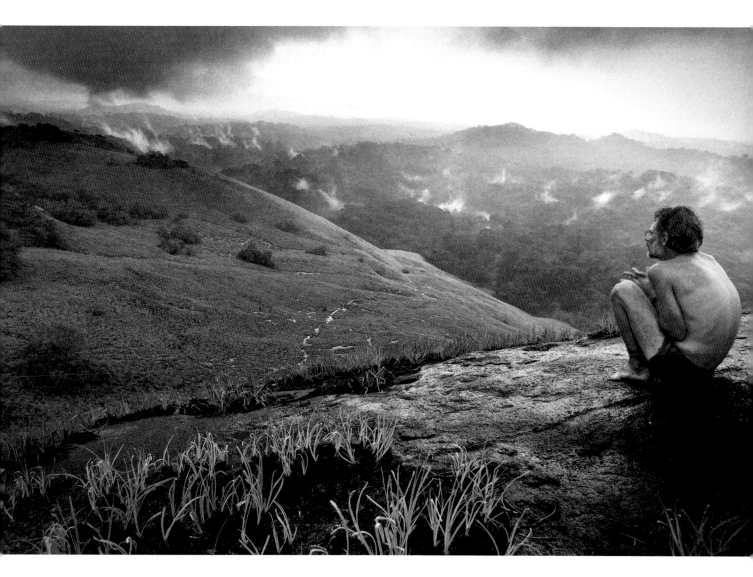

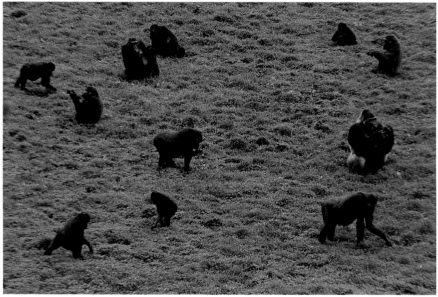

Above: After nine months trekking beneath the dense jungle canopies, Fay huddles on a mountain outcrop above the Minkébé forest in Gabon. Ascending the highest dome, Fay wrote: "I have been to the mountainop." Left: A large group of western lowland gorillas feeds on grass and soil for mineral content in a clearing along the Lokwe River in Odzala National Park.

Melanie Oyola was the 2000 Queen of the Puerto Rican Festival Parade. Each year in July, Chicago's Puerto Rican community celebrates its heritage with the festival in Humboldt Park. The community is one of many along Division Street. From the wealthy Gold Coast through the famous Cabrini Green housing projects, this seven-mile stretch of blacktop is a microcosm of urban American culture and contrast.

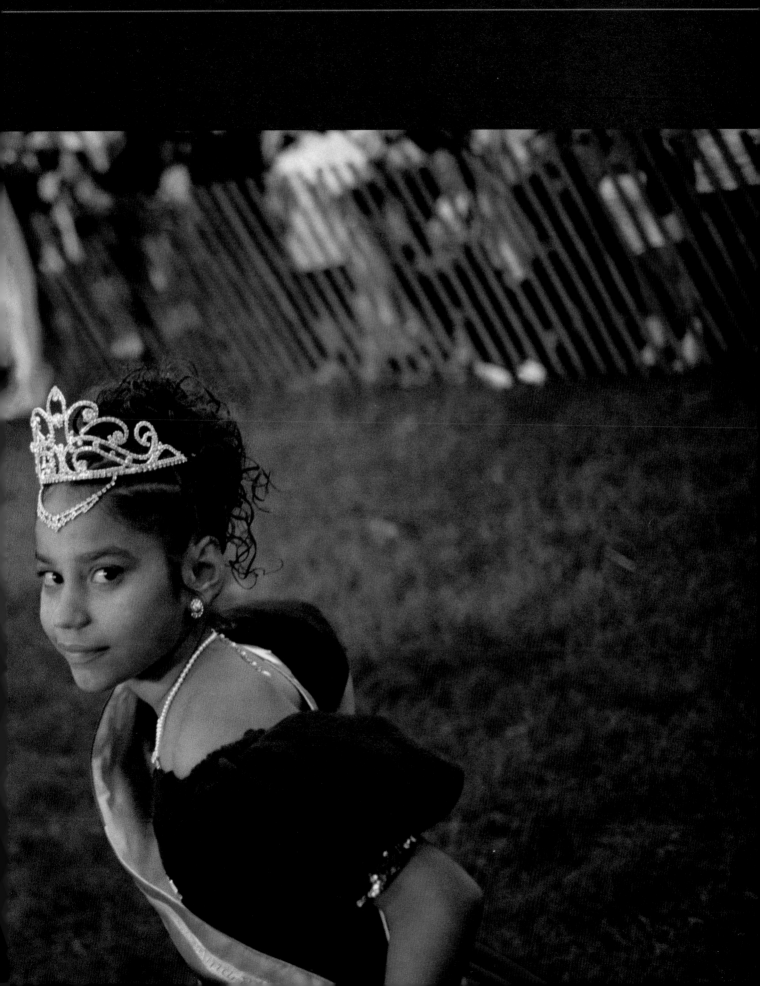

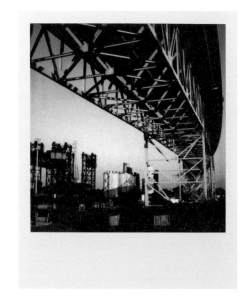

■ A privately funded documentary project, Chicago in the Year 2000 became the basis of the portfolio of this year's Magazine Photographer of the Year, Jon Lowenstein. One story from this work, "Home Away From Home," which documented the plight of illegal immigrants in Chicago's day-labor trade, was additionally recognized with the Fuji Community Awareness Award.

The 31-year-old Massachusetts native worked in the Chicago suburbs for two years with Sun Publications before being lured into the city to join CITY 2000, a year-long, non-profit enterprise to preserve the city in images and words.

"I feel that Chicago is awesome, but it's also a very segregated and an intense, in-your-face place," said Lowenstein. "I had not worked heavily in the city for six years and at first I was quite intimidated. I had to learn to completely believe in myself and my ideas. I had started to learn that at the Sun Publications because I had to carry out my own ideas each week, but now I really had to follow my heart and keep on going to things I believed in. It was tough to do that at times because great pictures are often not made the first time you meet people or go to a place."

CITY 2000's staff included eight full-time photographers, a picture editor and two assignment editors. The project's goal was to create an archive showing the texture of city life—its joys, tragedies, rituals, and surprises—to be displayed in books, exhibits, and on the Web.

This diversity of assignments appealed to Lowenstein. "How do you represent people? How do you show their lives, their stories?" he asked. "For instance, one day I was working on the Division Street project, and I met a guy I had seen on the day-labor corner at Lawrence and Springfield. Many worlds coming together. This helped make the connection in my mind between the gentrification of the city and the immigrants who help build the condominiums that wealthier, more established people buy."

The project let Lowenstein explore Chicago while expanding his horizons as a photographer. "With the Polaroids, I attempted to convey a sense of place through the light, color and atmosphere," he said. "They also helped to keep me sane because I could see the pictures immediately so I could sequence them at the end of the day and see where I should go next."

Lowenstein sees Chicago as a place with an endless variety of stories. "I have a desire to travel and check out other parts of the world, but would love to stay in Chicago," he said. "I am currently working on an incredibly interesting project about developmentally disabled people living in group homes or living independently. Although I got into photography for the photographs, that really has combined with an interest in communicating what I understand about the people I meet and who want to show themselves to the world. The most important thing is to keep on producing meaningful work. That's the bottom line.

"And it's fun."

■ *Above: The Indiana Skyway's looming structure dominates the landscape of Southeast Chicago. Opposite, top: On New Year's Day 2000, members of the Polar Bear Club run into the frigid waters of Lake Michigan. Opposite, bottom: Shortly after waking up on his sister's living room couch in Wicker Park, Herb Waldroup talks on the phone while his wife, Grace, rests against his chest.*

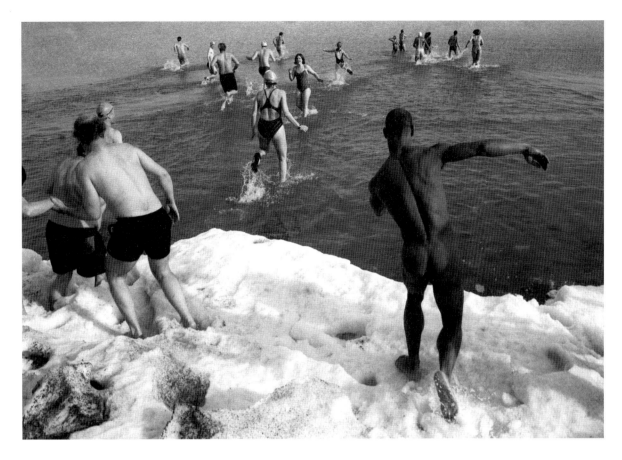

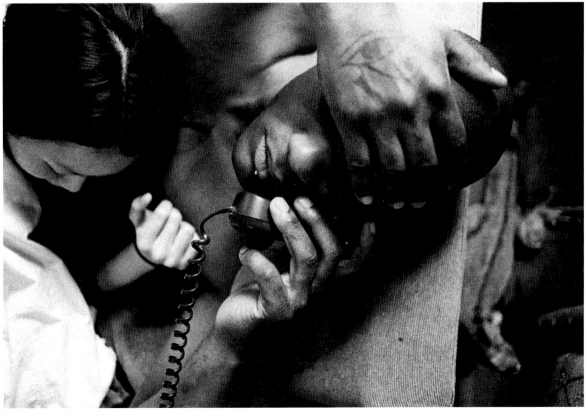

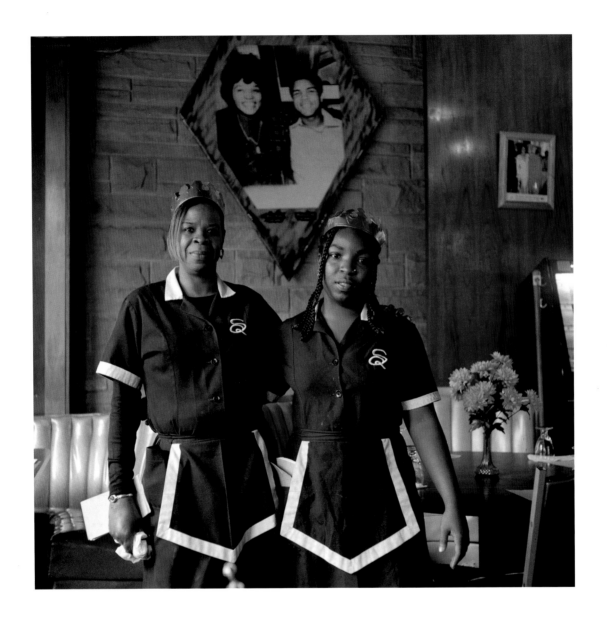

■ *At The Soul Queen restaurant, waitresses Doris Evans and Lolita Gholson stand in front of a picture of owner Helen Anglin with Muhammad Ali. Anglin had little formal education but managed in her 50 years in the business to become a successful entrepreneur whose eatery is a destination for everyone from pastors to presidents.*

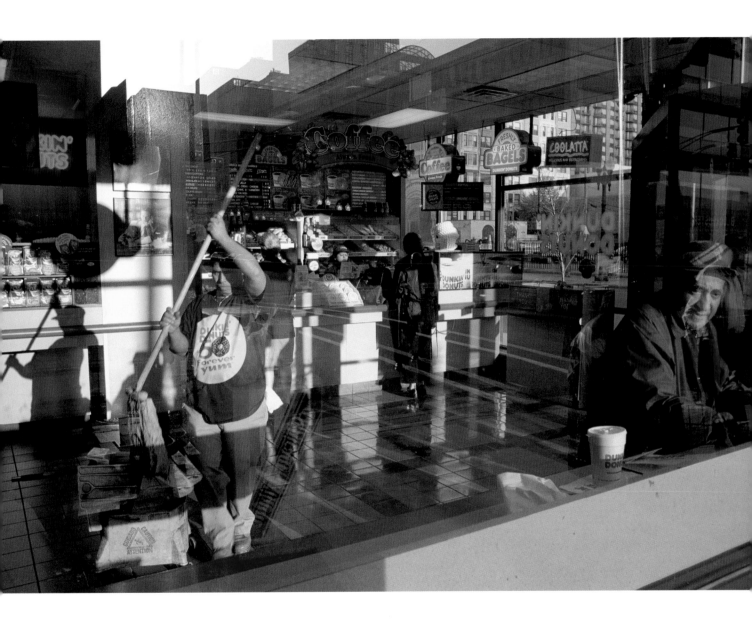

■ *Corporate chain storefronts now dominate the eastern end of Division Street.*

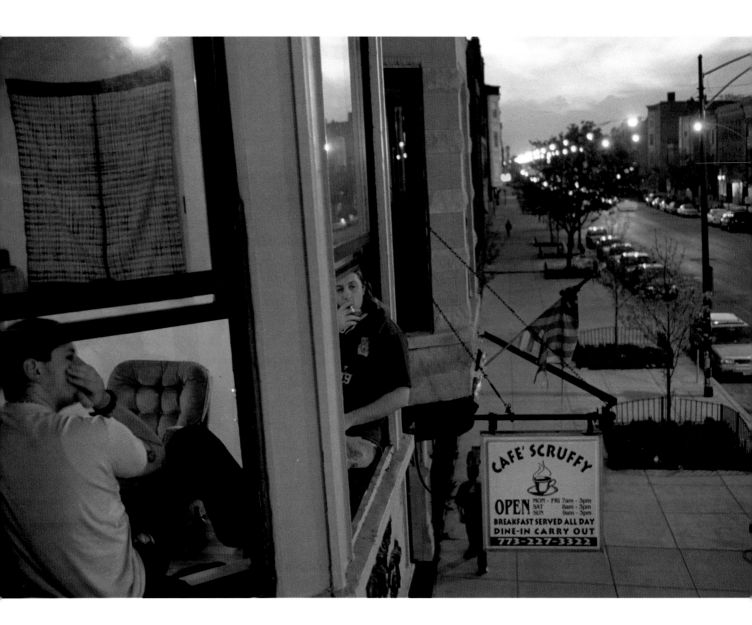

Life Along Division Street

■ *Energy, life and change blend along Chicago's Division Street. The neighborhoods along this artery are in constant flux and are rapidly being redeveloped. Sitting in a second-floor window, David Whitaker, right, and his roommate enjoy a warm May evening. Like many other young people moving to Chicago, Whitaker graduated from college and found an apartment in the trendy Wicker Park neighborhood.*

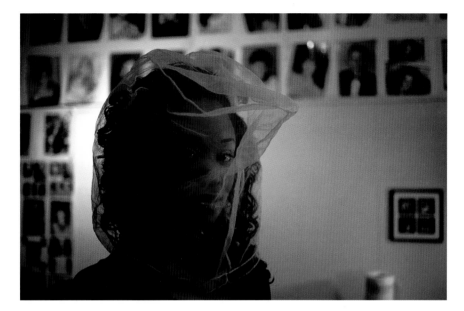

■ *At the DuVarney Portrait Studio, an aspiring model covers her face with a net so she doesn't ruin her makeup during outfit changes.*

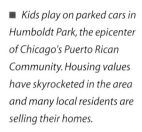 ■ *Kids play on parked cars in Humboldt Park, the epicenter of Chicago's Puerto Rican Community. Housing values have skyrocketed in the area and many local residents are selling their homes.*

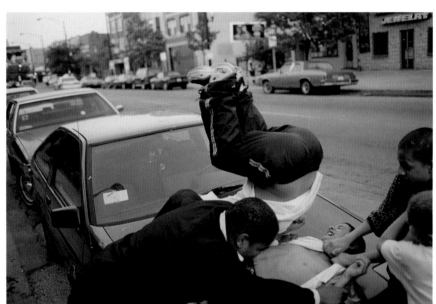

■ *Giselle Morales, left, and Olga Gonzalez dance at the Puerto Rican Festival in Humboldt Park.*

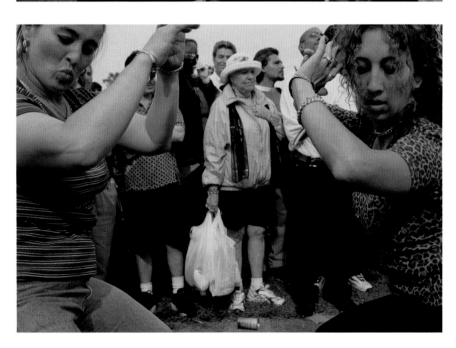

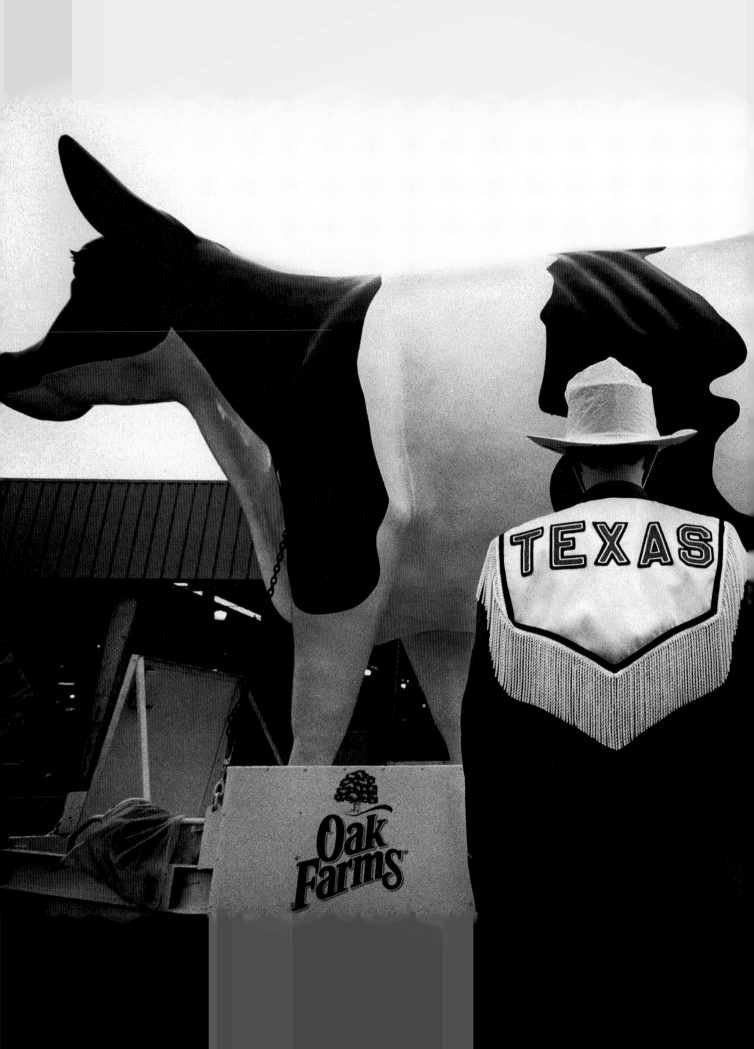

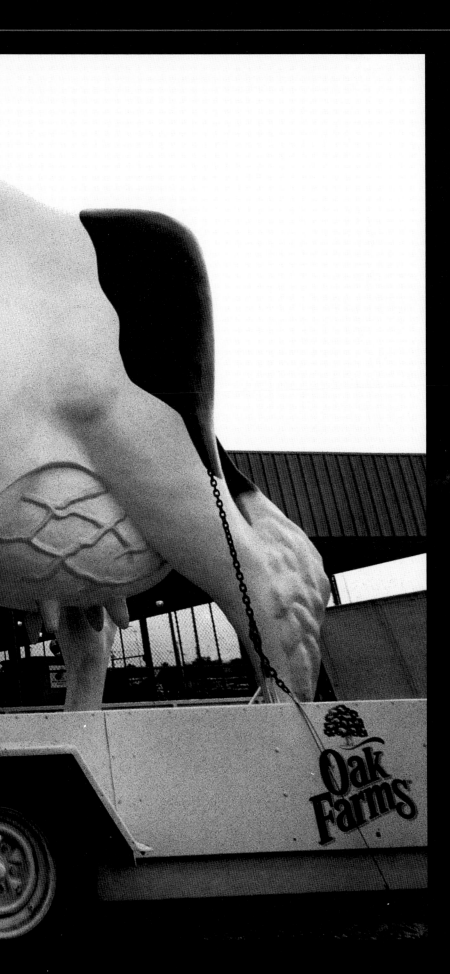

Barbara Davidson
The Dallas Morning News

Texans pride themselves on having "the granddaddy of all fairs." The three-week state fair attracts 3 million visitors per year—the largest fair crowd in the country. In the livestock area, University of Texas Longhorn Band member Jason Parker takes a last look at the giant "cow on wheels" before joining his own herd for the trip back to Austin following a performance.

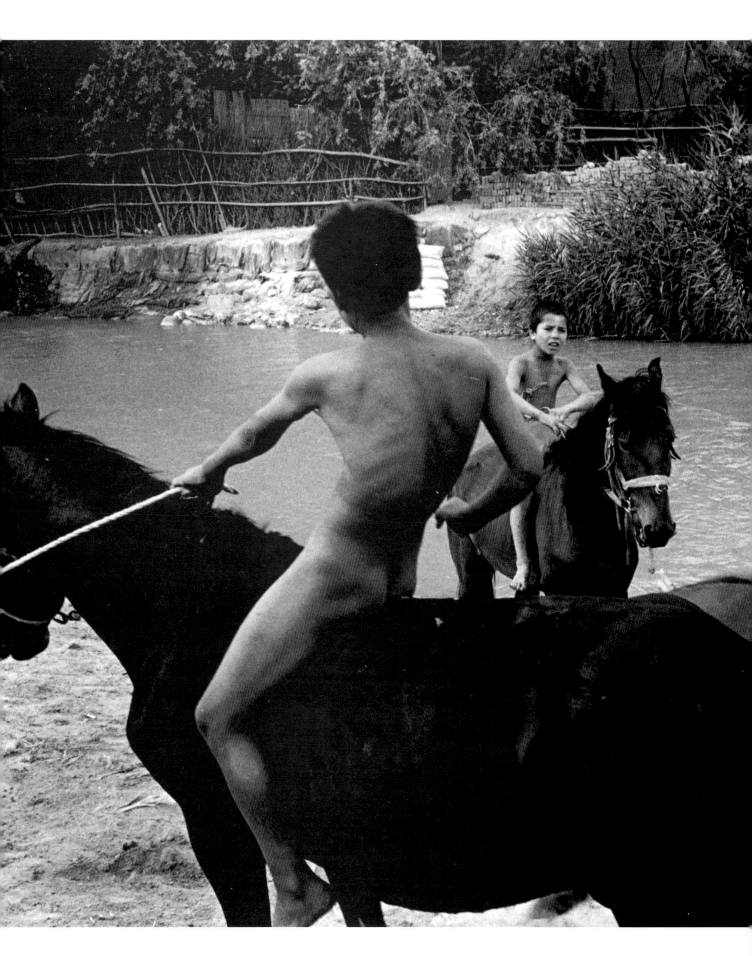

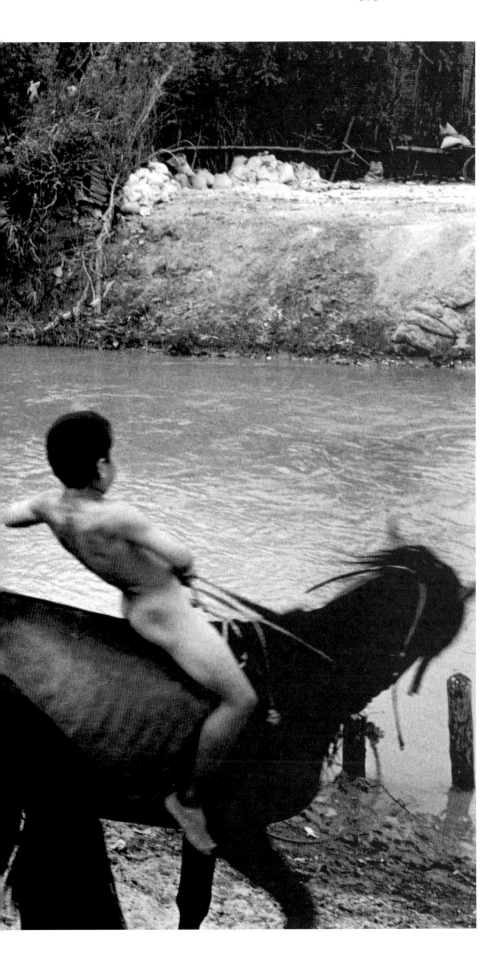

Michael Amendolia
Network Photographers

Kashgar is China's westernmost city and is situated in the Xinjiange Uygar Autonomous Region. Mass migration of Han Chinese into this area is putting pressure on the Uygur people to abandon their traditions and culture. During a horse sale, three boys ride through the river to show the quality of their horses.

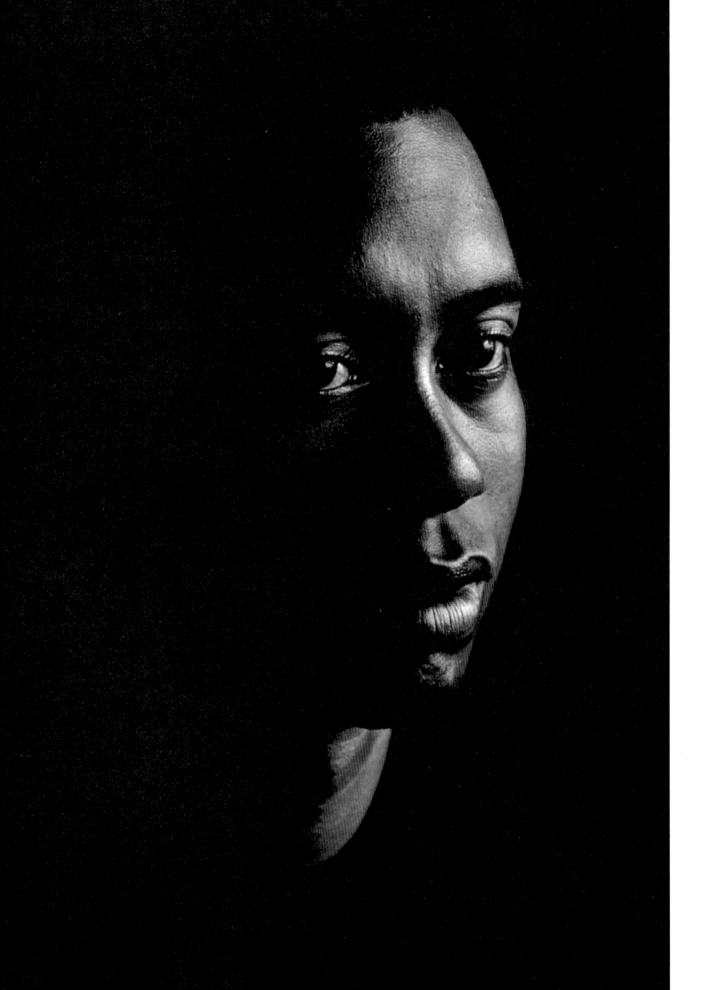

Genaro Molina
Los Angeles Times

Actor Laurence Fishburne's image is captured in a mirror in Beverly Hills, CA. The actor turned director for "Once in the Life," the movie based on his play. "I told him that I wanted to photograph him holding a mirror in his hand as a symbol that he was taking control of his own fate by directing his first feature film," explained Molina.

Herb Ritts
TIME

Opposite: Golfer Tiger Woods is captured in a reflective moment far from the usual throngs of worshipful fans. "I've worked with just about everybody, from presidents to rock stars," says Herb Ritts, "and Tiger lived up to his reputation. He was a very cool guy, very easy and humble. He was very in the moment."

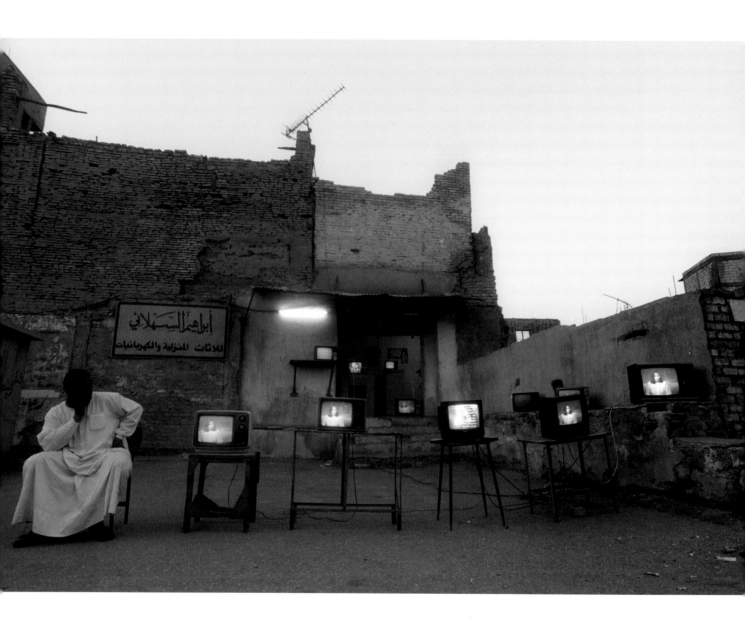

Jamie Francis
St. Petersburg Times

In Basra, Iraq, Ibrahim Al-Shalami, 32, waits for customers—who rarely arrive. He has 13 used televisions for sale; nine of them work and are tuned to the only station in town. Such is life after 10 years of U.S. sanctions. Al-Shalami fought on the front lines during both the Iran-Iraq and the Persian Gulf wars.

Reza
National Geographic Adventure/IMAX/Freelance

The wife of Mostafa Gol holds her 3-month-old baby, Hossein, at the Moghol Gheshlagh refugee camp in Khaje Bahaoddin, Afghanistan. She gave birth to premature twins, Hassan and Hossein, after leaving her home for the camp. Thousands of Afghan refugees from various ethnic groups have escaped the Taliban regime by moving to areas controlled by Cmdr. Ahmed Shah Massoud. When photographer Reza visited the family, both children were in ill health. Reza asked Massoud to send a doctor to examine the twins.

Jackie Belden
Ohio University/Naperville Sun, IL

The South African troupe
Thula Sizwe dances at the
Around the Corner, Around
the World International
Festival at North Central
College in Naperville, IL.

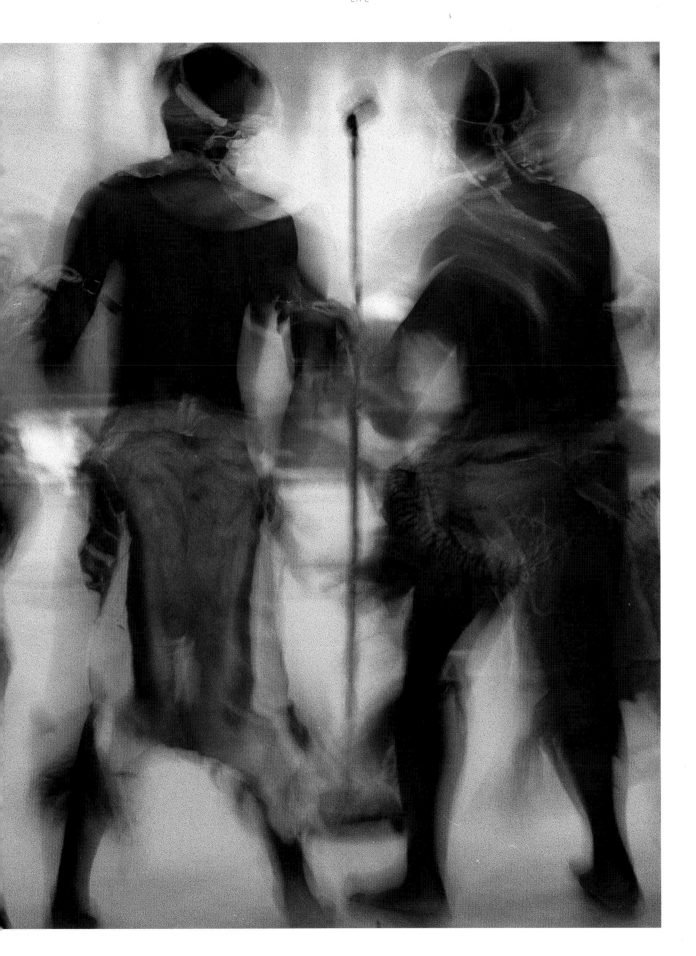

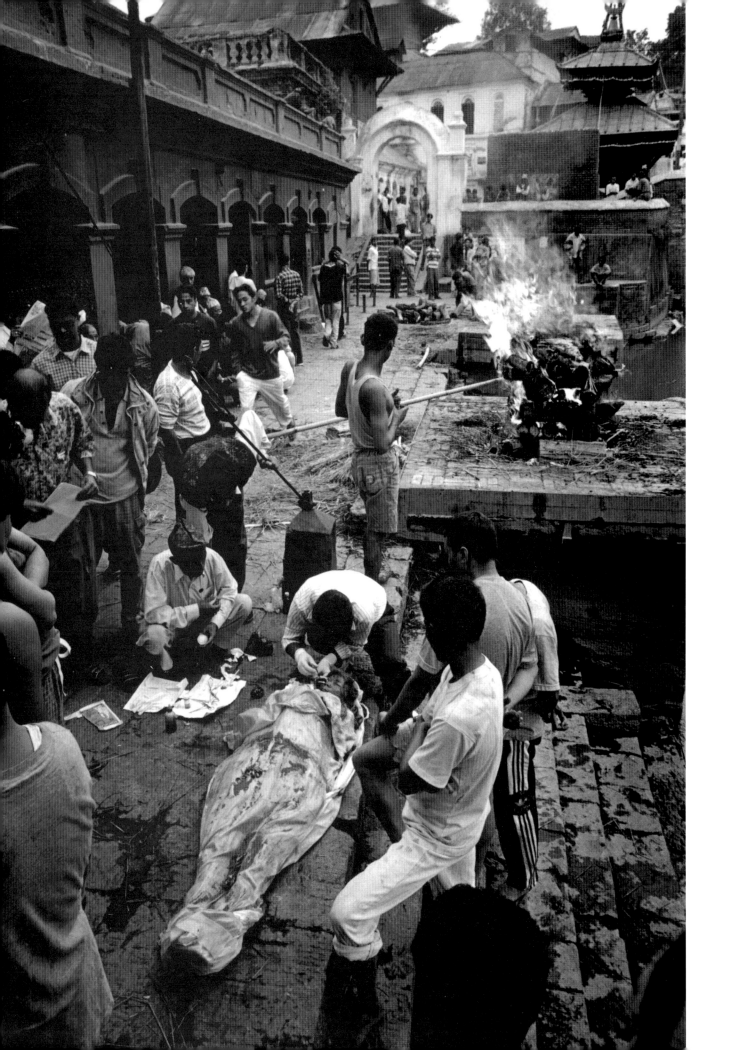

Michael Amendolia
Network Photographers

CORNEAL DONATION IN NEPAL

Opposite: Nurses from the Tilganga Eye Centre in Nepal extract corneas from corpses that await cremation at the Pashnupatinath Temple. Hours later, opthalmologists will transplant the corneas into the eyes of needy patients. Right: A man with severe corneal opacity. Below right: Corneal transplant patient Goma Mainali, 15, walks through Kathmandu traffic after a check-up.

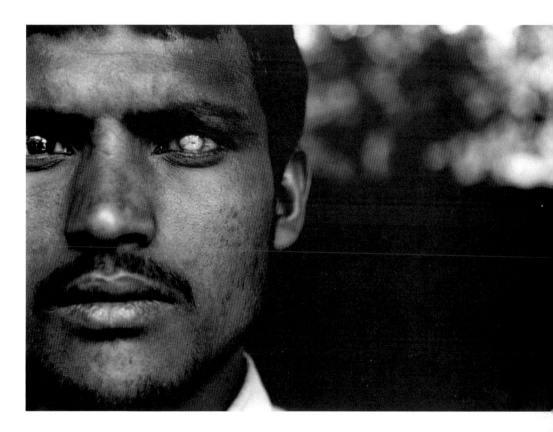

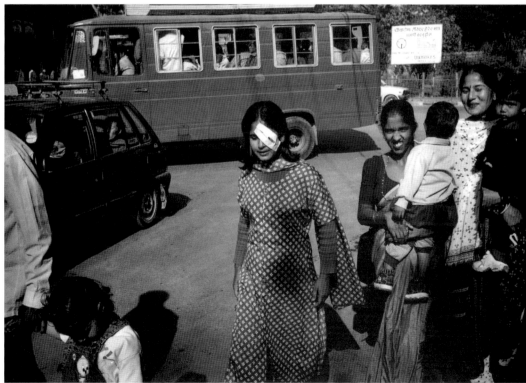

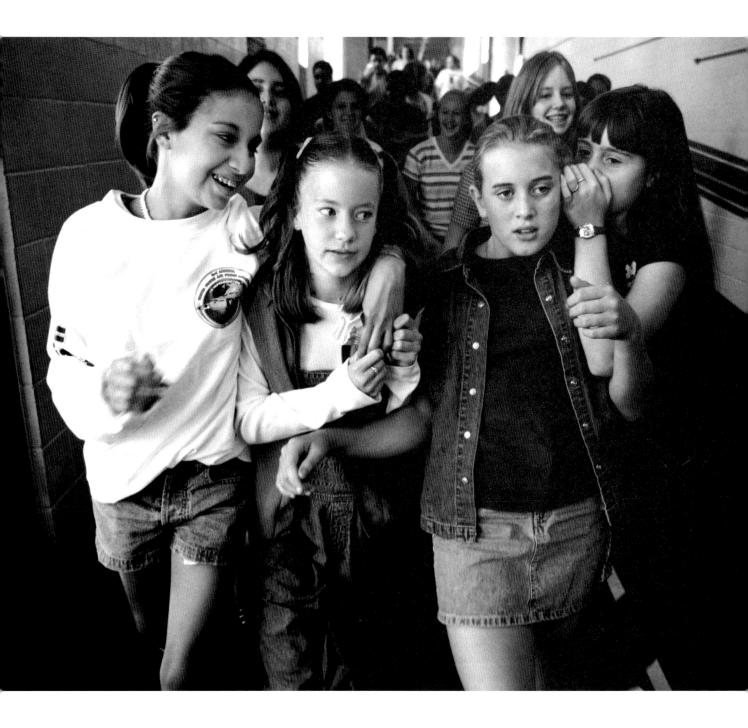

Colin Mulvany
The Spokesman-Review/Spokane, WA

Ashley Muzatko, 13, second from left, shields herself with friends as she faces the thrills and trauma
of seventh grade at Salk Middle School in Spokane.

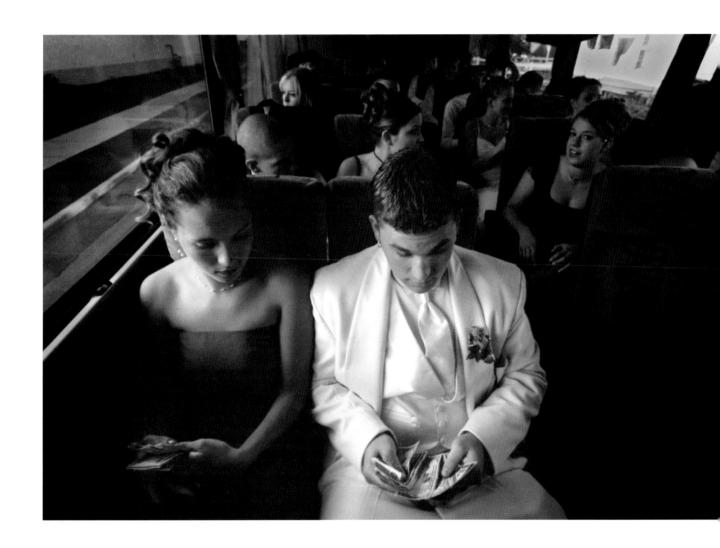

Torsten Kjellstrand
The Spokesman-Review/Spokane, WA

Seth Battista and Sarah Traves of Lewis and Clark High School assess their resources for prom night
in Spokane. About 20 couples chartered the bus to take them to the evening's activities.

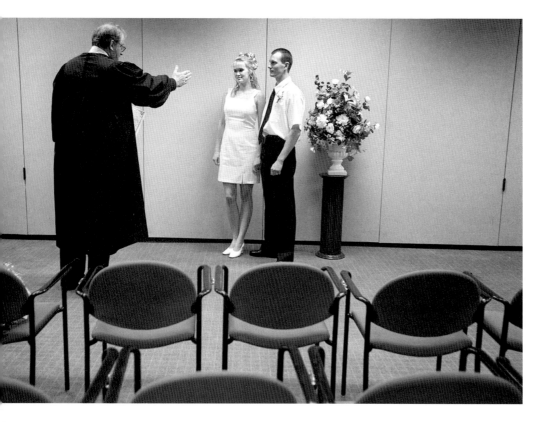

Stephanie Sinclair
Chicago Tribune

Couples are married each Friday at the DuPage County Courthouse in Illinois. Judge Edmund Bart, who has been presiding at weddings for 19 years, pronounces a young Lithuanian couple husband and wife. "I love doing weddings," said Judge Bart, "This is the fun part. The people come in, they're happy, they leave happy and we can help them be a little happier."

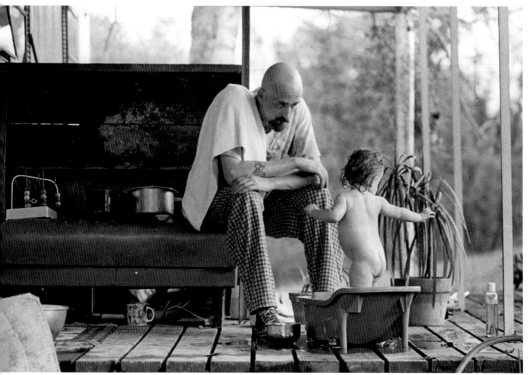

Ann Arbor Miller
Ohio University

Craig Elliott, 30, says being a single father has its ups and downs, but he wouldn't have it any other way. When 14-month-old Reilly's mother wanted to give her up for adoption, she needed the consent of the unwed father. "When the time came to legally sever his rights to the child, he surprised everyone—and himself to some extent—and told the court that he wanted to raise her," explains the photographer. Elliott and Reilly live in rural Athens County, Ohio.

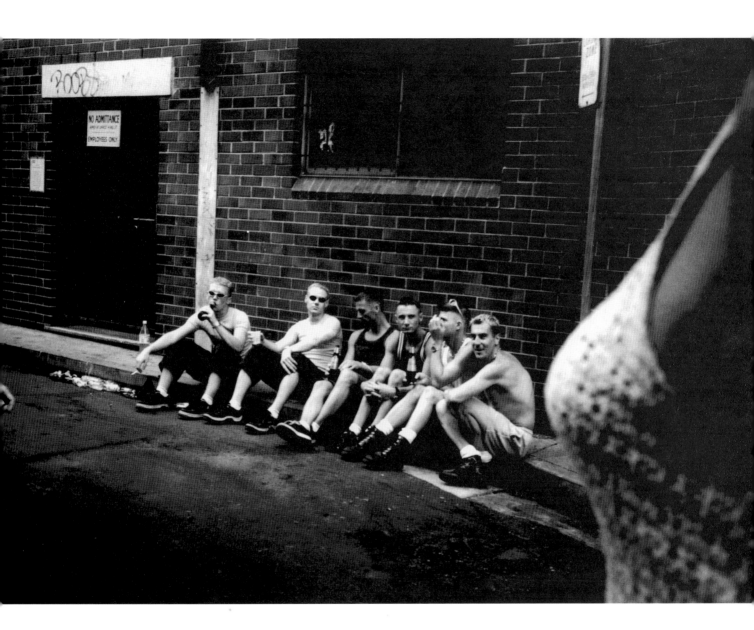

Tamara Voninski
Oculi

A drag queen walks through the "Laneway" showing off her fake breasts. The Laneway is a narrow street in Sydney, Australia, where parties are held following all-night gay and lesbian events. Sydney's drag queens are the stars and prima donnas at these wild early-morning gatherings.

Rob Finch
The Beacon-News/Aurora, IL

Along New York Street in Aurora, IL, Michangelo Bautista pouts because he wasn't invited to play in his sisters' game of tag.

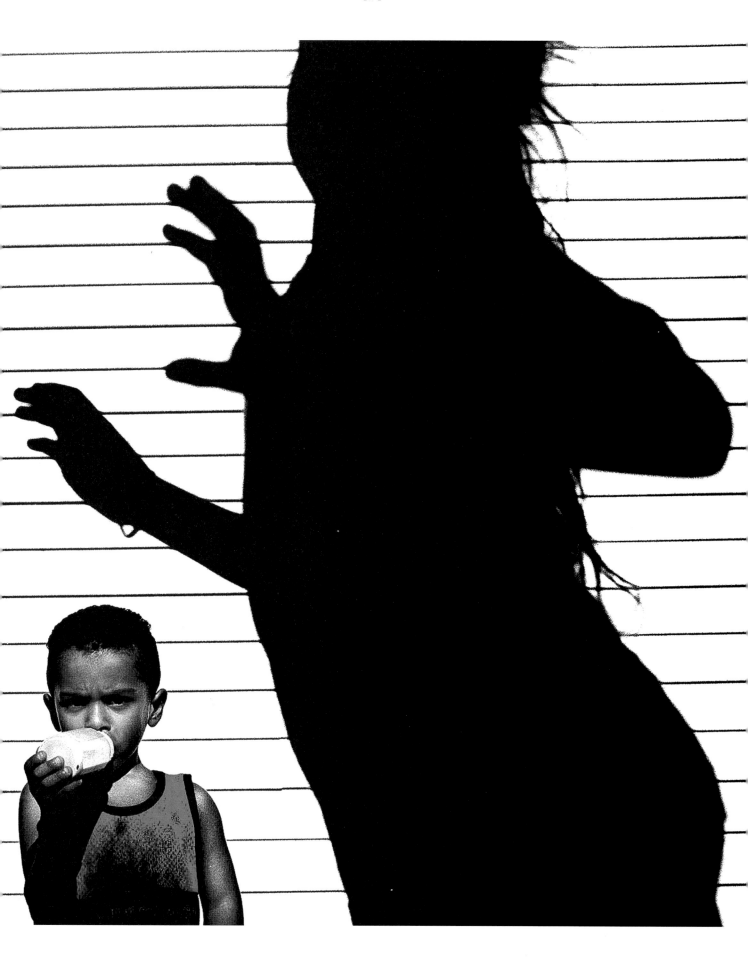

Allison V. Smith
The Dallas Morning News

A mechanical bull gets the best of Lacy Billingsley at the Fort Worth Stockyards. Billingsley, 19, was at the
Stockyards to enter the Miss Rodeo Pioneer Days 2000 competition, which she won the previous year.
Contestants are judged on horsemanship, roping, appearance and essay writing.

Franka Bruns
Pittsburgh Post-Gazette

Thirteen-year-old Lekha Tummalapalli of Fox Chapel, PA, practices the piano, an instrument she learned to play at age 6. Last year she was invited to play at Carnegie Hall in New York City.

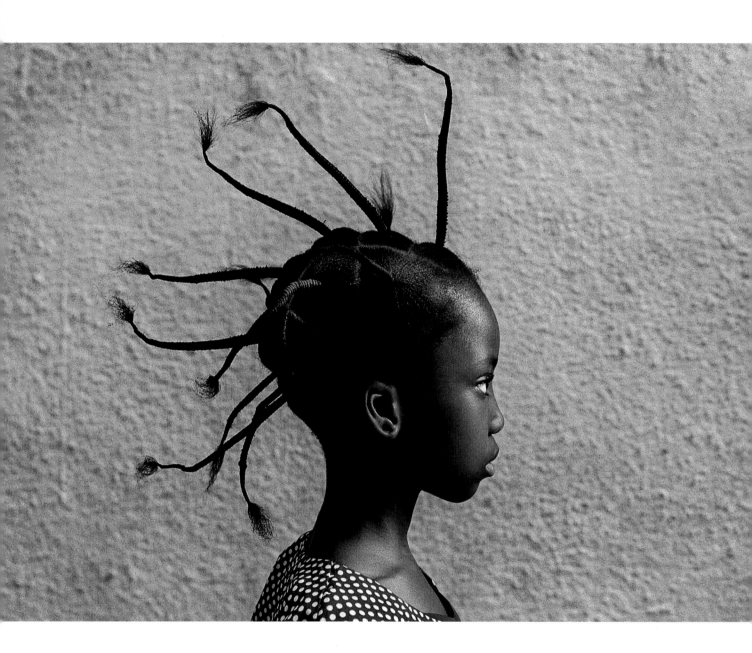

Barbara Davidson
The Dallas Morning News

Dressed in her Sunday best, Christebbe Kayemba attends services at the Army of Victory church in
Kinshasa, Democratic Republic of Congo. Many of the 50 million Congolese have turned to religion
during the ongoing civil war.

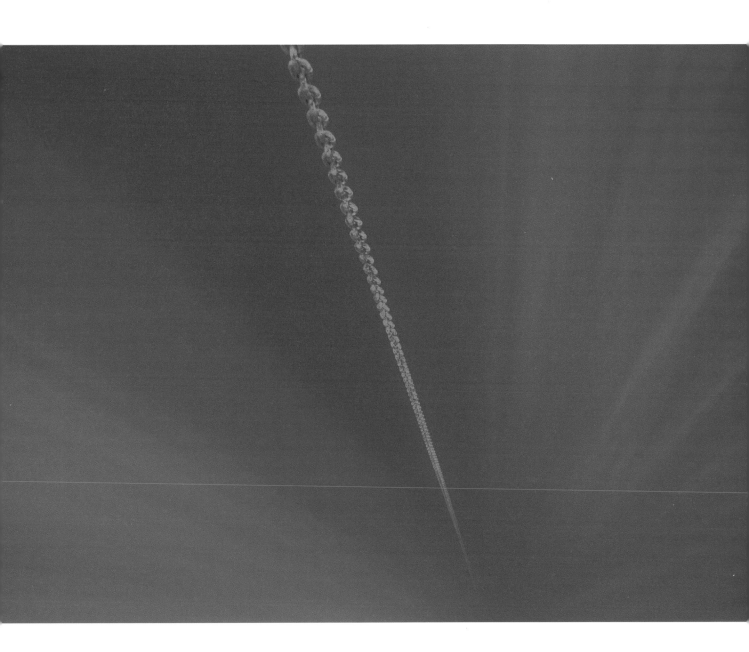

David McLain
Aurora and Quanta Productions / Freelance

Rays of light follow an anchor chain into the of the cobalt-blue waters off Australia's Great Barrier Reef.

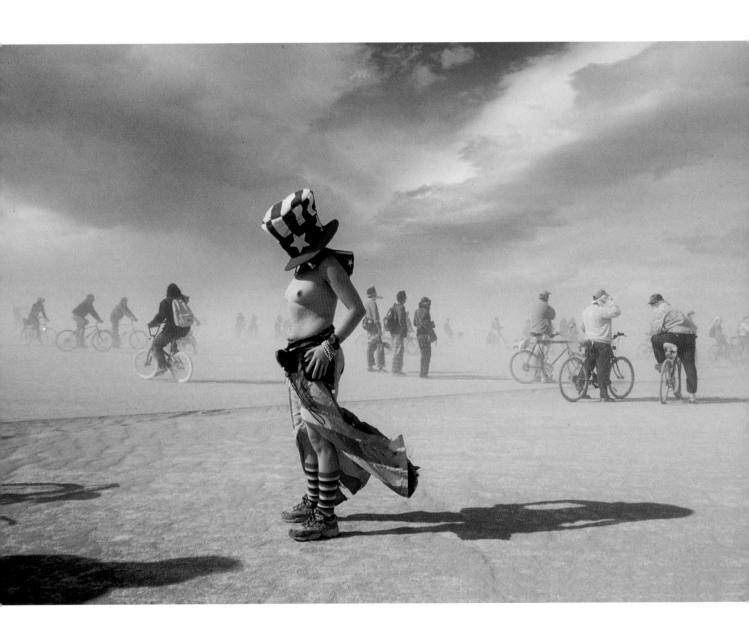

Patrick Tehan
San Jose Mercury News

A participant in the topless women's bicycle parade shields her face during a sudden sandstorm at the annual
Burning Man Festival in Nevada's Black Rock Desert. The annual festival is a venue for artistic expression and
community bonding, culminating in the burning of a large wooden man. "People dress in wild costumes.
Anything goes," says Tehan. "There are daily parades, large sculptures, wild vehicles—very 'Mad Max.'"

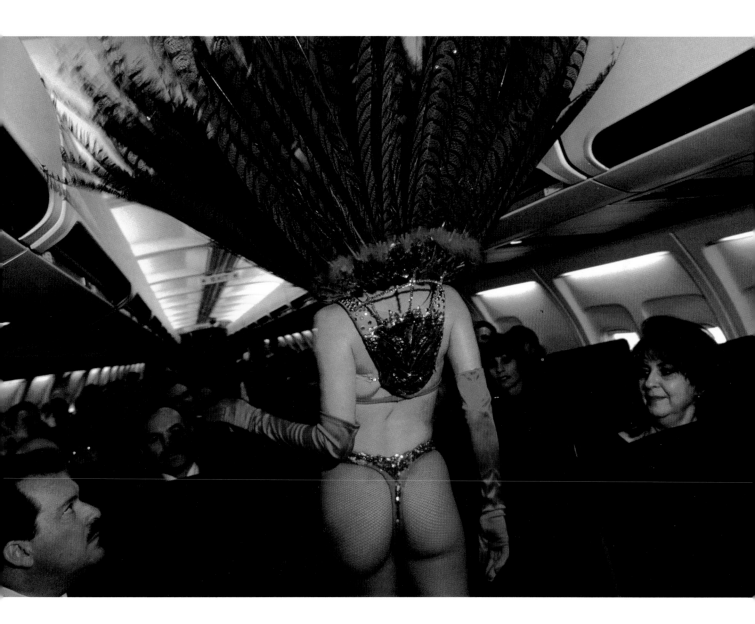

Lauren Greenfield
Stern/ Freelance

Showgirls from the Stardust Resort and Casino in Las Vegas, NV, present a fashion show for executives
of the Nevada Gaming Commission and Western Pacific Airlines. The show was supposed to take
place in the air above Las Vegas, but mechanical problems with the airplane grounded the event.

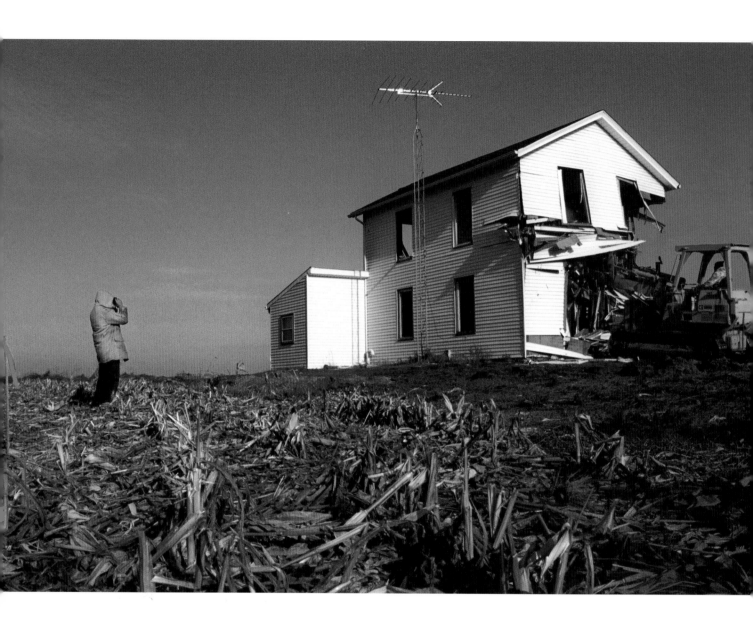

Callie Lipkin
The Beacon-News/Aurora, IL

Robin Ochsenschager, 63, of Aurora, IL, photographs the demoliton of his family home. The 205-acre
farm, which had been in the family for 60 years, was sold to a developer to pay inheritance taxes. The
developer plans to build 257 single-family homes where the last farm in West Aurora once stood.

Todd Heisler
Sun Publications/ Chicago

Children play in Manhattan, one of the many newly built subdivisions in Lincoln-Way, IL, a rural community 35 miles south of Chicago. When farmland meets suburbia, it often loses out to development, as more families come looking in rural areas for good schools and safe neighborhoods.

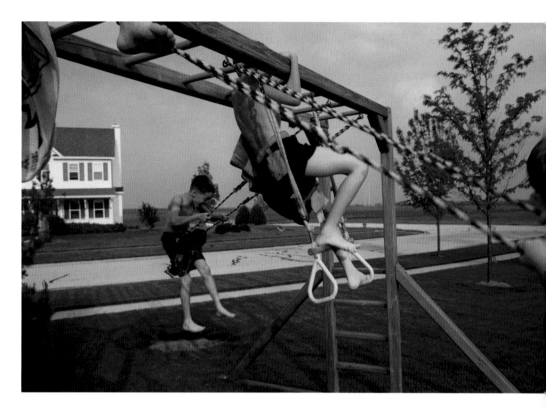

Susana Vera
The Raleigh News & Observer

Five-year-old Annie Buckingham holds her breath under water during a suburban beach party thrown to celebrate a neighbor's 50th birthday in Raleigh, NC. "Why should we go to the beach when we can bring it here?" said party host Jesse Rhinehart.

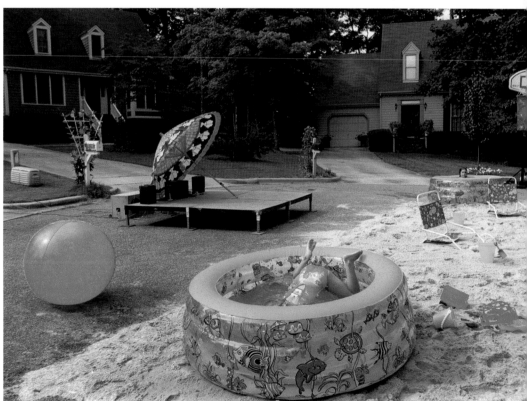

Mark Zaleski
The Press-Enterprise/ Riverside, CA

Newlyweds Todd Wilson and Marci Bond soak in a bubble bath at a Riverside, CA, Holiday Inn after their honeymoon dinner. When they married they knew their time together would be short. Todd, 37, is mentally handicapped and has a spinal defect. Marci, 27, who had been diagnosed with cancer, was mentally handicapped also. She died after 171 days of marriage.

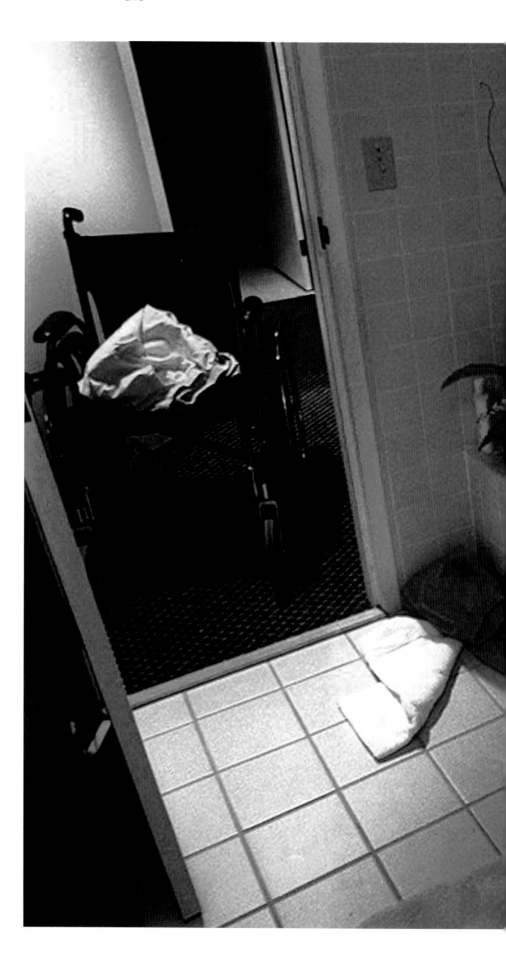

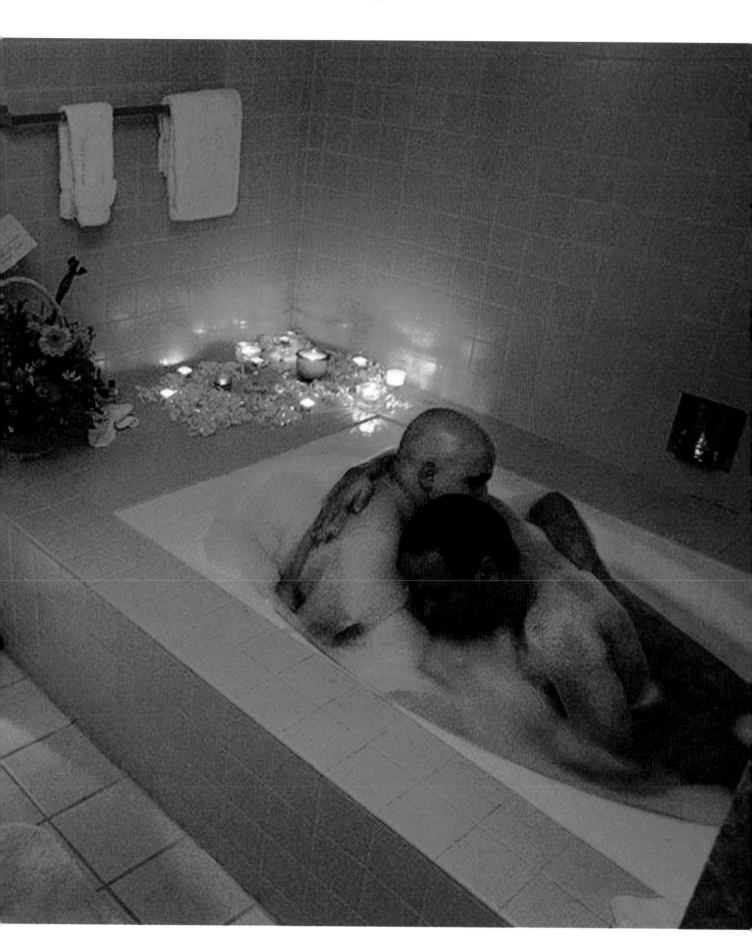

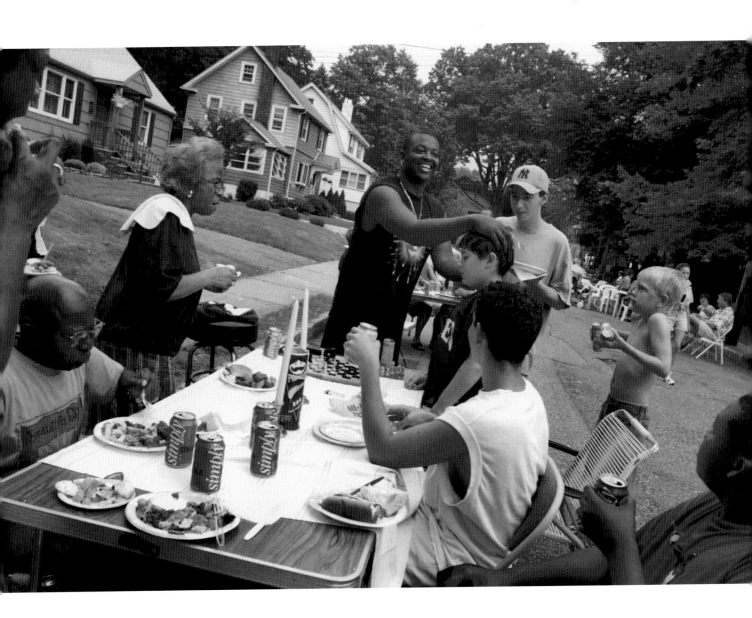

Jon Naso
The Star-Ledger/ Verona, NJ

While sociologists wrestle with the demographics of "white flight" from America's cities and inner suburbs, blacks and whites have lived alongside one another on Martin Road in Verona, NJ, for more than 50 years. Chuck Armstead rubs the head of neighbor Paul Fulton after the 12-year-old beat him in a game of chess during the annual Martin Road block party.

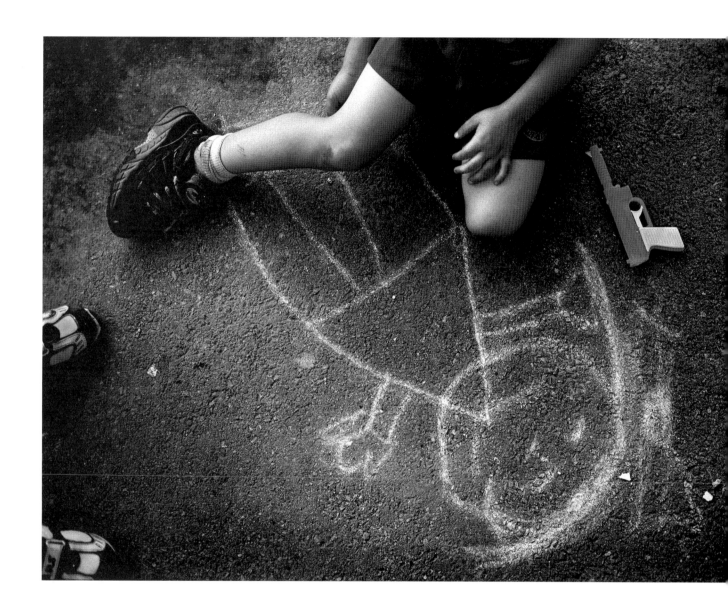

Rob Finch
The Beacon-News/Aurora, IL

A one-mile stretch of New York Street that runs through downtown Aurora, IL, is the city's eyesore. Twenty years ago, downtown businesses failed and longtime Aurorans fled. Crime and violence have marred the area, but children like Eric Hernandez still find simple pleasures in a driveway and a piece of chalk. The toy gun and outline, however, evoke the troubled area's other activities.

Journey of Hope

Tara McParland documented her three-year fight with breast cancer; she died last year at 33. Her journals and photographs were published by her newspaper, *The Florida Times-Union,* in Jacksonville.

JUNE 27, 1998

To quell nausea after high-dose chemo and the re-infusion of my stem cells, I meditated each morning. The time alone helped center me, particularly amid the constant interruption of doctors and nurses. After spiking a temperature and passing out at home, I was admitted to Baptist Medical Center and spent a week in this laminar air flow room on Tower 5C. These deep-breathing exercises focused my efforts on healing as I imagined my body vanquishing the cancer cells. Soon after this, my blood counts began rising and I was discharged.

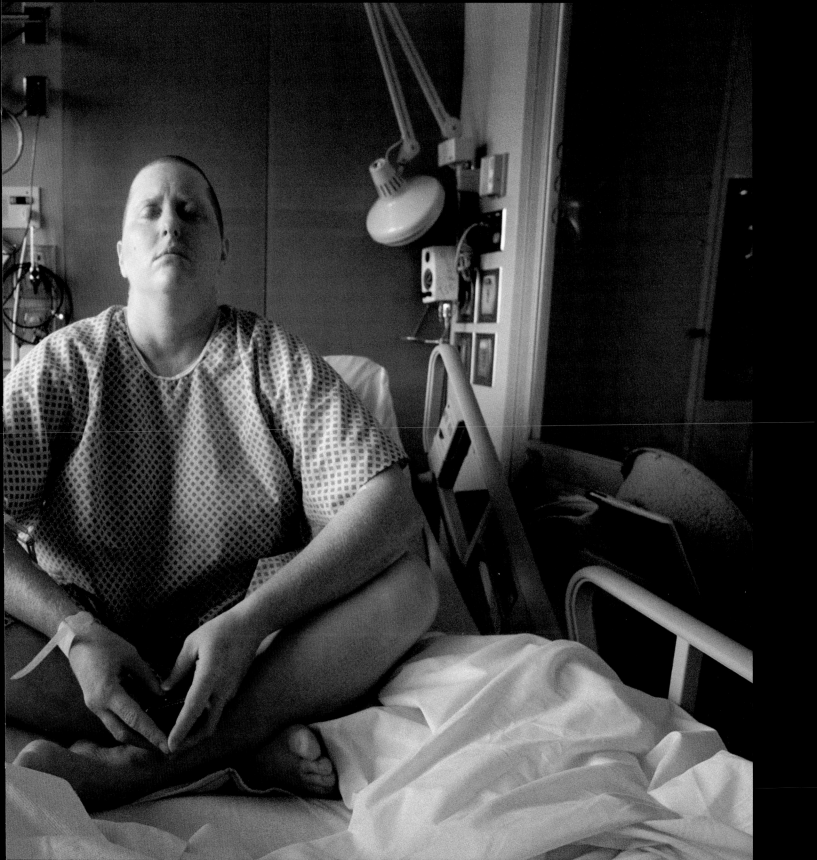

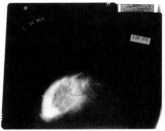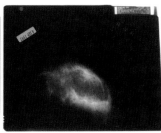

SEPTEMBER 29, 1997
Finally I'd photographed my mammograms. The heavy shadowing on the left side looked ominous, but also nebulous. There was cancer in my left breast.

"Breast cancer had stripped away the certainties of my life."

■ Tara McParland, a 33-year-old Florida Times-Union photographer who died on November 21, 2000, after a three-year fight with breast cancer, was posthumously awarded the Canon Photo Essay Award.

Times-Union photo editor and close friend Dennis Hamilton Jr. said McParland knew it would be hard emotionally and technically to document her journey with cancer, but as she said toward the end of her life, "I'm also gratified that my published cancer journals touched so many people. I wasn't quite sure why I began them, except to say that turning the camera on myself for a change seemed appropriate. It was a way to explore and process my own feelings. It also was my way of offering women diagnosed with metastatic breast cancer some hope that it needn't be an instant death sentence." The resulting journals and photographs were published in four installments.

After viewing McParland's entry, the POYi judges commented that they were impressed by the degree of courage it took to document oneself in such an emotionally charged situation.

"I drove to the St. Johns River, to sit alone and think," McParland wrote about a painful day in January 1999. "As I set up a camera inside my car to continue documenting this journey, I remember feeling odd recording the steps of my demise. Dr. Joyce's words, 'The CT scan showed mets to the lungs and the liver,' echoed in my head. Soon I broke down in sobs, gasping for breath. Disappointment washed over me like a tidal wave. Then I went home to tell my family."

McParland suggested entering the series in Pictures of the Year. Ten days before her death she organized her photographs and journals on a laptop at the hospice for the final time.

"I used a light stand to support my camera," she said in the published series. "The process evolved from using a self-timer to radio remotes to keep a more documentary spirit. I captured the scenes in a wide angle, natural way to show context. I pursued the whole thing in a documentary spirit to ensure that it was an accurate reflection of my journey, but I never contrived a moment. I just visually journaled my response and reaction to the tumult and the fact that I could do treatment, share the feeling, and go on living my life under the specter of having metastatic breast cancer—a treatable, but ultimately incurable disease."

Florida Times-Union, October 6, 1998

My diagnosis is a distant memory, but I live with it every day. Cancer. On September 9, 1997, the lump I'd found earlier in my left breast finally had a name: Infiltrating ductal carcinoma.

My life was altered in a way I could not comprehend then. I wasn't afraid, nor was I angry. Was I too naive to know better? Perhaps. But somehow I'd suspected all along that cancer had invaded my body. I prepared to fight the enemy.

For those like myself with distant metastases— cancer that has spread to bone or other organs—the survival rate is 21 percent. That is the figure with which I grapple. But what does it mean to me?

No longer do I take for granted the passing days. I still pursue all the activities—work, relationships and recreation—that give my life its form and meaning. I wield my sense of humor like a karmic shield. That alone has buffered my passage through the past year.

Florida Times-Union, September 12, 2000

The whispers have become louder and more disquieting. How much longer can I last? As one treatment has given way to another, I mark my achievements in small steps.

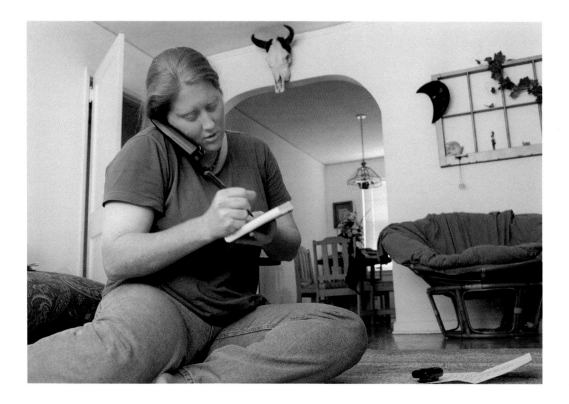

SEPTEMBER 9, 1997 *Before returning the call on my pager, I set my camera on a mini-tripod to start my visual journal. My head reels as the radiologist repeated the biopsy results. Cancer. Documenting my journey may help me make sense of all this.*

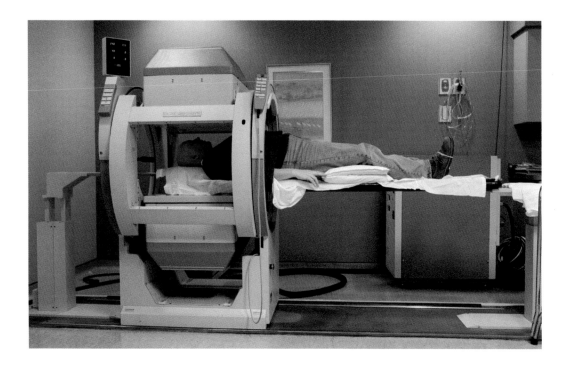

DECEMBER 19, 1997 *As I lay inside the bone scan machine, which recorded any metabolic activity in my bones, I remember feeling calm.*

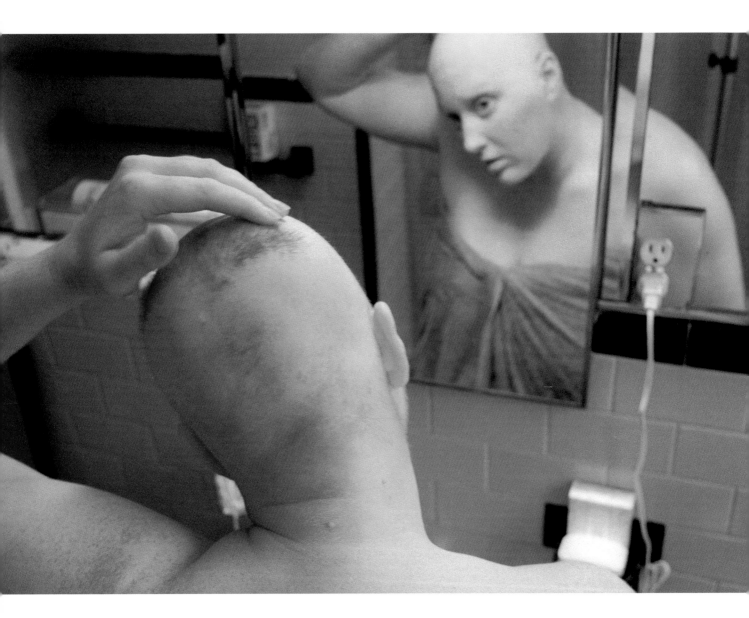

JULY 8, 1998 *After high-dose chemotherapy, I lost my hair for the second time in a year. When it first fell out last November, it all disappeared rather quickly. This time, one patch stubbornly held fast. So I took a photo to remind myself later how goofy I thought I looked. It's a reminder that, with the right attitude, there's humor in the strangest things.*

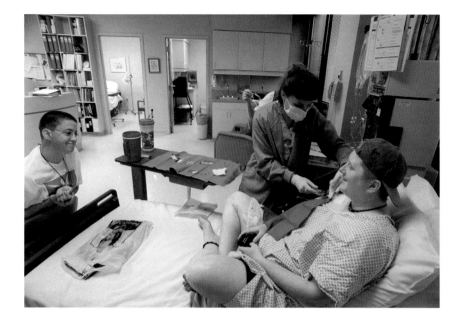

MAY 6, 1998 *Monotony. That was my nemesis during the ten days it took to collect all the stem cells required to replenish my bone marrow after high-dose chemo. Rusty helped entertain me while Rita, the oncology nurse, made this phase of treatment more bearable with her warmth and humor.*

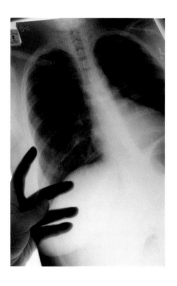

SEPTEMBER 20, 1998
My first chest X-ray after the stem cell transplant—in which doctors harvested my stem cells, froze them and, after three days of high-dose chemotherapy, returned them to my body. The X-ray signaled clear lungs—no further metastasis. To me, the X-ray indicated my body had weathered the worst as I looked forward to a reprieve from the cancer. For now.

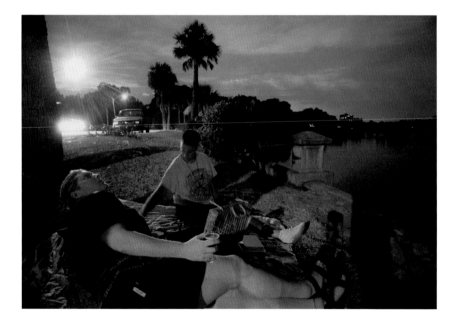

JUNE 16, 1998 *My final fling before high-dose chemo. I keenly felt the stress of final preparations for the month I'd be in isolation. Soon I wasn't allowed outside my house without a mask protecting me from infection. So my partner Rusty surprised me with this sunset picnic on the Ortega River.*

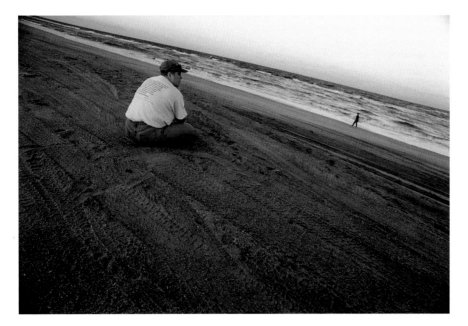

OCTOBER 25, 1998

It's been a year of renewal and reflection. The experience has tested and tempered me. In one sense, I'm starting life anew, struggling to find my way amid the emotional turbulence after treatment. Yet I also find myself back where I was before all this began, blowing dust off the same problems I had placed on the shelf. My trip to Vilano Beach this afternoon cleared the angry, painful thoughts from my head. The sunset was soothing.

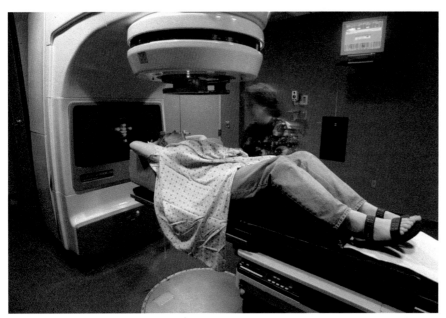

DECEMBER 14, 1998

Radiation gave me the sense of being offered on the altar of medical science. The experience is cold and precise, just you in a breezy room and a machine shooting photons and electrons into your body. I lay in the darkened room as a technician lined up exact coordinates using the machine's laser beams and some tiny tattoo marks on my chest. Each day's routine was the same. Arms overhead. Don't move. I could only hope these invisible bullets are finding their mark and eradicating the cancer.

SEPTEMBER 29, 1999

When my hair finally returned after stem cell, it was Orphan Annie curly. This was my first haircut since the onset of treatment in 1997.

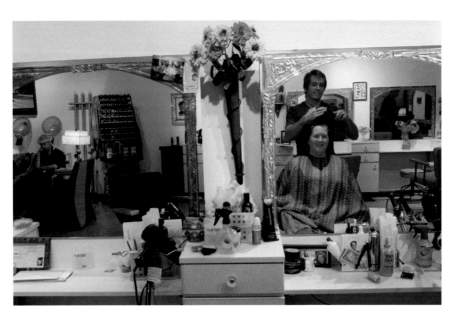

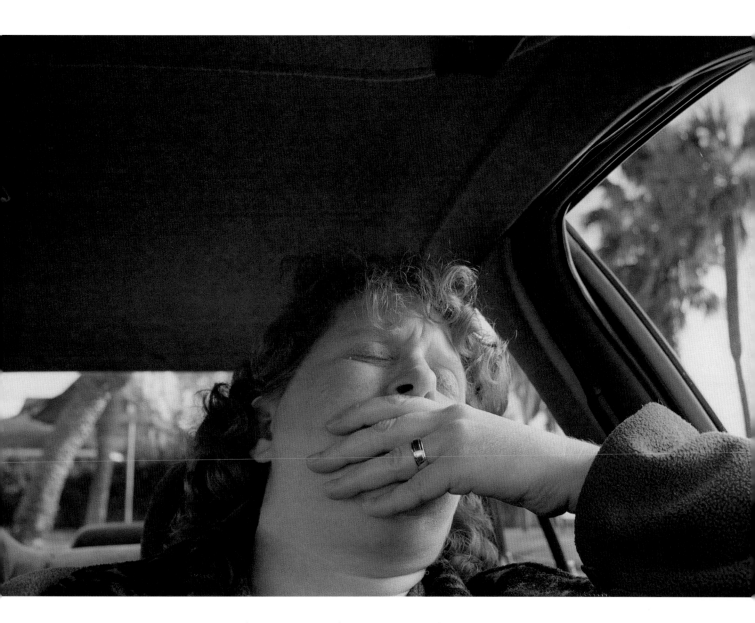

JANUARY 26, 2000 *Disappointment washed over me as I sat alone in my car to absorb the grave revelation that cancer had spread to my lungs and liver. I'd left my doctor's office not long ago, with shock giving way to the realization that I might die soon. I muffled sobs while looking out on the St. Johns River and wondered how long I might survive this latest setback.*

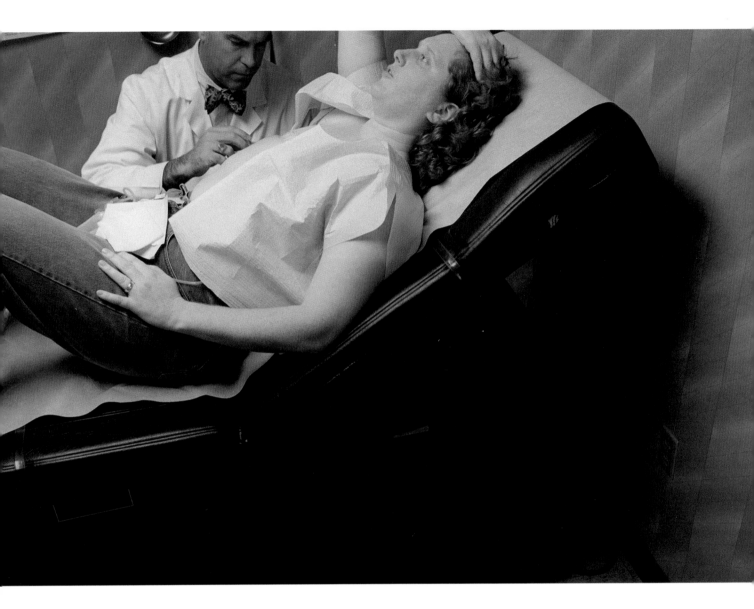

JANUARY 28, 2000 *To my relief, Jeff Edwards, my surgeon, finally removed the drains 18 days after my bilateral mastectomy. They had really started to irritate my skin, which left me pretty cranky. Mainly I looked forward to healing and beginning more chemotherapy soon to shrink the recent metastasis to my lungs and liver. I hoped the chemo would make me feel better.*

MAY 2, 2000

My sister, a physical therapist, worked me into her schedule after seeing the chronic swelling in my chest and left armpit following numerous surgeries and radiation therapy. This therapy relaxed me, relieved some of my symptoms and offered me a more active role in my recovery.

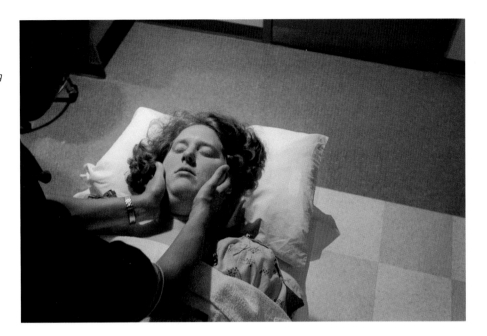

AUGUST 28, 2000

Already I had learned the results of my most recent CT scan weren't so encouraging. While I waited for my oncologist to discuss the situation, I had a few moments to mull over my concerns and to collect my thoughts. Feeling somewhat worse in recent weeks, I'm not altogether surprised that my cancer is progressing. Mainly, I want to know how much the disease has spread and what treatment we'll pursue next as my options dwindle.

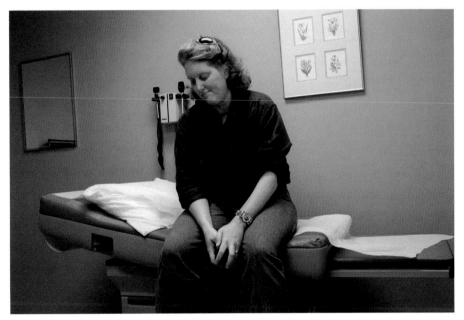

DECEMBER 5, 2000, *Florida Times-Union*

Published posthumously in the final installment of the four-part series:
"The unbelievable support I have received has touched me so very deeply. I could not have imagined the enormous impact I've had on others' lives. How does one know the life reach of just one life?"

Dave Kendall
Sports Illustrated/Press Association

Aston Villa's Gareth
Southgate gets to a high
ball during the English
Premiership soccer match
against Everton at Goodison
Park in Liverpool, England.
Aston Villa won, 1-0.

Alan Hawes
The Post and Courier/Charleston, SC

Football players Corey White, left, and Aaron Capps avoid the blazing summer heat at The Citadel's Johnson Hagood Stadium in Charleston, SC, as other players give interviews during media day.

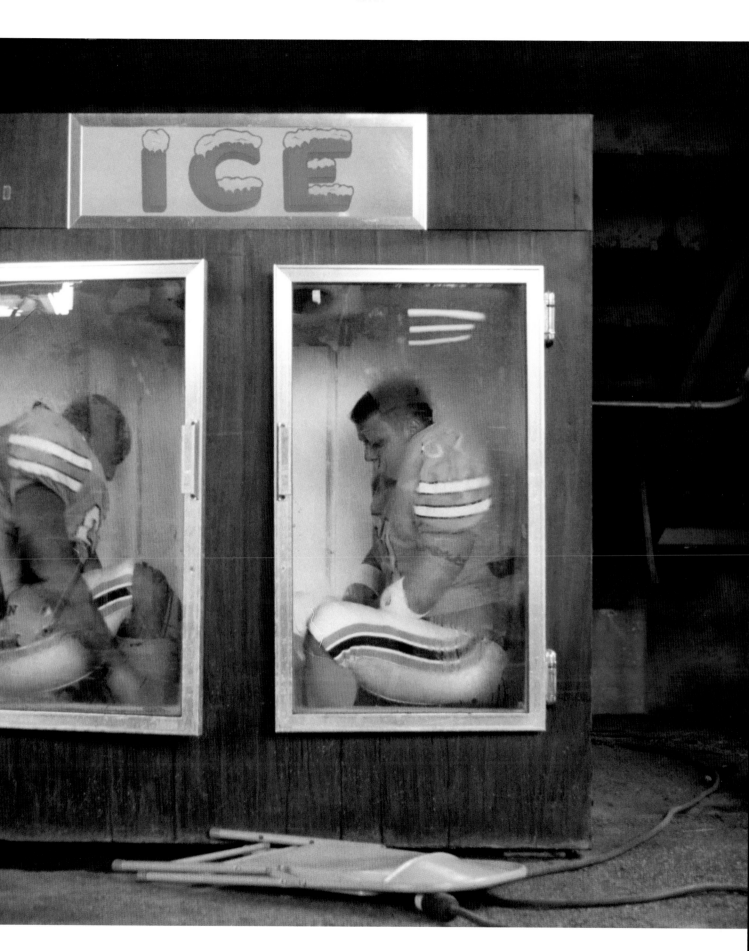

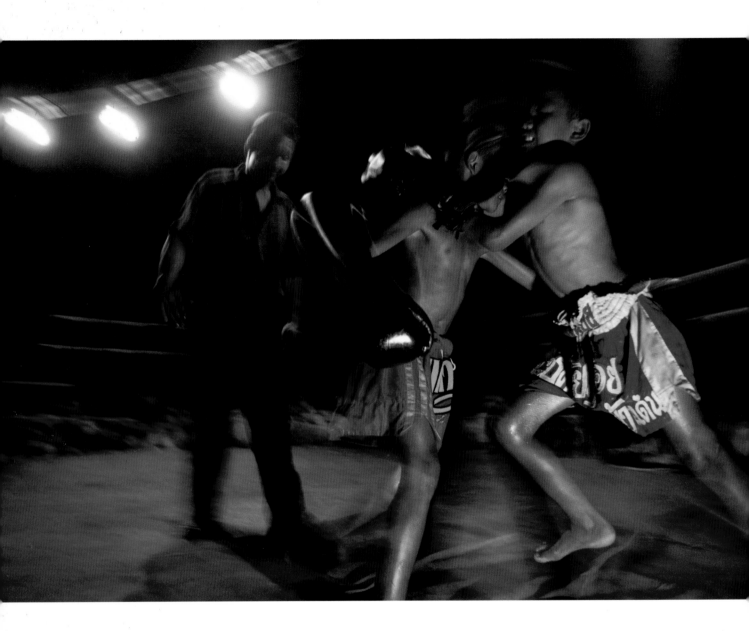

Adam Nadel
NRC Z / Freelance

Muay Thai boxing camps train tens of thousands of Thais, some as young as 5 or 6, to compete in the ring. Muay Thai is a full-contact competitive sport, said to be among the most lethal of the martial arts. "No one fights Mauy Thai because they enjoy it," reports manager Prasan Sudangnoi. "They do it to make money to support their family." The most successful can make more in one fight than a family makes in a year.

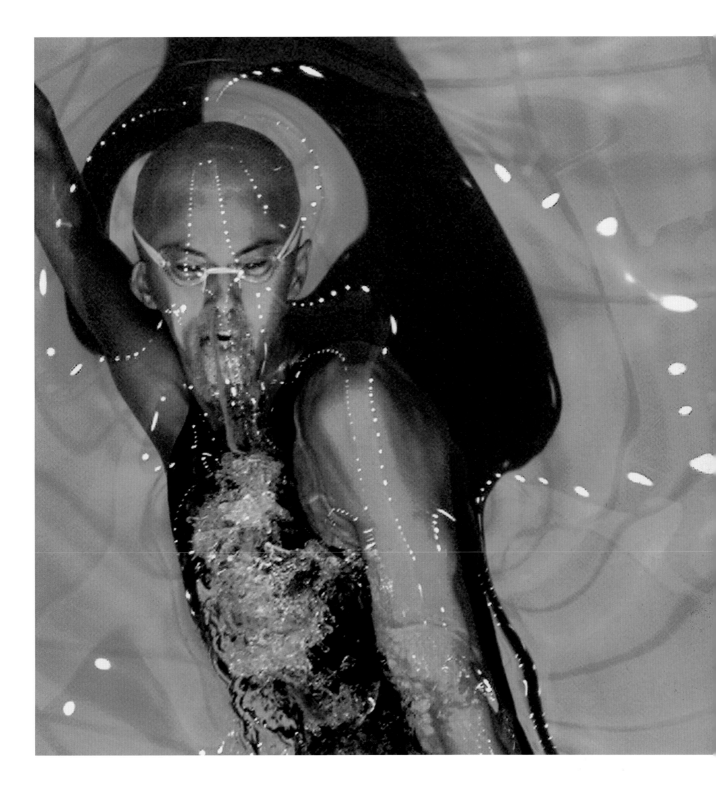

Julian Gonzalez
Detroit Free Press

Chris Dejong of Western Michigan University acquires a halo effect from the distortion of a lane
marker on the pool bottom during a 100-meter preliminary heat at the U.S. Olympic Swim Trials.

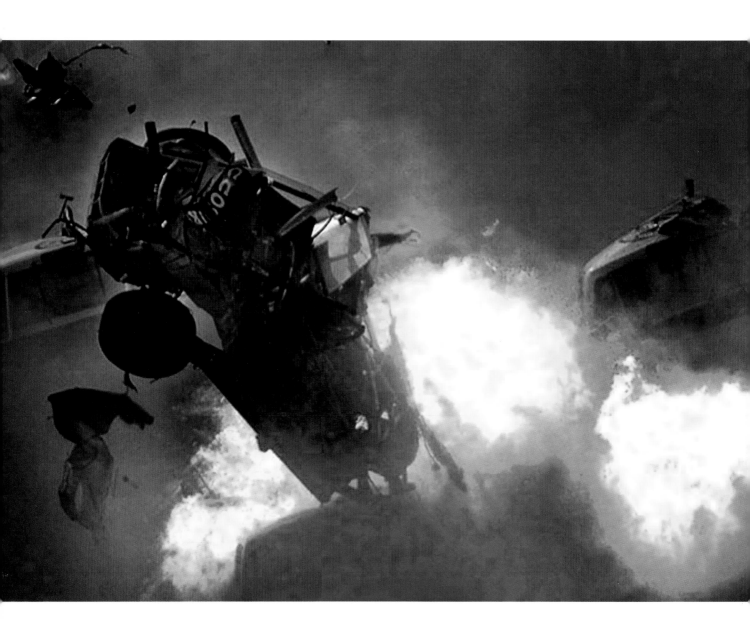

Phil Coale
Tallahassee Democrat

Geoffrey Bodine's arm reaches into the flames as his Line-X Ford comes apart during an accident in the first running of the Daytona 250 Craftsman Truck Series race at the Daytona International Speedway in Florida.

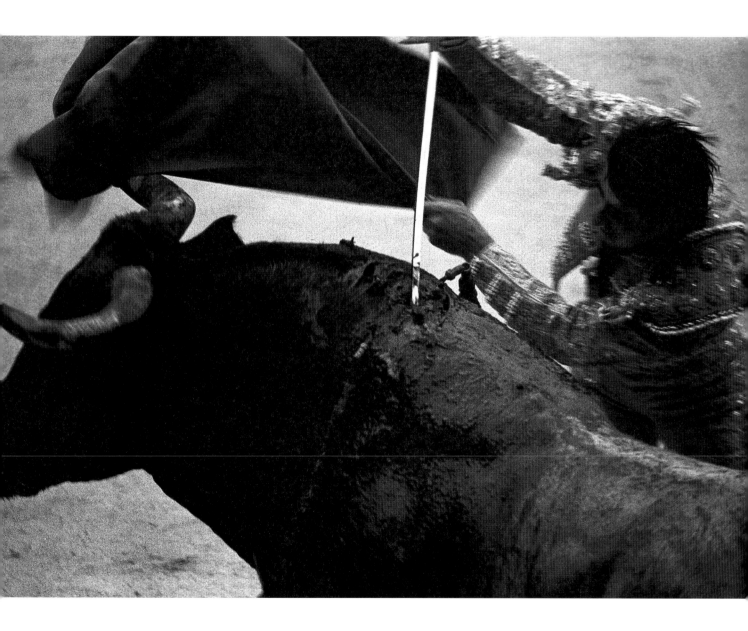

John Kimmich-Javier
University of Iowa / Freelance

A matador gives the fatal thrust in a manuever called the *estocada* during the *faena*, the final 10 minutes of a bullfight, in Pamplona, Spain.

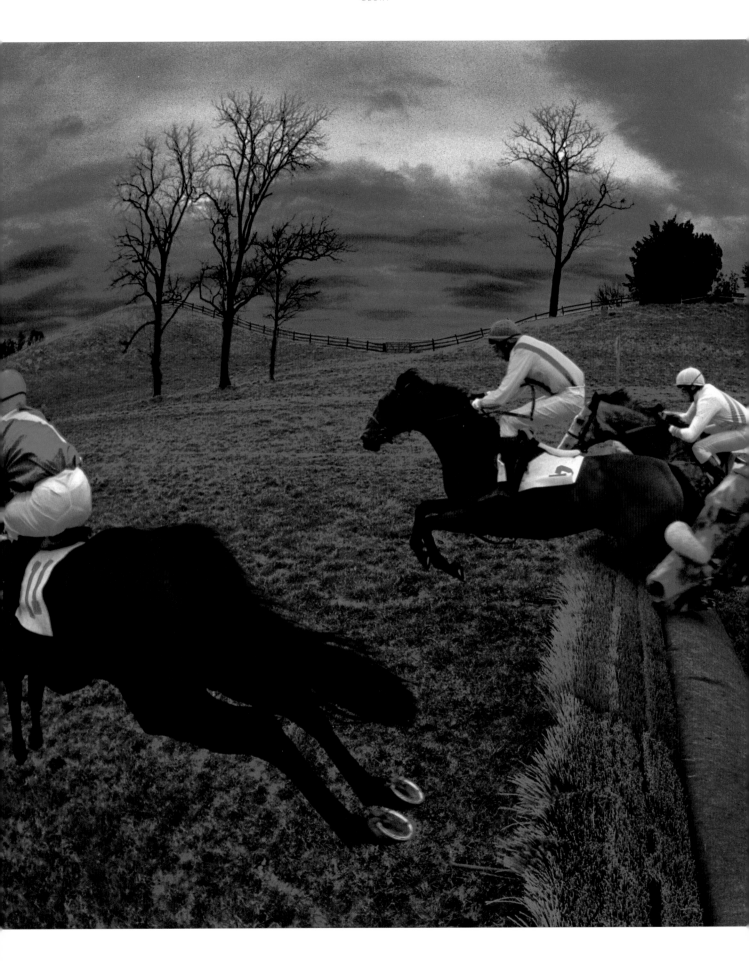

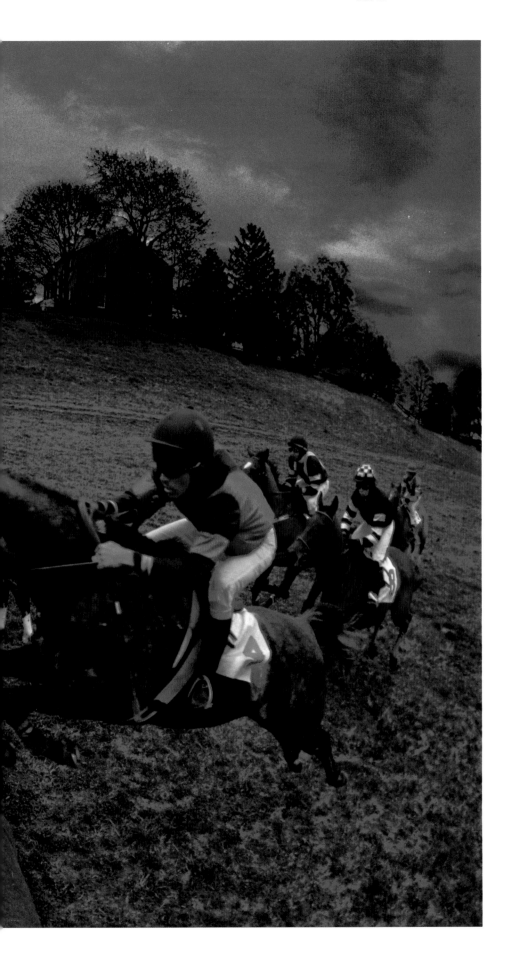

Karl Merton Ferron
The Baltimore Sun

Storm clouds gather overhead as jockeys clear a Camden fence in the Raberg Maiden, a two-mile steeplechase, at the Marlborough Hunt Races at Roedown in southern Maryland. Michael Traurig, in foreground, on *Prior Approval*, finished third.

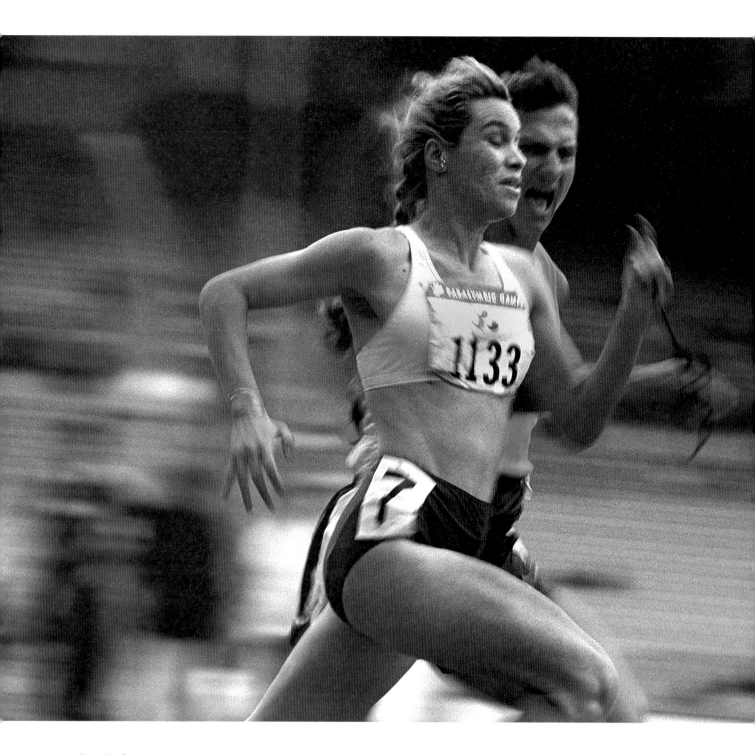

Scott Barbour
Allsport

PARALYMPIC GAMES Above: A guide runner shouts encouragement during the womens' 400-meter race for blind athletes at the Paralympic Games. Top right: Cyclists stand for the national anthem after receiving their medals. Center right: Troy Sachs of Australia is pinned between two opponents during a wheelchair basketball game. Bottom right: John Cronis of Ireland celebrates his shot during the Boccia. Due to his disability, Cronin can only play the ball with the use of a special instrument attached to his head.

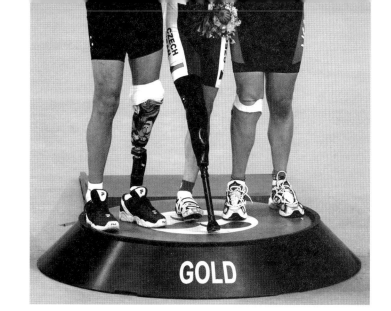

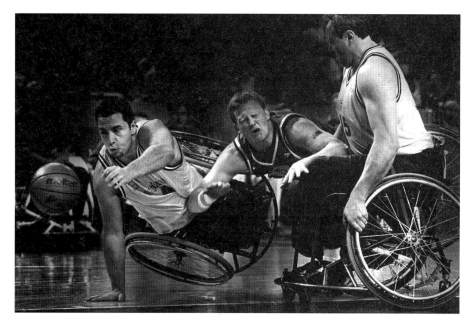

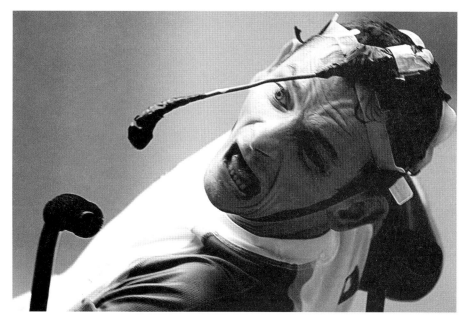

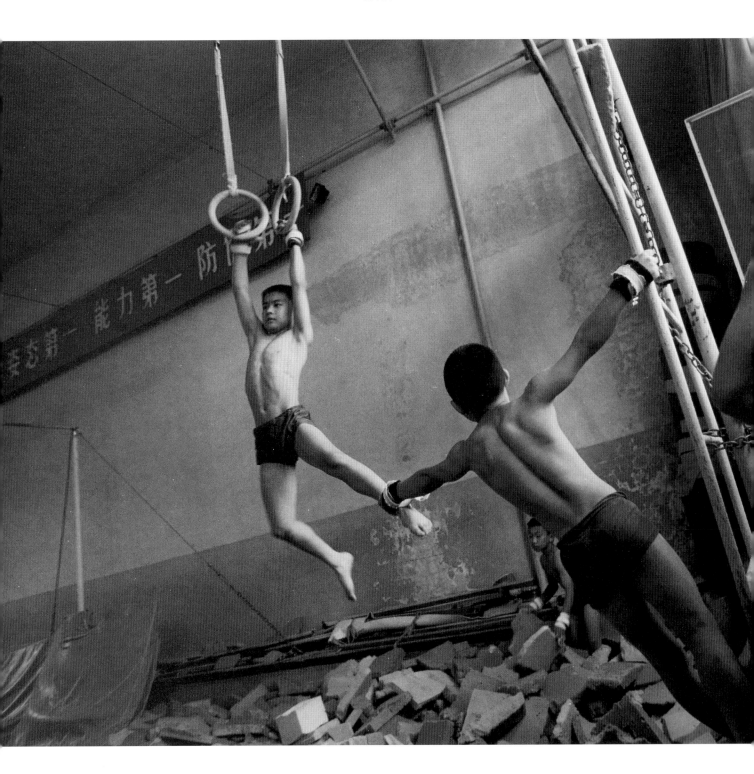

John Lee
Chicago Tribune

LITTLE MEN The Shi-Cha-Hai Sports School, in Beijing's Forbidden City, is a proven factory for Olympic gymnasts. Tapped before they can read, the boys spend five days a week training. The winners, the coaches promise, will live comfortable lives with the fate of their family secured. Above: Liu Yue steadies Li Xi as they work on their rings routine. Opposite: Gymnasts wait for their turn to work on their jumping skills.

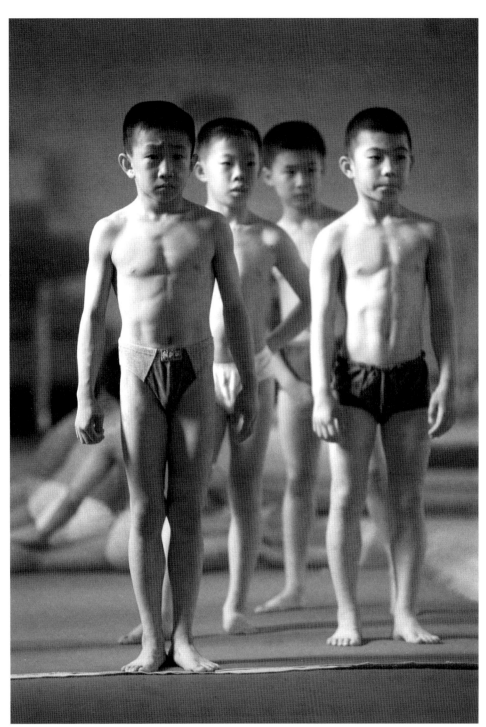

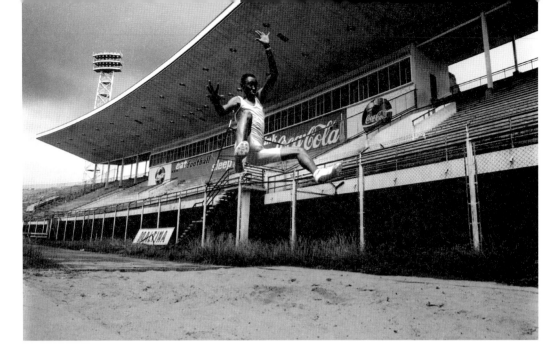

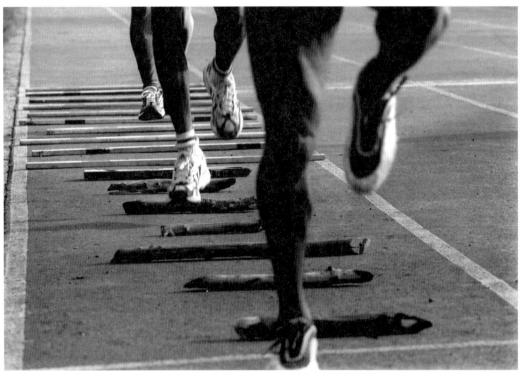

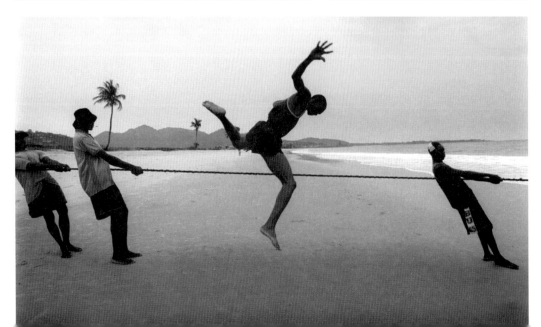

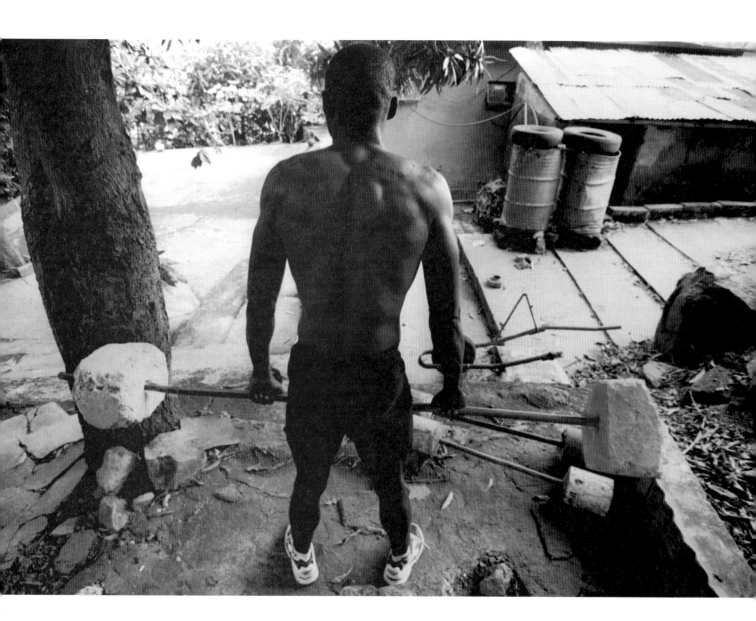

Seamus Murphy
SABA

LEAP OF FAITH: SIERRA LEONE'S OLYMPIC HOPEFULS Fighting in the West African country of Sierra Leone has raged for nine years. The only real chance for a Sierra Leonean athlete to thrive is to leave the country. "We all want to go to America," says Frank Turay, 24, captain of the relay team. "We all want to have the opportunity to do our best, and the chances are too slim in our own country." Above: Turay, 24, lifts weights made from stones and cement, near his home in Lumley. Top left: Quintin Hindwejivah Saliakonneh, 17, works on his long jump at the National Stadium in Freetown. Center left: Sticks are used to train rhythm. Bottom left: On Lumley beach, Saliakonneh practices his high jump by leaping over the rope of fishermen pulling in their nets.

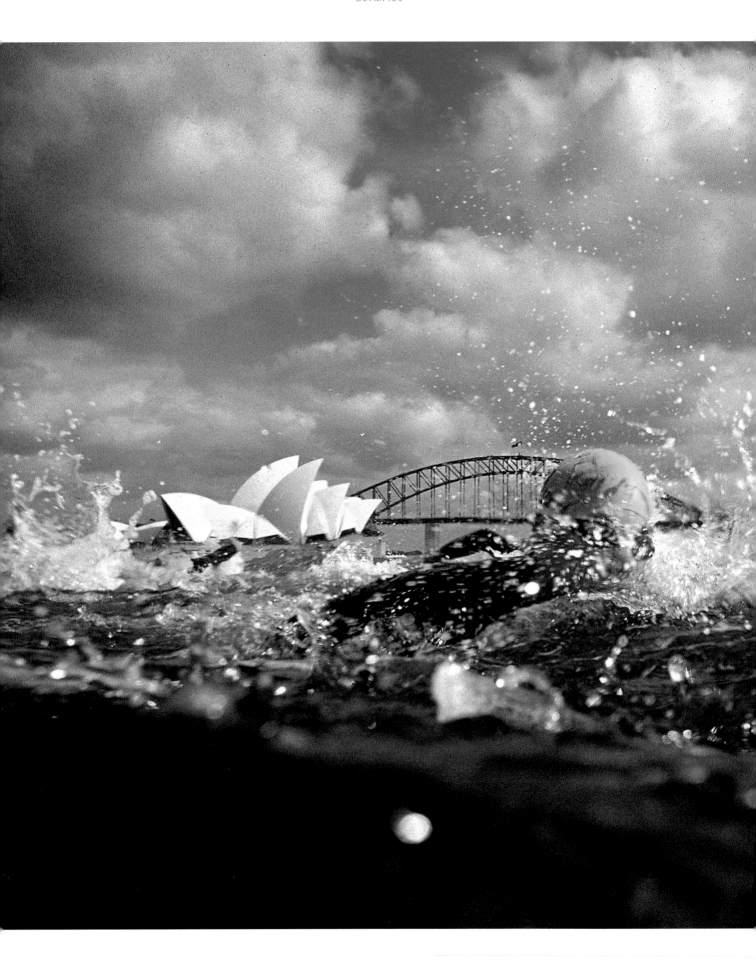

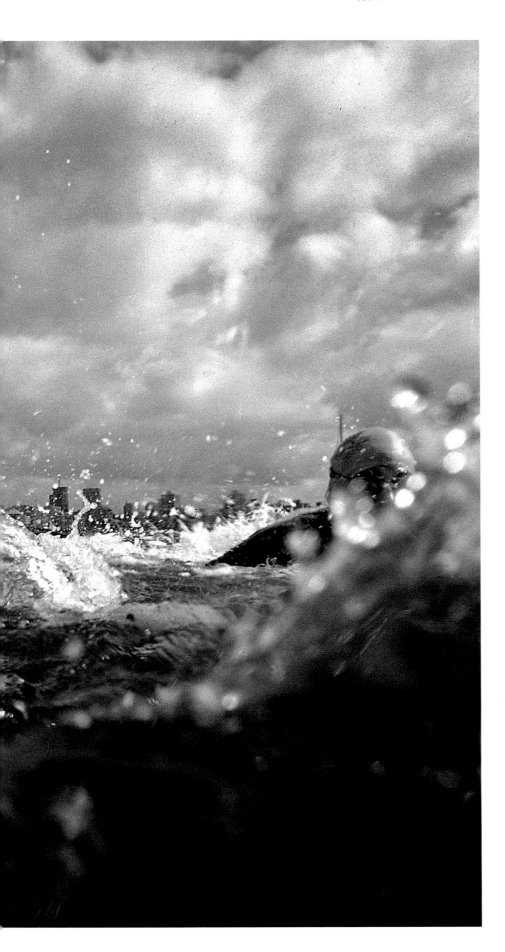

The Olympics

Adam Pretty
Allsport

Competitors fight
challenging conditions in the
womens' triathlon swim in
Sydney Harbour.

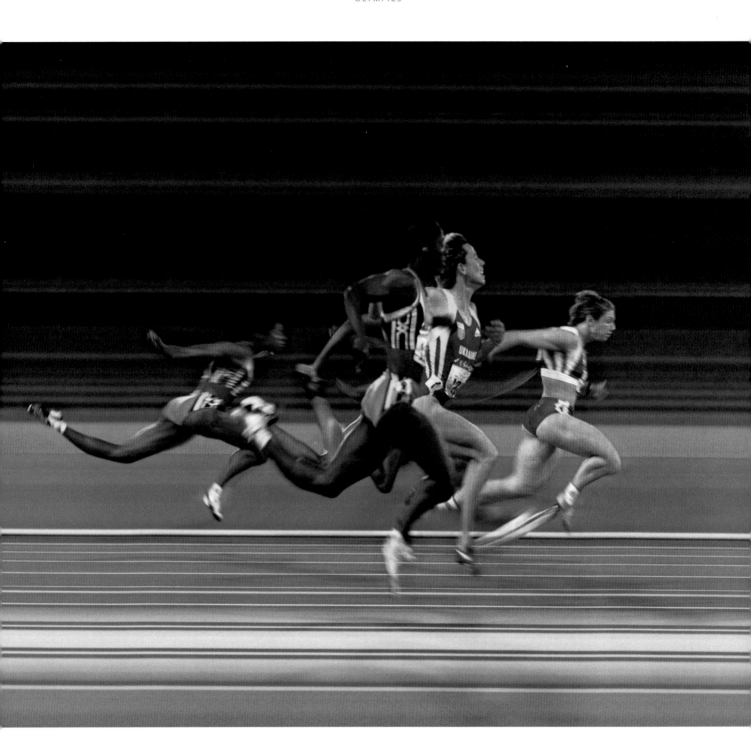

Bill Frakes
Sports Illustrated

U.S. runner Marion Jones, 25, wins the 100-meter dash by 0.37 seconds, the largest margin since the 1952 Olympic
Games. Jones finished eight meters ahead of Ekaterini Thanou of Greece to win with a time of 10.75 seconds.

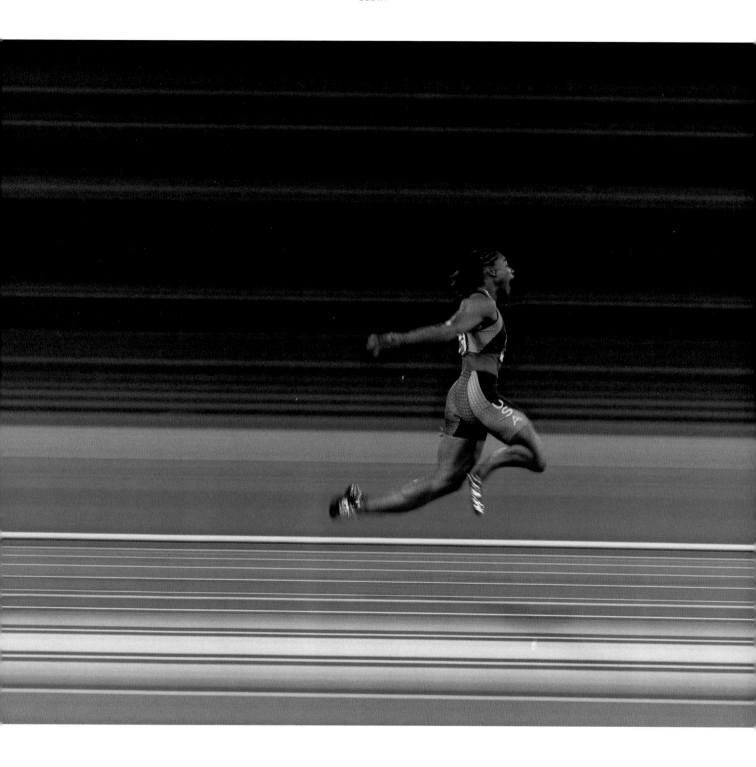

Scott Barbour
Allsport

Cuban players celebrate after winning the gold medal in the womens' volleyball final.

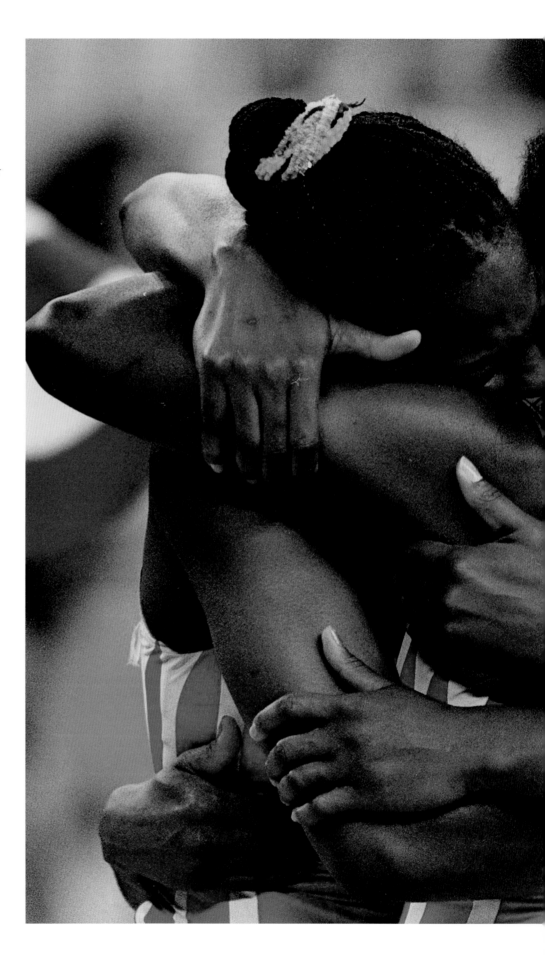

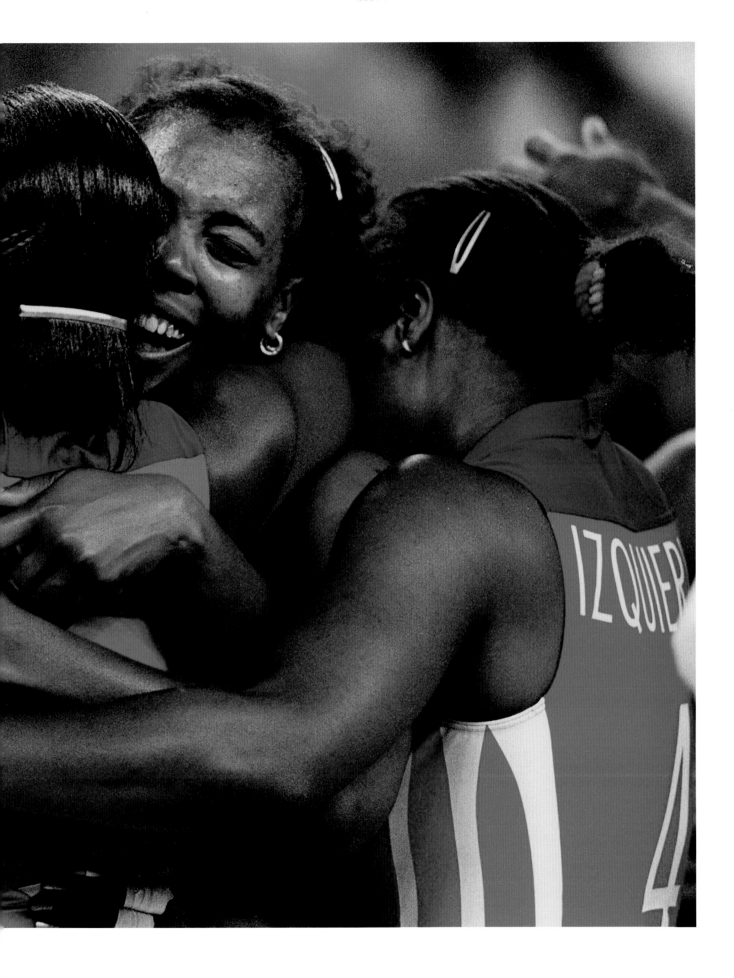

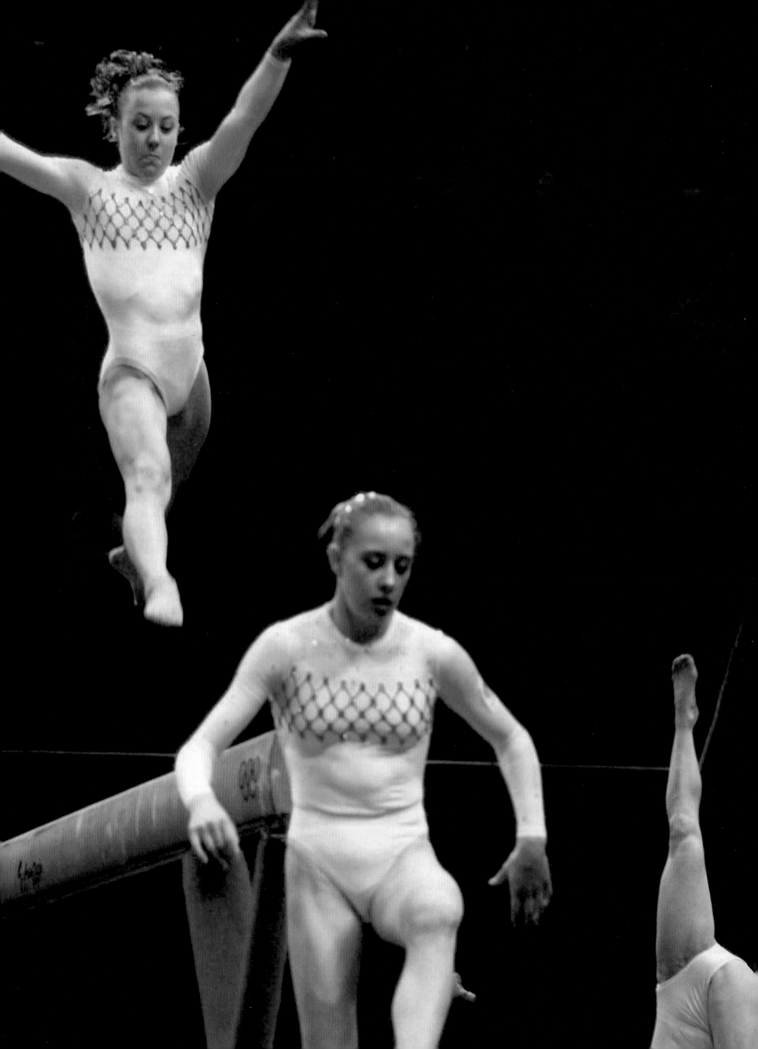

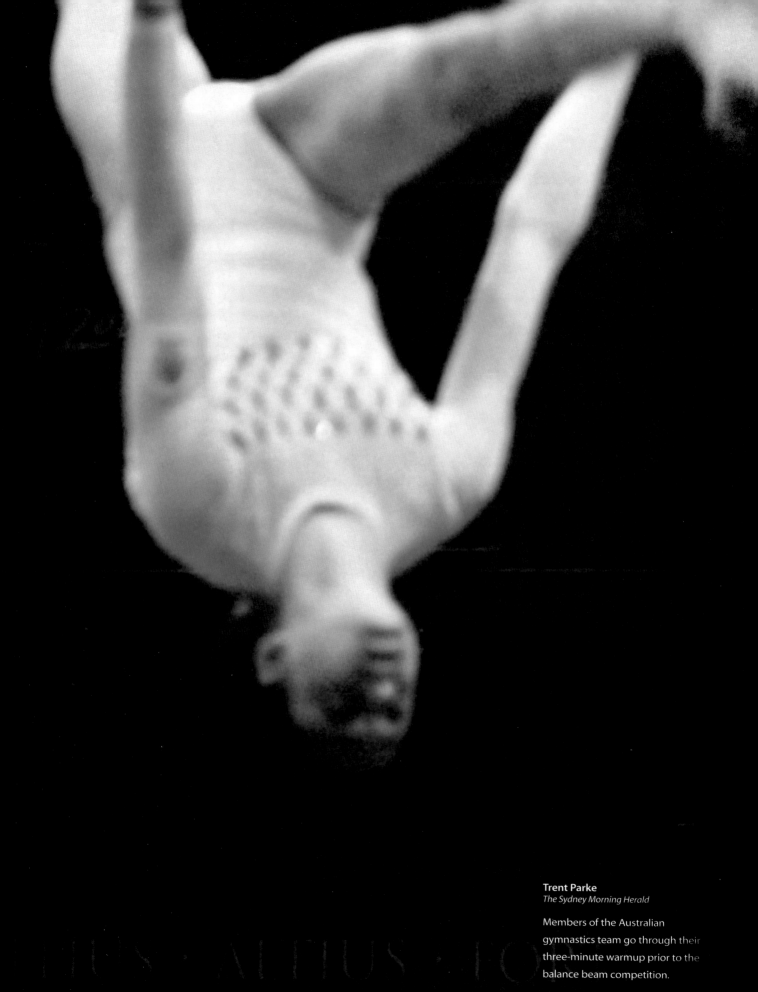

Trent Parke
The Sydney Morning Herald

Members of the Australian gymnastics team go through their three-minute warmup prior to the balance beam competition.

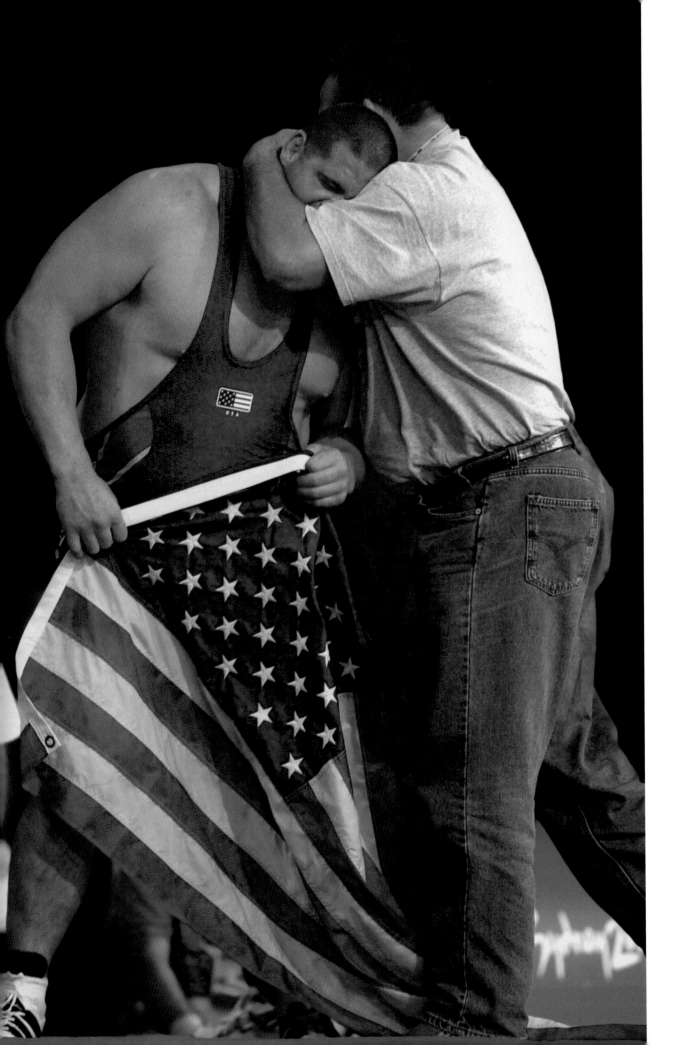

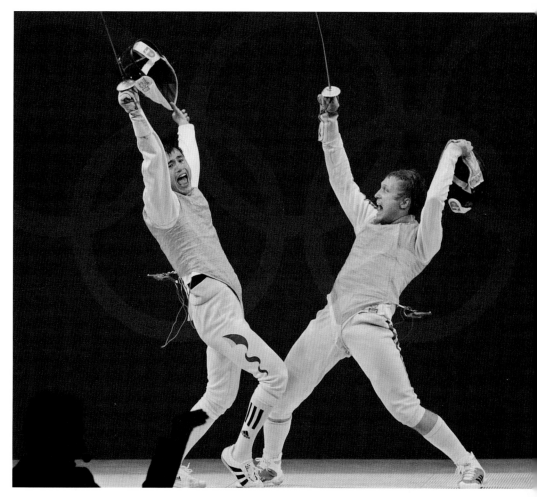

Jacques Demarthon
Agence France-Presse

France's Jean-Noel Ferrari, right, and China's Haibin Wang celebrate simultaneously, each thinking he scored the winning point during the men's team foil in Sydney. Judges awarded Ferrari the crucial point and the gold medal.

Craig Golding
The Sydney Morning Herald

Min Sung of Korea gives thanks after winning his heat in the men's 100-meter backstroke at the Sydney International Aquatic Centre. However, his time was not good enough to take him to the semifinals.

Mark Reis
Colorado Springs Gazette

Opposite: U.S. Greco-Roman wrestler Rulon Gardner is embraced by his father after his gold medal upset of Russia's Alexandre Kareline.

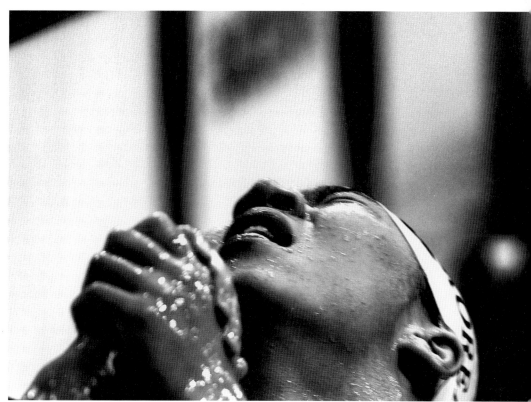

Home Away From Home

The majority of Chicago's day laborers are illegal immigrants who must work in temporary employment where they earn low wages and have few rights. Each morning at the corner of Lawrence and Springfield on Chicago's northwest side, immigrant laborers from Mexico wait for contractors to arrive and offer them jobs for the day. Wages run from five to 12 dollars an hour. The workers are often harassed by the police for loitering and at times are arrested.

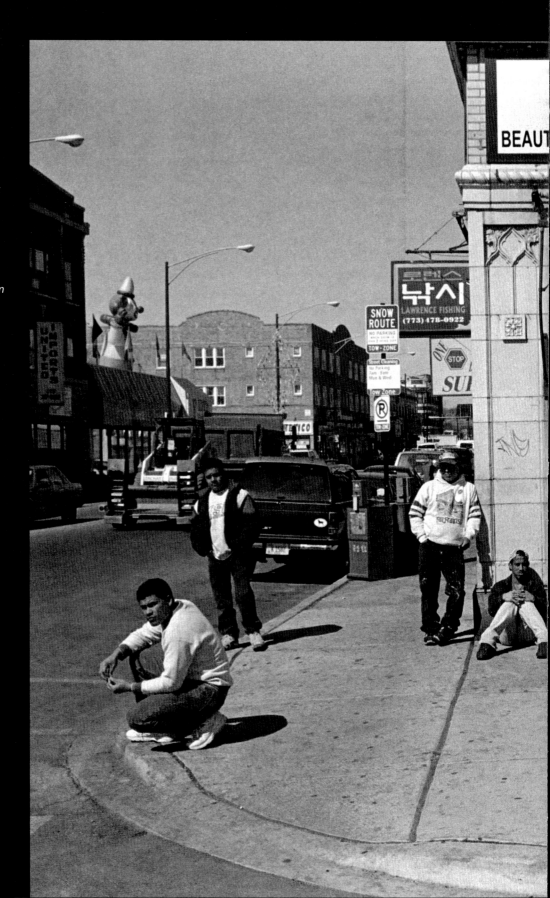

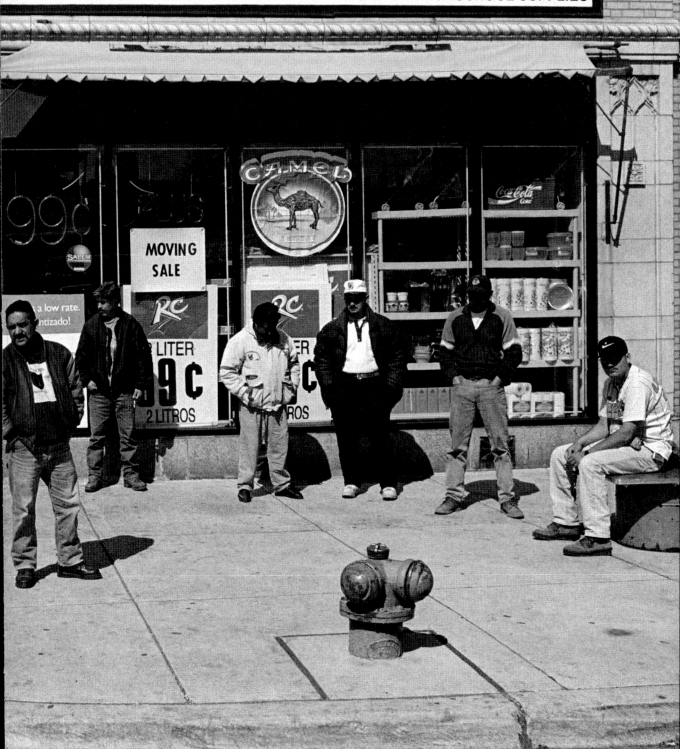

■ Chicago has long been a mecca for immigrants from around the world, and in recent years it has seen a dramatic increase of Latin American and Mexican immigrants. Mexico's economic crash of 1994 increased already widespread poverty, forcing many Mexicans to make the arduous journey across the United States border and into the ranks of the day-labor work force.

The Fuji Community Awareness Award recognizes Jon Lowenstein for his CITY 2000 project focusing on the community of immigrant day laborers in Chicago. "By being on the street, at the work site, and in their homes," Lowenstein wrote to introduce his entry, "my goal is to humanize this situation" and to document the role of low-wage earners often overlooked in the U.S. economy.

Lowenstein said he wanted "to show what Mexican life was like" here in America for the new immigrants by examining the community, the regard they show one another, and their sense of family.

Growing up in Boston as a first-generation American, Lowenstein witnessed how immigrants adapt to a new society. "Immigrant issues hit close to home," said Lowenstein, whose father emigrated from Germany. "I've always been interested in immigrants, to see how people assimilate into the U.S."

According to the 2000 Census, 12.3 percent of Illinois' population and 26 percent of Chicago's—more than 750,000 people—are of Hispanic origin.

Few options exist for illegal immigrants, so increasing numbers work as day laborers in factories, restaurants, or construction. As temporary employees, they receive low wages, no health insurance, no sick pay, and no benefits, even though they often work beside higher paid, permanent employees. Day laborers are often charged for transportation to work sites—although the practice is illegal—and must pay for their checks to be cashed. Sometimes they don't get paid at all. Estimates show that by 2010, half the Hispanic immigrant population will be working in day labor.

"Your eyes are closed if you live in Chicago and don't know about these people," said Lowenstein, who is fluent in Spanish. Mexico is never forgotten for these new Chicagoans, and particularly for first-generation adults the homeland shines bright in their memories. Lowenstein continues to follow one family, Anselmo Nino and his wife, Remidios, who use their earnings to buy cattle and land in Mexico. "They hope to move back one day," he said.

■ *Above right: Day laborers Jose Luis Olivarez, left, Umberto Marin and Jorge Estudillo negotiate their fee through the window of a contractor's van. Most often, the workers get between $40 and $100 a day. Right: At the end of a long day, brick stackers relax. These workers earn $13 for every 540 bricks stacked.*

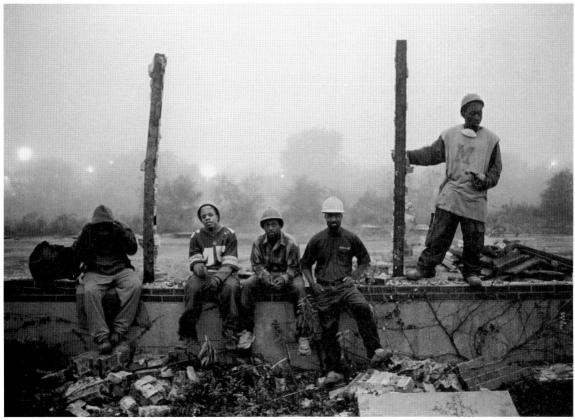

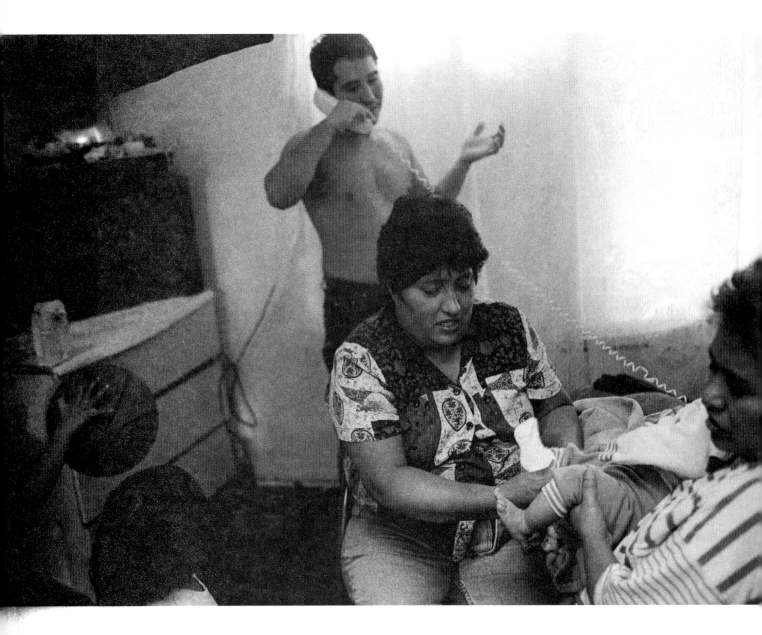

■ *The household of Remidios Nino and her sister, Lupe Guzman, is in constant flux as family members continue to arrive throughout the year. Two people sleep in the living room, two in the front bedroom, one on the couch in the kitchen and three in the back bedroom.*

■ Day laborer Antonio Velazquez files a complaint with the Chicago Police after being physically expelled from the building in which he and Eliceo Caballeros Zamorra had just completed a painting job. When the owner of the building refused to pay the contractor, the contractor in turn refused to pay the workers.

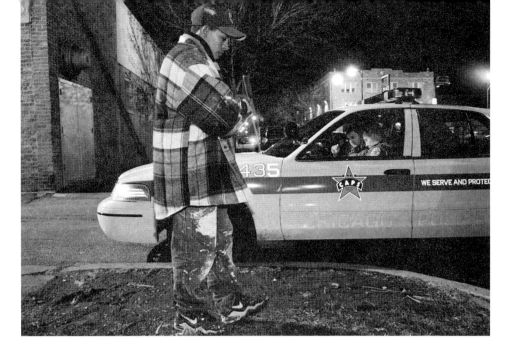

■ Working long hours at a factory and caring for a household takes its toll on Remedios Nino. Here she counts out $4,500 to send to a "coyote" to pay for three family members' passage into the United States.

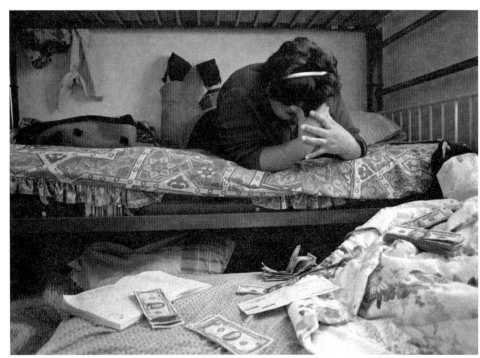

■ The Nino family waits in the car outside another family member's apartment on the way to Aldi's supermarket. Usually the Ninos prefer small, local markets, but on this day Anselmo decided to venture farther west and try Aldi's, well-known for its low prices.

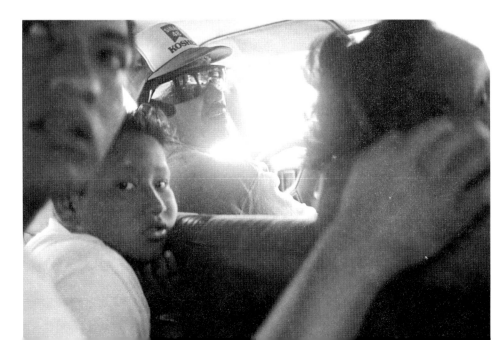

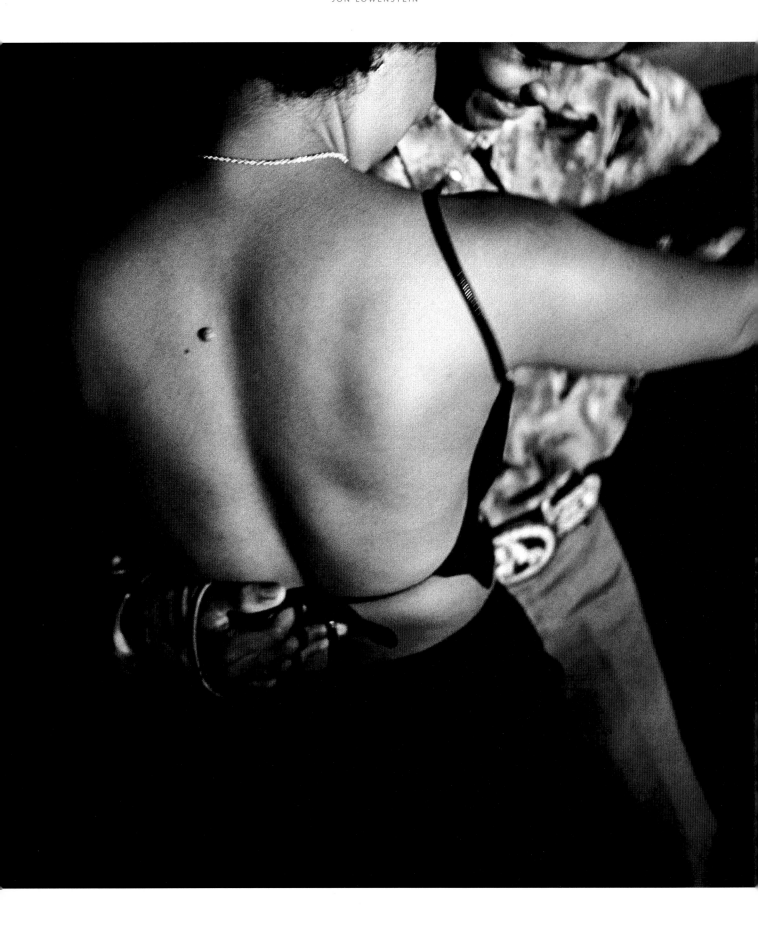

■ *Left: Late-night dancing at Anselmo Nino's sister's home. Top: At 3 a.m. on Christmas, Anselmo argues with his nephew about issues ranging from drugs to spousal abuse. Above: Lupe Guzman and her family wait at Midway Airport for her brother and two other family members to arrive from Acapulco, Mexico.*

In a Dark Room

DAVID HANDSCHUH
President, National Press Photographers Association

OUT!
OUT!
OUT!
OUT!
OUT!
OUT!
IN!

■ Those were the shouts heard this winter during judging of the Pictures of the Year International contest in a darkened room at the University of Missouri. What is it about an image that stops a judge? We only need to look at the pages of this book to see the energy, the spark and the excitement that made these images rise to the top.

POYi is more than a collection of images—it is a barometer of the health and vitality of press photography around the world. "The Best of Photojournalism 2001" is an appreciation and celebration of this work.

Both the contest and this book acknowledge the women and men behind the lenses. We take the technology of cameras, film and pixels, mix in a desire to inform and motivate—add a large dose of passion—and create photographs for magazines, newspapers and, increasingly, the Internet.

But it shouldn't take a contest to show the value of the photographs that we see every day in our publications. Photojournalists document wisdom and ignorance, glory and defeat, celebration and mourning. A photograph on the page goes straight from the eyes to the heart.

We can't forget the image of John F. Kennedy Jr. saluting at his father's funeral, the award-winning picture of a lone man in front of a tank in Tiananmen Square, or the photograph of a lifeless child, tenderly carried by a firefighter through the smoking rubble of an Oklahoma building. Some of our most prized possessions are our family photographs. These images have amazing power, hold historical significance and have become etched in our minds and hearts. They help us remember the history, the day, the moment in time.

We congratulate the winners displayed in this book. Scott Strazzante, The Newspaper Photographer of the Year, and Jon Lowenstein, The Magazine Photographer of the Year and Fuji Community Awareness Award winner, both captured the essence of Chicago. And this year the Canon Photo Essay Award had a special poignancy: It was given posthumously to Tara McParland for images of her fight against the disease that claimed her young life.

Their moments in time have competed against, and have been chosen above, thousands of other remarkable milliseconds. But every image submitted—indeed, every image captured last year—is a winner, and we'd really like to say "thank you" to the photographers who document our lives every day of the year, one split second at a time.

The Pictures of the Year International competition, sponsored by the National Press Photographers Association and the University of Missouri, celebrates photojournalism and photographers. We look forward to a lasting relationship, where we can nurture young, creative visions, support photographers, showcase the best of photojournalism and continue to prove that this art and craft is alive and well—and clicking.

THE BORNEAN KATYDID HAS GENETICALLY EVOLVED TO ELUDE PREDATORS, PREY, AND AVERAGE PHOTOGRAPHERS.

ARE YOU READY?

The camera:
The N90ˢs.
Fast and accurate
autofocus performance.

The lens:
300mm f/2.8 AF-S.
Superb image clarity.

The system
accessory:
PK13
Extension Ring.

10 system cameras
Over 60 lenses
8 Speedlights
Make history.

Nikon
WE TAKE THE WORLD'S
GREATEST PICTURES®

Win. Place. Show.

DAVID REES
Director, Pictures of the Year International

■ Pictures of the Year International recognizes the photographs that best illuminate the human condition—photographs that show what unites us as well as photographs that illustrate the conflicts between us. The awards set a standard of excellence that permeates all of journalism. We *expect* the winning images to be newsworthy and visually powerful. To impress the judges, a photograph must have staying power. Still, sometimes you'd think that the contest is a horse race.

"Yeah, second place; you're the first loser across the line," said one of this year's judges, relating an old conversaton. She had been pleased to win a second-place award. Her co-worker thought it represented failure.

Why are the judges asked to rank the winning images? What kind of impossible task is this? Like King Solomon, we can't divide the baby. Yet we seek clarity in a world of subjectivity.

Many of you have viewed the judging in person and know what I mean when I say that sometimes we are transported back to the Lincoln-Douglas debates—where one judge tries to convince the others. Sometimes a picture argued for is one that had been voted out in the first round. But now, plucked from the wall of rejects, it is brought back into consideration. Judges are encouraged to reach a consensus. There is lots of discussion. And lots of looking—long looking. That is one reason POYi judging takes thirteen 12-hour days.

And then a vote is called. Is it the words that sway or something in the photo? Which picture can be seen again and again—always fresh with each viewing? In many categories there is unanimity. A truly excellent picture almost seems to push itself forward.

A few years ago in the College Photographer of the Year competition, I worked with a graduate student, Kelley McCall, who wanted to see if a "citizen panel" would pick the same pictures as a panel of professional photographers and editors. It turned out that four mid-Missouri residents with no particular photojournalism experience picked the same set of pictures as Larry Towell, John Trotter, Kenneth Walker and Pauline Lubens. Their ranking order was only slightly different. Remarkable, we thought.

The goals of POYi reflect the goals of working photographers who try to shine a light on the ugliness of injustice or who hope to elevate the human spirit by showing us beauty. We want others to see, to understand, and then be moved to action. We want to make a difference.

It's true that the first-place awards are special—that they give a photographer star status, if only for a year—and there are prizes of money and material goods.

But we all know that the real prizes are those images that endure—the ones that burn into our consciousness. POYi is one way to have extraordinary work validated and to have those images distributed widely.

If POYi is indeed like a horse race, many pictures *might* win. Would the results change on a different day, or if a category were decided after lunch instead of before? Perhaps. After all, in a close field of fast horses—or superb pictures—it's often a photo finish.

Certainly it matters who wins. But for me, the only "losers" are those who do not try to make pictures that challenge us, and, in a way, those who choose not to present their pictures for consideration of an award. The part that each of us has control over is running the race—doing our best work and then pushing it out on the track one more time.

This is how we make a difference.

58th POYi Judges

CAMPBELL GOLON JAMES MOSS MUSI PEATTIE REED SARTORE SHELL SOMMERDORF WINSLOW ZAVOINA

Cole Campbell
Fellow, Kettering Foundation

■ Campbell is a fellow at the Kettering Foundation, which supports research and forums devoted to the study of democracy. He spent most of 2000 as a Poynter Fellow. He has served as editor in chief of the *St. Louis Post-Dispatch, The Virginian-Pilot, The Daily Tar Heel* and *Tar Heel: The Magazine of North Carolina.* He was a reporter at the *Chapel Hill (NC) News-paper* and a reporter and editor at *The News & Observer* and the *Greensboro News & Record.* He has been a teacher, a writing coach, a Pulitzer juror, a freelance writer, the editor of several books and the author of another. He graduated with an A.B. in English from the University of North Carolina at Chapel Hill. He was a John S. Knight Fellow at Stanford and is now study-ing for a Ph.D. through The Union Institute in Cincinnati.

MaryAnne Golon
Picture editor, *TIME*

■ Golon recently rejoined *TIME* as a picture editor. Previously, she was director of photography at *U.S. News & World Report,* where she helped the magazine win numerous awards for its use of photography. In addition, Golon has judged two previ-ous Pictures of the Year International competitions and has been a jury member for the 1998-1999 Alfred Eisenstaedt Awards and the Visa Pour L'Image photojournalsim festival in Perpignan, France. During the Gulf War, Golon served as the on-site photography editor for *TIME* and *LIFE* magazines, and she coordinated the photographic coverage of the Olympic Games from 1984 to 1996. Golon, who is on the board of directors for the Eddie Adams Workshop, graduated with honors from the University of Florida in 1983 and completed a fellowship at Duke University in 1990.

Terrence Antonio James
Publisher/Editor, *Souleyes*

■ James launched *Souleyes,* an online journal of documen-tary photography located at http://www.souleyes.com, with the mission of documenting communities of color. The site publishes photo essays, single images and works-in-progress, with a strong preference for photographers' per-sonal projects, and always with the goal of presenting new visions of diverse communities. *Souleyes* won an Award of Excellence in the 57th POY competition and has been a "site of the day" on Yahoo, britannica.com and usatoday.com, among others. Currently a staff photographer at the *Chicago Tribune,*

James previously worked at the *Bergen Record* in New Jersey. Before working at the *Record,* he was a photo intern at *Newsweek* and a freelance photographer in New York.

Bryan Moss
Photo coach, *St. Louis Post-Dispatch*

■ Moss has been a manager, a picture editor, a photography coach, a photographer, a multimedia producer, a teacher and a computer programmer. He's worked at 12 different newspa-pers in 34 years, including *The Courier-Journal* in Louisville, KY, *The Rocky Mountain News, The Los Angeles Times, The San Jose Mercury News* and *The San Francisco Chronicle.* At the *Courier-Journal,* he was on the photo staff that won a Pulitzer Prize in 1976 and he was the director of photography at *The Mercury News* when the whole newspaper staff was awarded a Pulitzer. He graduated from Indiana University in 1966 with a journal-ism degree. In 1997 he was a visiting professor at the University of Montana. In addition to serving as a faculty member of the Kalish Picture Editing Workshop, he and wife Mary Jo also run the White Cloud Workshop for photojournalists.

Vince Musi
Freelance photographer

■ Musi's work is regularly featured in the pages of *National Geographic* on subjects ranging from life under an active vol-cano to life along Route 66. His work has also been published in a variety of magazines and newspapers around the world. He has contributed to a number of books and recently com-pleted one on Asturias and Cantabria, two regions in the north of Spain. He is currently working on a book of photo-graphs from Route 66. He is a former *Pittsburgh Press* staff pho-tographer and a former intern at *The Troy Daily News, The Missoulian, The Palm Beach Post* and the *San Jose Mercury News.* He thanks them all for their patience. He has won numerous awards in both the newspaper and magazine divisions of the Pictures of the Year International competition.

Peggy Peattie
Photographer, *San Diego Union-Tribune*

■ Peattie joined the *Union-Tribune* in 1998. She spent two years at Ohio University on a Knight Journalism Scholarship, teaching and earning a master's degree in visual communica-tion. In 1997, she won the first professional Alexia Foundation Grant for World Peace and Cultural Understanding. She spent three years at *The State* in Columbia, SC; one year at *The Daily Breeze* in Torrance, CA, and five years at *The Long Beach Press-*

So there you go.
Out again on a hike, a bike,
an around-the-world point
and shoot tour. Or maybe just
another day as a photojournalist—
with the whole planet as your office.
Searching for just the shot.
The one that supports your story.
Or tells it for you.

Go there.

Nothing helps you—and your camera
equipment—get there like Lowepro. Since
1972, we've been making camera bags of
such exquisite design and engineering that
pros and hobbyists alike take us into the
far corners of the world (and also down to
the neighborhood park) with unshakable
confidence. So when you're shooting for
the best, take the best along with you.

Lowepro. *We'll help take you places.*

Lowepro

Telegram. She was named the Greater LA Press Photographer of the Year five years in a row, and has twice been the California POY runner-up. She has also won several awards in the NPPA's POY contest. In addition, she has taught at two International Photojournalism Workshops and was a speaker for the NPPA Flying Short Course in 1992.

Rita Reed
Photographer, *Minneapolis Star Tribune*

■ Reed has been with the *Minneapolis Star Tribune* for 14 years. She began her career at *The Gazette* in Cedar Rapids, IA, after earning a graduate degree from the Missouri School of Journalism in 1984. She was the 1993 recipient of the Nikon Sabbatical Grant, with which she continued her photography of gay and lesbian teenagers, initially undertaken for the *Star Tribune.* The resulting project was published in 1997 as the book "Growing Up Gay." Reed has been named Minnesota Photographer of the Year three times and Iowa Photographer of the Year once. In 1990, The World Press Photo Association exhibited her photographs of the drug war in South America. She frequently serves on the Missouri Photo Workshop faculty. Reed is currently on leave from the *Star Tribune* for a year while serving as a visiting associate professor of photojournalism at the Missouri School of Journalism.

Joel Sartore
Freelance, *National Geographic*

■ Sartore graduated from the University of Nebraska in 1985 with a degree in journalism. He then became a photographer for *The Wichita Eagle* before beginning his career with *National Geographic* in 1990. Since then, he has covered land-use issues and wildlife extensively, completing 14 stories for the magazine. He recently wrote and photographed a book, "Nebraska: Under a Big Red Sky," and has also collaborated with noted author Douglas Chadwick on "The Company We Keep: America's Endangered Species." His work has also appeared in *Audubon, LIFE, Newsweek, Sports Illustrated, TIME* and numerous book projects, including the "Day in the Life" series. Sartore and his work have been featured on "National Geographic Explorer," NPR, the National Geographic Channel, and CBS's "This Morning." Recently, he helped found the Conservation Alliance of the Great Plains in Lincoln, NE.

Callie Shell
Freelance, former White House photographer

■ Shell was the official photographer for Vice President Al Gore during his entire term. Her work is that of a "photographic historian," documenting three political campaigns, one impeachment, numerous state dinners and roughly 50,000 handshakes. Her work from the White House has been published extensively around the world. She was part of the book project "The Way Home: Ending Homelessness in America;" an exhibit of the work was shown at the Corcoran Gallery of Art in Washington. She has also exhibited her work at the Silver Eye Center for Photography in Pittsburgh and at Visa Pour L'Image in Perpignan, France. Before coming to the White House, she was a staff photographer at *The Pittsburgh Press.* She has also worked for *USA Today* and the *Nashville Tennessean.* She graduated from the College of Charleston with a BA in political science.

Scott Sommerdorf
Director of photography, *San Francisco Chronicle*

■ Sommerdorf started as a photographer at *The San Francisco Chronicle* in 1987, then transitioned into picture editing in 1991. He was promoted to his current position in 1994. A native of Minneapolis, Sommerdorf later moved to Sacramento, CA, and attended Sacramento City College, where he served as photo editor, and later as editor, of the weekly student newspaper. He later studied at the University of California at Davis. While still a student there, he was hired as a photographer at the *Sacramento Union.* He spent nine years there before coming to *The Chronicle.* Sommerdorf has received numerous awards from the NPPA, and has also been honored by the California Press Photographers Association and the San Francisco Bay Area Press Photographers Association.

Donald Winslow
Producer/co-founder, New Media for Non Profits

■ Winslow's new venture, New Media for Non Profits, located at http://www.nmnp.org, designs Web strategies, Web sites and new media methods for non-profit organizations, humanitarian missions, and philanthropic groups and individuals whose goals and vision coincide with those of the NMNP founders. He is also the media archive manager at CNET: The Computer Network in San Francisco. He has also served as the director of photography for CNET Online. Winslow has had a lengthy career as a photojournalist, writer, picture editor, graphics editor, producer and news designer. He has worked for Reuters and Reuters NewMedia, as well as *The Palm Beach Post, The Pittsburgh Press,* The Milwaukee Journal Co., *The Republic* in Columbus, IN, *The Wabash* (IN) *Plain Dealer* and *The Indiana Daily Student.*

Susan Zavoina
Associate professor, University of North Texas

■ Zavoina is associate professor and coordinator of the photojournalism sequence at the University of North Texas. Currently, she is co-writing a textbook, "Digital Photojournalism," and is co-editor and contributing author of "Sexual Rhetoric: Media Perspectives on Sexuality, Gender and Identity." She has also served as a research fellow for the Poynter Institute. Zavoina's most recent study, "Photojournalism in the 21st century," done in conjunction with *Newsday* and the Poynter Institute, was presented during the national APME conference. She received a grant from the Freedom Forum Foundation to photograph the effect of litter on Texas beaches. Her most recent pictures are exhibited in the show "Image 2000." She has served as head of visual communication for the Association for Education in Journalism and Mass Communication and has taught classes in Romania.

NATIONAL GEOGRAPHIC
Photographic & Digital Imaging Lab

Quality Laboratory Services

58th POYi Awards

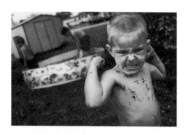

Newspaper Photographer of the Year

1st **Scott Strazzante,** *The Herald News* / Copley Chicago Newspapers / CITY 2000
2nd **Rob Finch,** *The Beacon News* / Copley Chicago Newspapers / *The Oregonian*
3rd **Kathy Plonka,** *The Spokesman-Review*
AE **Barbara Davidson,** *The Dallas Morning News*

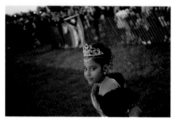

Magazine Photographer of the Year

1st **Jon Lowenstein,** CITY 2000
2nd **Randy Olson,** Freelance / *National Geographic*
3rd **Michael Nichols,** *National Geographic*

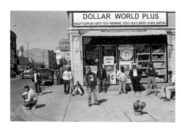

Fuji Community Awareness Award

Jon Lowenstein, CITY 2000, "A Home Away From Home"

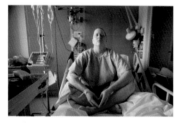

Canon Photo Essay

1st **Tara McParland,** *The Florida Times-Union,* "Journey of Hope"
JSR **Matt Rainey,** *The Star-Ledger,* "After the Fire"

Angus McDougall Award for Excellence in Overall Editing

The Hartford Courant

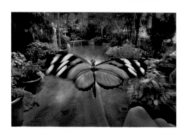

Public's Best Picture of the Year

1st **Dale Guldan,** *Milwaukee Journal-Sentinel,* "Butterflies are Free"
2nd **Dave Kendall,** Press Association / *Sports Illustrated,* "Stairway to Heaven"
3rd **Ann Arbor Miller,** Ohio University, "The Unexpected Father"

General Division

AE **Roberto Schmidt**, Agence France-Presse, "Brother"
AE **Rhona Wise**, Agence France-Presse, "The Inspector"

GENERAL DIVISION**CAMPAIGN 2000**

1st **Eric Mencher**, *The Philadelphia Inquirer*, "Sea of Balloons"
2nd **Molly Bingham**, The White House, "Dancing"
3rd **Pete Souza**, *Chicago Tribune*, "Behind Bradley"
AE **Ruth Fremson**, *The New York Times*, "Southern Support"
AE **Brooks Kraft**, Corbis Sygma / *TIME*, "The Wave"
AE **Brooks Kraft**, Corbis Sygma / *TIME*, "A Time Out"
AE **Kenneth Lambert**, Associated Press, "Bush Backer"
AE **Pete Souza**, *Chicago Tribune*, "Tie Adjustment"

GENERAL DIVISION**2000 OLYMPICS**

1st **Jacques Demarthon**, Agence France-Presse, "Who Won?"
2nd **Craig Golding**, *The Sydney Morning Herald*, "Swimmers Prayer"
3rd **Bill Frakes**, *Sports Illustrated*, "Golden Stretch"
AE **Scott Barbour**, Allsport, "Team Celebration"
AE **Trent Parke**, Freelance / *The Sydney Morning Herald*, "Flash"
AE **Smiley Pool**, *The Houston Chronicle*, "Contrast"
AE **Adam Pretty**, Associated Press, "World Record"
AE **Michael Probst**, Allsport, "Olympics USA"
AE **Mark Reis**, *The Colorado Springs Gazette*, "Rulon"
AE **Heather Stone**, *Chicago Tribune*, "Greco-Roman Victory"

GENERAL DIVISION**SPOT NEWS**

1st **Alan Diaz**, Associated Press, "Political Maneuver"
2nd **Toshihiko Sato**, Associated Press, "Concorde Crash"
3rd **Awad Awad**, Agence France-Presse, "Shot"
AE **Jean-Marc Bouju**, Associated Press, "Watching in Horror"
AE **Sergey Chirikov**, Agence France-Presse, "Explosion Victim"
AE **Ronald Erdrich**, *The Abilene Reporter News*, "Pipeline Fireball"
AE **Bob Freitag**, *Griffin Daily News*, "Stand Off"
AE **Michael Laughlin**, *The Sun-Sentinel*, "Seized"
AE **Chip Litherland**, *The Longmont Daily Times-Call*, "Rifle Arrest"
AE **Lefteris Pitarakis**, Associated Press, "Clashes"
AE **Donna E. Natale Planas**, *The Miami Herald*, "Sunken Living Room"
AE **Antonio Scorza**, Agence France-Presse, "Bus Hijacker Yells"
AE **Kuni Takahashi**, *The Boston Herald*, "Seizure"

GENERAL DIVISION**GENERAL NEWS**

1st **Lannis Waters**, *The Palm Beach Post*, "Lining Up to Vote"
2nd **Noah Addis**, *The Star-Ledger*, "Hero"
2nd **Rob Finch**, *The Beacon News* / Copley Chicago Newspapers, "New President"
3rd **Ilkka Uimonen**, Gamma Presse / *Newsweek*, "Ariel Sharon Visit"
AE **Sergey Chirikov**, Agence France-Presse, "Chechen Refugee"
AE **Carolyn Cole**, *The Los Angeles Times*, "Face of Conviction"
AE **Peter Dejong**, Associated Press, "IMF Protest"
AE **Peter Dejong**, Associated Press, "Economy Clash"
AE **David Handschuh**, *The New York Daily News*, "No Ifs, Ands or Butts"
AE **Cyrus McCrimmon**, *The Rocky Mountain News*, "Family Sorrow"

GENERAL DIVISION**SCIENCE/NATURAL HISTORY**

1st **David Doubilet**, Freelance/*chicago tribune*/*National Geographic*, "Australian Sea Lion Watches Out"
2nd **Michael Nichols**, *National Geographic*, "Megatransect I"
3rd **Randy Olson**, Freelance /*National Geographic*, "Palmyra Atoll"
AE **David Duprey**, Associated Press, "Buffalo Weather"
AE **Michael Forsberg**, Freelance, "Balancing Act: Burrowing Owl"
AE **Dale Guldan**, *The Milwaukee Journal-Sentinel*, "Butterflies Are Free"
AE **Michael Nichols**, *National Geographic*, "Megatransect II"
AE **Mona Reeder**, *The Dallas Morning News*, "Fowl Play"

GENERAL DIVISION**ILLUSTRATION**

1st **Amy Guip**, *Newsweek*, "The Human Genome Project 1"
2nd **Bill Steber**, *The Tennessean*, "Hank's Suit"
3rd **Lara Solt**, Sun Publications / *The Lisle Sun*, "Community Spirit"
AE **Amy Guip**, *Newsweek*, "The Human Genome Project 2"
AE **Sarah Leen**, Freelance/*National Geographic*, "Luis' Lobster Fleas"
AE **Kevin Manning**, *St. Louis Post-Dispatch*, "Surveillance"
AE **Hans Neleman**, *Newsweek*, "Wired"

GENERAL DIVISION**NEWS PICTURE STORY**

1st **Ilkka Uimonen**, Gamma Presse/*Newsweek*, "The Visit"
2nd **Jon Naso**, *The Star-Ledger*, "Florida Recount"
3rd **P.F. Bentley**, *TIME*, "Untitled"
AE **Candice Cusic**, *Chicago Tribune*, "A Mother's Nightmare"
AE **Brooks Kraft**, Corbis Sygma / *TIME*, "Bush"
AE **Mike Stocker**, *The Sun-Sentinel*, "Florida Recount"
AE **Diana Walker**, *TIME*, "Campaign"

GENERAL DIVISION **SCIENCE/NATURAL HISTORY PICTURE STORY**

1st **Michael Nichols**, *National Geographic*, "Megatransect II"
2nd **Mark Moffett**, Freelance/*National Geographic*, "Ants and Plants: Tree Fortresses"
3rd **Michael Amendolia**, Network Photographers (Sydney), "Corneal Donation in Nepal"
AE **David Doubilet**, Freelance/*National Geographic*, "Portrait of a Great White Shark"
AE **Michael Nichols**, *National Geographic*, "Megatransect I"

GENERAL DIVISION**SPORTS PORTFOLIO**

1st **Adam Pretty**, Allsport
2nd **Scott Barbour**, Allsport
3rd **Christopher Anderson**, *The Spokesman-Review*
AE **Michael Laughlin**, *The Sun-Sentinel*
AE **John Lee**, *Chicago Tribune*
AE **Steven Rosenberg**, *The Beacon News* / Copley Chicago Newspapers

Newspaper Division

NEWSPAPER DIVISION**ISSUE REPORTING**

1st **Ann Arbor Miller,** Ohio University,
"The Unexpected Father"

2nd **Jeanie Adams-Smith,** Ohio University / *Chicago Tribune,*
"Peer Pressure"

3rd **Scott Strazzante,** CITY 2000, "Last Break"

AE **Bradley E. Clift,** *The Hartford Courant,*
"Refrigerated Children"

AE **Vicki Cronis,** *The Virginian-Pilot,* "Divided Congregations"

AE **Leigh Daughtridge,** Copley Chicago Newspapers,
"Bargain Hunt"

AE **Jamie Francis,** *St. Petersburg Times,* "TV's for Sale"

AE **Jake Herrle,** Sun Publications, "The Long Wait"

AE **Sylwia Kapuscinski,** *The Naples Daily News,*
"Foster Seniors"

AE **Tim Klein,** Sun Publications / *Fox Valley Villages,* "Shooter"

AE **Danielle Richards,** *The Record,* "Living in the Shadows"

AE **Nancy Stone,** *Chicago Tribune,* "Rugged Road"

NEWSPAPER DIVISION**GLOBAL NEWS**

1st **Dudley M. Brooks,** *The Washington Post,* "Body Count"

2nd **Barbara Davidson,** *The Dallas Morning News,*
"Praying for Peace"

3rd **Peter Dejong,** Associated Press, "Taking Cover"

AE **Kael Alford,** Freelance / Newsmakers, "Deja Vu"

AE **Dudley M. Brooks,** *The Washington Post,* "Mass Grave"

AE **Barbara Davidson,** *The Dallas Morning News,* "War Victim"

AE **Maxim Marmur,** Associated Press, "Russia/Chechnya"

AE **Alexander Zemlianichenko,** Associated Press,
"Crying Torture"

NEWSPAPER DIVISION**FEATURE PICTURE**

1st **Torsten Kjellstrand,** *The Spokesman-Review,*
"Prom Math"

2nd **Michael Lutzky,** *The Washington Post,* "Faux Pas"

3rd **Rob Finch,** *The Beacon News* / Copley Chicago Newspapers,
"Breaking Stride"

AE **Colin Mulvany,** *The Spokesman-Review,* "This Kiss"

AE **Tony Overman,** *The Olympian,* "Volcanic Clean-up"

AE **Allison V. Smith,** *The Dallas Morning News,* "Boots Up!"

NEWSPAPER DIVISION**SPORTS ACTION**

1st **Phil Coale,** *Tallahassee Democrat,* "Maximum Impact"

2nd **Karl Merton Ferron,** *The Baltimore Sun,* "Storm"

3rd **Julian H. Gonzalez,** *Detroit Free Press,* "Aqua Halo"

AE **Jeff Chiu,** *San Francisco Chronicle,* "A Hard Day's Fight"

AE **Chang W. Lee,** *The New York Times,* "I Got You!"

AE **Chip Litherland,** *The Greeley Tribune,* "Untitled"

AE **Steve Peterson,** *The Rocky Mountain News,* "Track Fall"

AE **Jeremy D. Redfern,** *The News-Review,* "Wrestling Flash"

AE **Chris Schneider,** *The Oregonian,* "A Close Call"

AE **L. Todd Spencer,** *The Virginian-Pilot,* "Over and Under"

NEWSPAPER DIVISION**SPORTS FEATURE**

1st **Alan Hawes,** *The Post and Courier,* "Football Freezer"

2nd **Scott Strazzante,** *The Herald News* / Copley Chicago
Newspapers, "Heads Up for Rain"

3rd **Vincent Laforet,** *The New York Times,* "Yankee Fan"

AE **Maria J. Avila,** *The San Antonio Express-News,*
"Lucha Libre 1"

AE **Torsten Kjellstrand,** *The Spokesman-Review,*
"The Big Game"

AE **Michael Lutzky,** *The Washington Post,* "Sandlotball"

AE **Keith Myers,** *The Kansas City Star,* "Farewell to #58"

AE **Dale Omori,** *The Plain Dealer,* "Closer Look"

AE **Nancy Pastor,** Freelance / *The Hartford Courant,*
"Miss Hartford"

AE **Lui Kit Wong,** *The Tacoma News-Tribune,*
"U.S. Diving Trials"

NEWSPAPER DIVISION **PORTRAIT/PERSONALITY**

1st **Jennifer Zdon,** *The Times-Picayune,* "Green Girl"

2nd **Genaro Molina,** *The Los Angeles Times,*
"Laurence Fishburne"

3rd **Laura Decapua,** Freelance / Ohio University / *The
Virginian-Pilot,* "Untitled"

AE **Noah Addis,** *The Star-Ledger,* "Veiled"

AE **Jay Capers,** *The Rochester Democrat & Chronicle,* "Hay"

AE **J. Kyle Keener,** *The Detroit Free Press,* "Moment of
Reflection"

AE **John Pendygraft,** *St. Petersburg Times,* "Swimmerman"

AE **Steven Rosenberg,** *The Beacon News* / Copley Chicago
Newspapers, "Feeling the Touch"

AE **Scott Strazzante,** CITY 2000, "Muscles"

AE **Rebecca Barger-Tuvim,** *The Philadelphia Inquirer,*
"Flower Girl"

AE **Vicki Valerio,** *The Philadelphia Inquirer,* "Pontiff"

AE **Damon Winter,** *The Dallas Morning News,*
"Out of the Shadows"

NEWSPAPER DIVISION **PICTORIAL**

1st **Franka Bruns,** *The Pittsburgh Post-Gazette,*
"Key Note Player"

2nd **Susana Vera,** *The News & Observer,* "Surburbia Splash"

3rd **Jackie Belden,** Ohio University / *Naperville Sun,*
"Africans Dancing"

3rd **Doug Loneman,** *The Bozeman Chronicle,* "Hotsprings"

AE **Richard Koci Hernandez,** *The San Jose Mercury News,*
"Princess"

AE **Rick Loomis,** *Los Angeles Times,* "Storm Chaser"

AE **Jason Millstein,** *The Palm Beach Post,* "Chinook"

AE **Mike Stocker,** *The Sun-Sentinel,* "Flying Fish"

NEWSPAPER DIVISION
ISSUE REPORTING PICTURE STORY

1st **John Freidah,** *The Providence Journal,*
"The Lead Poisoning Crisis"

2nd **Leigh Daughtridge,** Fox Valley (IL) Publications, "Painful
Choices: Seniors and Prescription Drugs"

3rd **Joachim Ladefoged,** Magnum Photos / *Pro Helvetia,*
"Kosovo: One Year After!"

AE **Jeanie Adams-Smith,** Ohio University / *Chicago Tribune,*
"Living Under Pressure"

AE **Todd Heisler,** Sun Publications, "Move Over Rover:
Suburbia Comes to Lincoln Way"

AE **Callie Lipkin,** *The Beacon News* / Copley Chicago
Newspapers, "Leaving Home"

AE **Jon Naso,** *The Star-Ledger,*
"Martin Road in Black and White"

NEWSPAPER DIVISION
GLOBAL NEWS PICTURE STORY

1st **Barbara Davidson,** *The Dallas Morning News,*
"War in Congo"

2nd **Anders Vendelbo,** Freelance / Ekstra Bladet, "Israel"

3rd **Dudley M. Brooks,** *The Washington Post,*
"Thou Shalt Not Kill"

3rd **Claus Bjorn Larsen,** Berlingske Tidende,
"Mozambique Flooding"

NEWSPAPER DIVISION **FEATURE PICTURE STORY**

1st **Stephanie Sinclair,** *Chicago Tribune,*
"Courthouse Weddings"

2nd **Colin Mulvany,** *The Spokesman-Review,* "Days of Discovery"

3rd **Tony Overman,** *The Olympian,* "One Body, Two Lives"

AE **Leigh Daughtridge,** Fox Valley (IL) Publications,
"This Is a Job for ... Superman Fans"

AE **David Pierini,** *The Herald News,* "Kelly and Jason"

AE **Kathy Plonka,** *The Spokesman-Review,*
"Life at Hauser Lake"

AE **Mona Reeder,** *The Dallas Morning News,*
"The Home Church"

AE **Scott Strazzante,** *The Herald News* / Copley Chicago
Newspapers, "Trying to Hold On"

AE **Mark Zaleski,** *The Press-Enterprise,*
"Todd and Marci: A Love Story"

NEWSPAPER DIVISION **SPORTS PICTURE STORY**

1st **John Lee,** *Chicago Tribune,* "Little Men"

2nd **John Lee,** *Chicago Tribune,* "An Irish Kingdom"

3rd **Adam Nadel,** Freelance, NRC Z, "Muay Thai's Fighters"

AE **Debbi Morello,** Freelance / *The San Diego Union-Tribune,* "A
Ritual of Life and Death: The Bullfight

AE **Trent Parke,** Freelance / *The Sydney Morning Herald,*
"Gymnastics: Sydney Olympics 2000"

NEWSPAPER DIVISION **ONE WEEK'S WORK**

1st **Rob Finch,** *The Beacon News* / Copley Chicago
Newspapers

2nd **Rob Finch,** *The Beacon News* / Copley Chicago
Newspapers

3rd **Wally Skalij,** *Los Angeles Times*

AE **Stephanie Sinclair,** *Chicago Tribune*

Magazine Division

MAGAZINE DIVISION **ISSUE REPORTING**

1st **Michael Nichols,** *National Geographic ,* "Megatransect I"

2nd **American Sciences & Engineering,** *Newsweek,*
"Truck in Southern Mexico"

3rd **Tyrone Turner,** Black Star / Institute of Current World
Affairs, "Sad Ecstasy"

AE **Chris Anderson,** Aurora and Quanta Productions, "Sick"

AE **Chris Anderson,** Aurora and Quanta Productions, "Fear"

AE **Sergei Guneyev,** SABA Press Photos / *TIME,*
"Soup Kitchen"

AE **Roger Lemoyne,** Freelance / Liaison Agency / UNICEF,
"Women's Clinic, Afghanistan"

AE **Tom Stoddart,** Freelance / IPG / Matrix / *U.S. News & World
Report,* "HIV Victim"

MAGAZINE DIVISION**GLOBAL NEWS**

1st **Ettore Malanca,** SIPA Press / *The New York Times Magazine,* "Ethnic Fencing"
2nd **James Nachtwey,** Freelance / Magnum Photos / *TIME,* "Prayer"
3rd **Oliver Jobard,** SIPA Press, "Dangerous Journey Without Roads"
AE **Luc Delahaye,** Magnum Photos / *Newsweek,* "Carried"
AE **Tyler Hicks,** Liaison Agency / *The New York Times Magazine,* "Mother and Child"
AE **James Nachtwey,** Freelance / Magnum Photos / *TIME,* "Israel Molotov Cocktail"
AE **David Silverman,** Newsmakers, "Photographer Row"
AE **Tom Stoddart,** Freelance / IPG / *U.S. News & World Report,* "Floods in Chokwe, Mozambique"
AE **Ilkka Uimonen,** Gamma / *Newsweek,* "Chest"

MAGAZINE DIVISION**FEATURE PICTURE**

1st **Tamara Voninski,** Oculi, "The Laneway"
2nd **Chris Hamilton,** Freelance / Aurora and Quanta Productions, "Trying to Be Normal Again"
3rd **Lauren Greenfield,** Freelance / *Stern,* "Showgirl in Plane"
AE **Sisse Brimberg,** Freelance / *National Geographic,* "Thermal Bath"
AE **Jodi Cobb,** *National Geographic,* "Frenchman's Dream"
AE **Patrick Tehan,** *The San Jose Mercury News,* "Gone With the Wind"

MAGAZINE DIVISION**SPORTS ACTION**

1st **John Kimmich-Javier,** Freelance / University of Iowa, "Estocada"
2nd **Dave Kendall,** PA / *Sports Illustrated,* "Stairway to Heaven"
3rd **Scott Barbour,** Allsport, "Crashing Chairs"
AE **Jon Ferry,** *ESPN The Magazine,* "Return to Sender"
AE **John Kimmich-Javier,** Freelance / University of Iowa, "Flying Bulls"
AE **Fernando Medina,** NBA Photos / *Sports Illustrated,* "Fresh Vince"
AE **Manny Millan,** *Sports Illustrated,* "Net Income"
AE **Adam Pretty,** Allsport, "Jubo!"

MAGAZINE DIVISION**SPORTS FEATURE**

1st **Scott Barbour,** Allsport, "Run!"
2nd **Al Bello,** Allsport, "Blowing Bubbles"
3rd **Yvette Marie Dostatni,** CITY 2000, "Beer Can Crusher"
AE **Stephen DuPont,** Contact Press Images, "Sweeping"
AE **Adam Pretty,** Allsport, "Lasting Impression"
AE **Damian Strohmeyer,** *Sports Illustrated,* "There's No Place Like Home"

MAGAZINE DIVISION**PORTRAIT/PERSONALITY**

1st **Randy Olson,** Freelance / Aurora and Quanta Productions / *National Geographic,* "Ariadna "
2nd **Jodi Cobb,** *National Geographic,* "Miss Universe"
3rd **Jock Fistick,** Freelance, "Wounded Warrior"

AE **Gordon Baer,** Freelance, "Finally at Rest"
AE **Jodi Cobb,** *National Geographic,* "Huli Wigman"
AE **Jodi Cobb,** *National Geographic,* "Mudman"
AE **J. Carl Ganter,** Freelance / MediaVia, "Farm Hug"
AE **Edward Keating,** *The New York Times Magazine,* "Asphalt Blues"
AE **Randy Olson,** Freelance / *National Geographic,* "Bird Hunter"
AE **Herb Ritts,** *TIME,* "Tiger Woods"
AE **Tyrone Turner,** Freelance / ICWA / Black Star, "Glue Kid"

MAGAZINE DIVISION **PICTORIAL**

1st **Steve Simon,** Freelance / Liaison Agency, "Fire"
2nd **Jeff Mermelstein,** Freelance / *U.S. News & World Report,* "Blame the Pundits"
3rd **David McLain,** Aurora and Quanta Productions / Classroom Connect, "Chain of Light"
AE **Sarah Leen,** Freelance / National Geographic Society Books, "Nebraska Coal Train"
AE **Steve McCurry,** Freelance / *National Geographic,* "Women in Field, Yemen 2000"
AE **Rick Rickman,** Freelance / NewSport, "Heaven's Hole"
AE **Tom Stoddart,** Freelance /IPG "Flood"

MAGAZINE DIVISION
ISSUE REPORTING PICTURE STORY

1st **Felicia Webb,** Katz Pictures, "Anorexia: Slow-Dance With Suicide"
2nd **Geert van Kesteren,** *Newsweek,* "AIDS in Zambia"
3rd **Tyrone Turner,** Freelance / ICWA / Black Star, "Discarded: Glue Kids of Recife, Brazil"
AE **Seamus Murphy,** SABA Press Photos, "Ebola"
AE **James Nachtwey,** Freelance / Magnum Photos / *TIME,* "Rwanda's Sorrow"
AE **Ilkka Uimonen,** Corbis Sygma, "Water Crisis in India"

MAGAZINE DIVISION
GLOBAL NEWS PICTURE STORY

1st **Joachim Ladefoged,** Magnum Photos / NRC Handelsblad, "Kakum Refugee Camp"
2nd **Ilkka Uimonen,** *Newsweek,* "Rage Days"
3rd **Seamus Murphy,** SABA Press Photos / *TIME,* "Parched Earth"
AE **Stanley Greene,** Agence Vu / *Newsweek,* "The Forgotten People of Chechnya"
AE **Seamus Murphy,** SABA Press Photos, "War in Afghanistan"

MAGAZINE DIVISION **FEATURE PICTURE STORY**

1st **Ed Kashi,** Freelance, "Pine Ridge"
2nd **Michael Amendolia,** Network Photographers (Sydney), "Kashgar: Islamic China"
3rd **Stephen DuPont,** Contact Press Images / *TIME,* "People of Tibet"
AE **Reza,** Freelance / IMAX / *National Geographic Adventure,* "Afghanistan: Forbidden Zone"
AE **Tamara Voninski,** Oculi, "The Laneway"

MAGAZINE DIVISION **SPORTS PICTURE STORY**

1st **Scott Barbour,** Allsport, "Paralympic Games"
2nd **Stephen DuPont,** Contact Press Images, "Mundine: The Man, The Moment"

3rd **Seamus Murphy,** SABA Press Photos, "Leap of Faith: Sierra Leone's Olympic Hopefuls"
AE **Lynn Johnson,** *Sports Illustrated,* "Gymnastics Trials"

Editing Division

NEWSPAPER EDITING DIVISION
SINGLE PAGE NEWS STORY

1st **Frederic C. Nelson,** *The Seattle Times,* "Dome's Final Roar"
2nd **Toni Finch Kellar,** *The Hartford Courant,* "Euphoria"
3rd **Adele Chavez,** *The Albuquerque Tribune,* "Western Walls of Fire"
AE **Victor Vaughan, Photo and Design Teams,** *The Virginian-Pilot,* "Rains Bring Bangladesh, India a Flood of Misery"
AE **Victor Vaughan, Photo and Design Teams,** *The Virginian-Pilot,* "Remember Them"
AE **Victor Vaughan, Photo and Design Teams,** *The Virginian-Pilot,* "Revolt in Belgrade"
AE **Alex Burrows, Norm Shafer, Victor Vaughan, David Hollinsworth,** *The Virginian-Pilot,* "The Final Salute"
AE **Greg Griffo,** *The Indianapolis Star,* "Left Behind Bars"
AE **Stephanie Heisler,** *The Hartford Courant,* "Acts of Rage, Retaliation"
AE **Merrill Oliver,** *The New York Times,* "A Far Cry From Boston"
AE **Cecilia Prestamo,** *The Providence Journal,* "Pain Without End"

NEWSPAPER EDITING DIVISION
SINGLE PAGE FEATURE STORY

1st **Sid Hastings, Jake Herrle, Jon Shoemaker, Mike Davis,** *The Homer Sun* / Sun Publications, "Chrome Sweet Chrome"
2nd **Loup Langton, Michelle Patterson, Leigh Daughteridge, Penny Falcon, Jan Houseworth, Jeannie Tustison,** *The Beacon News* / Copley Chicago Newspapers, "Home Sweet Porch"
3rd **Greg Peters, Kim Kim Foster, Susan Ardis, Brian Tovaz,** *The State,* "A Sweet Season"
AE **Loup Langton, Mike Davis, Leigh Daughtridge, Betsy Guzior, Jan Houseworth, Jeannie Tustison,** *The Beacon News* / Copley Chicago Newspapers, "The Nature of Nurturing"
AE **Michael Madrid, Kevin Eans,** *USA Today,* "It Helped Me Out the Way They Told Me It Would"
AE **Mark Edelson, Greg Lovett,** *The Palm Beach Post,* "Place of Praise"
AE **Kevin Keister, Chuck Liddy, Bonnie Jo Mount, Damon Cain, John Hansen, Robert Miller, Sherry Johnson,** *The News & Observer,* "Marion"
AE **Kristen Sladen, Kevin Eans, Leslie Spalding,** *USA Today,* "Women's World"
AE **JoEllen Black, Sherry Peters, Chris Moore,** *The Hartford Courant,* "Pleasing From Plate to Palate"
AE **Janet Reeves, Patrick Davison,** *The Rocky Mountain News,* "It's Disneyland"
AE **Susan K. Zake, Robin Witek, Kimberly Barth, Michael Chritton,** *The Akron Beacon Journal,* "The Spirit of Goodyear"
AE **JoEllen Black, Rich Messina,** *The Hartford Courant,* "The Quiet Side of Nantucket"
AE **Bruce Moyer,** *The Hartford Courant,* "Carnival of Hope"
AE **Frederic C. Nelson,** *The Seattle Times,* "Photo Finish"

NEWSPAPER EDITING DIVISION
MULTIPLE PAGE NEWS STORY

1st **Kathleen Hennessy,** *San Francisco Chronicle,* "Waiting for War, Praying for Peace"

2nd **Maggie Steber, Roman Lyskowski,** *The Miami Herald,* "Seized: Raid Returns Elian"

3rd **Cecilia Prestamo, John Freidah,** *The Providence Journal,* "Dreams Deferred"

AE **Loup Langton, Michelle Patterson, Callie Lipkin, Martin Stockwell, Amy Hayden,** *The Beacon News /* Copley Chicago Newspapers, "Leaving Home"

AE **Mark Damon, Akili C. Ramsess,** *The San Jose Mercury News,* "Dream Denied"

AE **Joe Cavaretta, Dough Sehres, Joe Barrera Jr., Anita Baca, Ron Jaap,** *San Antonio Express-News,* "Thank God!"

AE **JoEllen Black, Cloe Poisson, Malanie Shaffer,** *The Hartford Courant,* "A Hard-Scramble Election"

AE **Rob Kozloff, Victor Vaughan, J. Kyle Keener, Andrew Johnston, Laurie Jones, Mary Shroeder, Al Kamuda,** *The Detroit Free Press,* "Wow-2K"

AE **Bonnie Jo Mount, Scott Sharpe, Corey Lowenstein, John Rottet, Maria Rodriguez, Damon Cain, Kevin Keister, John Hansen, Robert Miller,** *The News & Observer,* "Fighting for Survival"

AE **John Sale,** *The Spokesman-Review,* "Parting Shot?"

NEWSPAPER EDITING DIVISION
MULTIPLE PAGE FEATURE STORY

1st **Andrew Cutraro, Larry Coyne, Wade Wilson,** *St. Louis Post-Dispatch,* "Hard Luck Haven"

2nd **Tim Broekema, Chad Stevens,** *Kalamazoo Gazette,* "Reaching Out for Timmy"

3rd **Tim Rasmussen, Reza Marvashti,** *The Free Lance-Star,* "Barry's Journey"

AE **Karin Anderson, Mike Davis, Lara Solt, Jon Shoemaker,** *Fox Valley Villages 60504 /* Sun Publications, "Pretty in Pink"

AE **Karin Anderson, Mike Davis, Lara Solt, Jon Shoemaker,** *The Lisle Sun /* Sun Publications, "The Real Santa Claus?"

AE **Alan Petersime, Greg Fisher,** *The Indianapolis Star,* "Latino Life"

AE **Torry Bruno, John Lee,** *Chicago Tribune,* "Miniature Men"

AE **Rita Reed, Vickie Kettlewell, Steve Rice, Rhonda Prast,** *Star Tribune,* "Tug of War"

AE **Patty Yablonski, Lisa DeJong,** *St. Petersburg Times,* "Way Over Yonder"

AE **Kevin Clark,** *The Seattle Times,* "Traveling Light"

AE **Catherine McIntosh, Dave Einsel,** *The Houston Chronicle,* "A Way Out"

NEWSPAPER EDITING DIVISION**SERIES**

1st **Matt Rainey, Pim Van Hemmen, Linda Grindberg,** *The Star-Ledger,* "After the Fire"
2nd **John Sale,** *The Spokesman-Review,* "Lifetime Decision"
3rd **Jamie Francis, Patty Lablonski,** *St. Petersburg Times,* "Florida Found"
AE **Loup Langton, Mike Davis, Michelle Patterson, Leigh Daughtridge, Julia Zolondz,** *The Beacon News* / Copley Chicago Newspapers, "Painful Choices"
AE **Mark Edelson, Sherman Zent,** *The Palm Beach Post,* "Sydney 2000"

NEWSPAPER EDITING DIVISION**SPECIAL SECTION**

1st **Paula Nelson,** *The Dallas Morning News,* "Hidden Wars"
2nd **Curt Chandler, Doug Oster, Lynn Johnson, Bill Pliske,** *The Pittsburgh Post-Gazette,* "Our Community of Faith"
3rd **Michael Franklin, Peggy Peattie, Chris Ross,** *The San Diego Union-Tribune,* "Bittersweet Journey Home"
AE **Paula Nelson,** *The Dallas Morning News,* "The MVP's"
AE **John Sale,** *The Spokesman-Review,* "Law of the Land"
AE **Eric Strachan,** *The Naples Daily News,* "A Right to Be Human"

NEWSPAPER EDITING DIVISION
PICTURE EDITING PORTFOLIO
Circulation less than 25,000

1st **John Rumbach, David Pierini,** *The Herald*
2nd **Karin Anderson, Mike Davis, Lara Solt, Deborah Pang, Dara Schwartz, Jon Shoemaker,** *The Lisle Sun* / Sun Publications
3rd **Dan Habib,** *Concord Monitor*
AE **Todd Winge, Brian Kratzer, Bill Carwin, Jason Cook, Jenna Isaacson, Frances Sayers, Toshiki Senoue,** *Columbia Missourian* / Missouri School of Journalism

NEWSPAPER EDITING DIVISION
PICTURE EDITING PORTFOLIO
Circulation more than 25,000

1st *St. Petersburg Times*
2nd **Pete Cross, Mark Edelson, Loren Hosack, John L. Lopinot, Sherman Zent, Jennifer Podis, Scott Wiseman,** *The Palm Beach Post*
3rd **Randy Greenwell, Kathleen Hennessy, Jim Merithew, Marianne Thomas, Russell Yip, Ron Mann,** *San Francisco Chronicle*
AE **Curt Chandler, Doug Oster, Pam Panchak, Jim Mendenhall, Andy Starnes, Bill Wade,** *The Pittsburgh Post-Gazette*
AE **Thomas McGuire, John Scanlon, Toni Finch Kellar, Bruce Moyer, Stephanie Heisler, David Grewe, JoEllen Black, Bill Sikes,** *The Hartford Courant*
AE *St. Louis Post-Dispatch*

MAGAZINE EDITING DIVISION
MULTIPLE PAGE NEWS STORY

1st **Sue Miklas,** *Newsweek,* "The Inside Story"
2nd **Kathy Ryan,** *The New York Times Magazine,* "Ethnic Fencing"
3rd **Keith W. Jenkins,** *The Washington Post Magazine,* "The Other War"

MAGAZINE EDITING DIVISION
MULTIPLE PAGE FEATURE STORY

1st **Kathy Moran, Robert Gray,** *National Geographic,* "Light in the Deep"
2nd **Kathy Ryan,** *The New York Times Magazine,* "The Pictures"
3rd **Michelle McNally, Meaghan Looram,** *Fortune,* "Running for President is an Unnatural Act"
AE **Kathy Moran, David Whitmore,** *National Geographic,* "Megatransect"
AE **Kurt Mutchler, Alexandra Boulat, David Whitmore,** *National Geographic,* "Eyewitness Kosovo"
AE **Steve Fine, James K. Colton, Jeff Weig, Maureen Grise,** *Sports Illustrated,* "Under the Gun"
AE **Michele McNally, Mia Diel,** *Fortune,* "Death of a Continent"
AE **Bert Fox,** *National Geographic,* "The Way West"

MAGAZINE EDITING DIVISION
PICTURE EDITING PORTFOLIO

1st **Kathy Ryan, Jody Quon, Kira Pollack, Evan Kriss,** *The New York Times Magazine*
2nd **Michele McNally, William Nabers, Courtenay Clinton, Nakung Han, Janene Outlaw, Alix Colow, Meaghan Looram, Mia Diehl, Scott Thode,** *Fortune*
3rd **Bert Fox,** *National Geographic*
AE **Kurt Mutchler,** *National Geographic*

BEST USE OF PHOTOGRAPHY**NEWSPAPERS**
Circulation less than 25,000

1st *The Herald*
2nd *Fox Valley Villages 60504* / Sun Publications
3rd *The News-Review*

BEST USE OF PHOTOGRAPHY**NEWSPAPERS**
Circulation between 25,000-150,000

1st *The Spokesman-Review*
2nd *The Naples Daily News*
3rd *The Times of Northwest Indiana*

BEST USE OF PHOTOGRAPHY**NEWSPAPERS**
Circulation more than 150,000

1st *The Seattle Times*
2nd *The Pittsburgh Post-Gazette*
3rd *The San Diego Union-Tribune*
AE *The Hartford Courant*

BEST USE OF PHOTOGRAPHY**MAGAZINES**

1st *National Geographic*
2nd *The Commission* / International Mission Board
3rd *Chicago Tribune Magazine*
AE *The Washington Post Magazine*

BEST USE OF PHOTOGRAPHY**BOOKS**

1st **Steve McCurry** Freelance / Phaidon Press Ltd., "South Southeast"
2nd **Trent Parke, Narelle Autio,** *The Sydney Morning Herald,* "The Seventh Wave"
3rd **James Nachtwey,** Freelance / Phaidon Press Ltd., "Inferno"

AE **Ron Haviv, Alison Morley,** SABA Press Photos / TV Books, "Blood and Honey: A Balkan War Journal"

AE **Kathy Moran, Marianne Koszorus,** National Geographic Society Books, "Women in Photojournalism"

AE **David Doubilet,** Freelance / *National Geographic* / Phaidon Press Ltd., "Water, Light, Time"

BEST USE OF PHOTOGRAPHY**NEW MEDIA**
INDIVIDUALS AND SMALL GROUPS

1st **Patrick Davison,** Ohio University / *The Rocky Mountain News,* "Undying Love," CD-ROM

2nd **Joe Weiss,** *The Herald-Sun,* "The Bull City Lions," http://heraldsun.com/gallery/peewee.html

3rd **Joe Weiss,** *The Herald-Sun,* "Little River Jamboree," http://heraldsun.com/gallery/jamopen.html

AE **Joe Weiss,** *The Herald-Sun,* "The Boys of Bundy," http://heraldsun.com/gallery/mmopen.html

BEST USE OF PHOTOGRAPHY**NEW MEDIA**
MAJOR MEDIA OUTLETS

1st **Tom Kennedy, Travis Fox, Mark Hill, Jeff Morley, Ben de la Cruz, Christina De Los Santos, Chris Kankel, Pierre Kattar, Michelle McAuliffe,** Washingtonpost.Newsweek Interactive, "Carol Guzy: Bearing Witness 1989-1999," http://www.washingtonpost.com/wp-srv/photo/onassignment/guzy/index.htm

2nd **Karl Schatz, Michael Enright, Anthony Suau,** TIME.com, "Beyond the Fall," http://www.time.com/btf/

3rd **Tom Kennedy, Dudley M. Brooks, Phaedra Singelis, Chet Rhodes, Travis Fox, Nelson Hsu,** Washingtonpost.Newsweek Interactive, "Thou Shalt Not Kill," http://www.washingtonpost.com/wp-srv/photo/uganda/index.htm

AE **Tom Kennedy, Eddie Adams, Kerry Kennedy Cuomo, Jane Menyawi, Mark Hill, Jeff Morley, Jody Brannon, Pierre Kattar, Michelle McAuliffe,** Washingtonpost.Newsweek Interactive, "Speak Truth to Power," http://www.washingtonpost.com/wp-srv/photo/onassignment/truth/flash.htm

AE **Tom Kennedy, Paul Fusco, Jane Menyawi, Jayne Matricardi, Ben de la Cruz, Dixie Barlow, Pierre Kattar, Michelle McAuliffe,** Washingtonpost.Newsweek Interactive, "RFK Funeral Train," http://www.washingtonpost.com/wp-srv/photo/onassignment/rfk/index.html

AE **Brian Storm, Meredith Birkett, Ron Haviv, Michael Moran, Janson Hollifield, Brenden West,** MSNBC.com, "Blood and Honey," http://msnbc.com/modules/bloodandhoney/splash.asp

Index

the EOS system

In the flash of an eye, the EOS system strikes. At 3 fps, the new D30 is the smallest, lightest digital SLR in the world. At 4 fps, the ELAN7E is an extension of your reflexes, with eye-controlled autofocus, along with the ultra-responsive EOS-3, at a lightning 7fps. The EOS-1v is the most advanced SLR on earth at 10 fps. And with Image Stabilizer technology, EF lenses are part of the most complete and innovative AF lens system ever made. Images can capture the soul. Will yours?

Eye Of Soul
-Stephen Wilkes

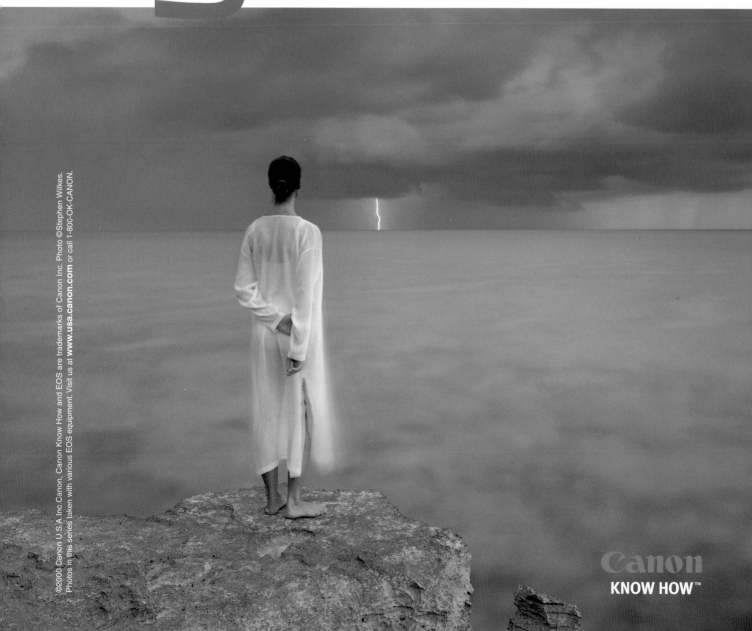

Canon

KNOW HOW™

"THIS FILM CAPTURES THE WHOLE TRUTH. UNFORTUNATELY, IT CAN'T MAKE IT ANY EASIER TO UNDERSTAND."

[ALBERT FACELLY]

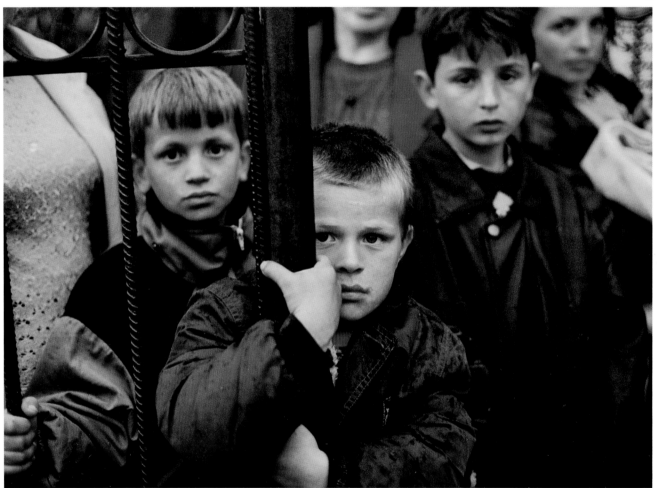

©1999 ALBERT FACELLY, SIPA PRESS

FUJICOLOR PRESS 800 (CZ)

[FUJICOLOR PRESS FILMS FOR PROFESSIONALS]

As a photojournalist, you rarely have control over the situations you photograph. Which is what makes the versatility of our Press films for professionals so important. Take our Fujicolor Press 400, and Fujicolor Superia 100 and 200 films. They employ Fujicolor's Fourth Color Sensitive Layer Technology to help give you realistically enhanced color, natural skin tones, outstanding sharpness and fine grain even under mixed lighting sources that include fluorescent light.

Not to be outdone, our Fujicolor Press 800 film can easily handle the most challenging lighting conditions to deliver images well exceeding your expectations for high-speed film. After all, even though the situation may be difficult, capturing it shouldn't be. For more information about our full line of Fujicolor Press films for professionals, call us at 1-800-800 FUJI.

FUJIFILM

Professional